S0-ATC-262

DATE DUE

FEB 2 7 1990 FEB 2 8 1990		DEC 03 1998
MAR 1 4 1990		
MAR 2 6 1990		
OCT 0 2 1990		
OCT 1 6 1990		
OCT 1 6 1990		
MAR 2 7 1992 NOV 23 '98		
APR 19 '98 MAY 2 8 2002		
APR 1 9		
NOV 7 '95		
DEC 5 '95		
DEC 7		
FEB 18		
FEB 1 3 REC'D		
AUG 1 0 1998		
JUL 2 4 REC'D		
OCT 1 9 2000		PRINTED IN U.S.A.
GAYLORD NOV 0 4 2000		

ART CENTER COLLEGE OF DESIGN

3 3220 00027 9880

CURVILINEAR PERSPECTIVE

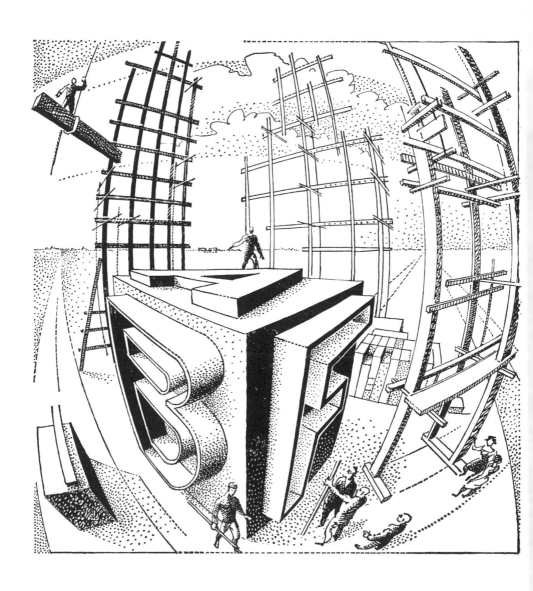

701.8
F628
c.4

CURVILINEAR PERSPECTIVE

FROM VISUAL SPACE TO THE CONSTRUCTED IMAGE

ALBERT FLOCON & ANDRÉ BARRE

TRANSLATION AND COMMENTARY
BY **ROBERT HANSEN**
WITH A SPECIAL INTRODUCTORY ESSAY
TO THE GERMAN EDITION BY **ALBERT FLOCON**
TRANSLATED BY LELAND BABCOCK

UNIVERSITY OF CALIFORNIA PRESS
BERKELEY LOS ANGELES LONDON

ART CENTER COLLEGE OF DESIGN LIBRARY
1700 LIDA STREET
PASADENA, CALIFORNIA 91103

University of California Press
Berkeley and Los Angeles, California

University of California Press, Ltd.
London, England

Originally published © 1968 Flammarion, Éditeur

Copyright © 1987 by
The Regents of the University of California

Library of Congress Cataloging in Publication Data
Barre, André.
 Curvilinear perspective.

 Translation of: La perspective curviligne.
 Bibliography: p.
 1. Space perception. 2. Visual perception.
3. Perspective. I. Flocon, Albert. II. Title.
QP491.B2713 1987 701'.8 86–30925
ISBN 0–520–05979–4 (alk. paper)

Printed in the United States of America

1 2 3 4 5 6 7 8 9

CONTENTS

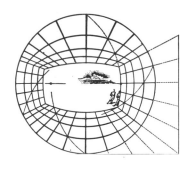

TRANSLATOR'S FOREWORD*

I

The thought of depicting our visible world of streets and buildings without straight lines will strike most readers—even artists—as a whimsical novelty. Indeed, Albert Flocon and André Barre have invited us to embark on a novel adventure: life in wide-angle vision. A single glance that takes in both ends of a long wall in front of us, receding to right and left at the same time, requires a continuous comparison of heights that produces curves that describe two straight edges, the top and bottom of the wall. Once we have been persuaded to examine the wide world around us with its rich environment of peripheral vision, we may be seduced by the swinging curves that turn the everyday grids and boxes of the familiar urban scene into ferris wheel and merry-go-round—entertaining fun. But there is also the roller coaster.

Adventure spells risk: the thrill of danger. Paying attention

*Major portions of my translation have been edited by Joan Moschovakis, Ph.D., professor of mathematics, and by Susan Grayson, Ph.D., and Jeanne Hart, Ph.D., professors of French language and literature. This edition could not have been prepared without their assistance.

It was through the generosity and advice of Professor Kim Veltman of the University of Toronto in granting access to his immense perspective bibliography that I was guided to discover texts by Malton, Herdman, de la Gournerie, Stark, and other pioneers of curvilinear perspective.

to the wide-angle world without straight edges can be scary, warping doors around us and floors beneath us, bending the pillars that support the protecting shelter over our head, discomfiting us in our comfortable easy chair, even in the still picture. A greater thrill awaits us: watching walls shrink and swell as we move. Attending now to the world as it turns or focusing on its changing shapes as we shift our gaze may throw us off balance. Momentary vertigo may threaten our inner ear. Never fear. Acquiring our sea legs brings visual control of a dynamic expanded universe. Flocon and Barre promise prompt recovery, and by breaking the shackles of received wisdom, the "laws" of perspective, the authors deliver on their promise: clear, mathematically precise, step-by-step procedures for constructing our own dependable signifier of a new voluptuous perception—this curving world.

Their book beckons us to join in the fun and excitement, but it is also a revolutionary manifesto, a call to liberation from dogma. Not "Down with Traditional Perspective!" but "Down with the Tyranny of Official Rules!" Not "Learn the ONLY TRUE PERSPECTIVE!" but "Let a Hundred Flowers Bloom!" The artist-authors challenge us to look with unbiased eyes at the entire spherical panorama that surrounds us, then to invent our own perspective and place it alongside the Flocon-Barre system and the classical "laws" of perspective in the marketplace of ideas and images. Let other perspectives compete with the Renaissance convention that has reigned unexamined for four centuries!

Flocon tells us in "Vanishing Points" (written for the 1984 German edition) of his dawning awareness of our spherical view of the world, from his childhood (as Albert Mentzel) near Berlin, through his seminal visual and psychokinetic experiences as a Bauhaus student, later as a refugee in Paris and then a prisoner of the Gestapo in a French village, to his position (as Flocon) of academy professor. In the first half of this autobiography, we learn how Flocon absorbs perspective lessons from the most diverse stimuli, sensing what no one

around him seems to take as seriously: the constancy of motion and the continuity of vision—the eyes' own motion picture. Listen to his musical diction as he recalls a bouncing baby buggy, a vibrating puppet theater, dancers on roof terraces, totaltheater surrounding an audience, an endless treescape surrounding a forest clearing, Buster Keaton defying the waves, and Harold Lloyd defying gravity. Prophetically, a wide-angle room compressed in a shiny metal ball. The geometry of the stage. The power of the frame, that breaker of continuity in drawing, photography, film, theater.

Flocon sings the exile's view from both sides of the frame, from flight point to flight point ("Fluchtpunkte"). Flight points become "Vanishing Points" for perspectives on the run. Up, down, right, left, and around; into and out of; discovery and poignant loss. His personal carousel revolves around the Bauhaus. But Hitler runs the circus.

Throughout "Vanishing Points" Albert Flocon reviews a lifelong kaleidoscope of almost random stimuli that generated the seeds of this book. When he shared his ideas with André Barre in 1956, they began together to write about their shared perceptions. Scattered hints of this curvilinear vision had been glimpsed before in the history of art but had never been assembled into cohesive theory or consistent practice. By 1968, when La Perspective Curviligne *was published in Paris, they had created the first systematic analysis and practical solution of this little-understood but fundamental conundrum of realism. (Brief introductions had appeared in their 1962 and 1963 publications. See Bibliography.) The mathematical foundations having been laid at a science session of the Royal Belgian Academy in 1964,[1] their book would now provide vernacular explanations and clear procedures for a variety of complex applications of spherical perspective. Yet until the 1983 German translation and the 1985 Spanish edition, it had been accessible only to those who read French.*

[1]See appendix.

II

Western artists have confidently applied the "laws" of perspective ever since they were "discovered" in the fifteenth century. Whereas medieval and oriental artists may seem to have invented metaphors in willful disregard of the real world's appearance, the Renaissance system has been accepted as imitative of nature, to judge from the nonchalance with which painters, illustrators, and architects have ever since portrayed "one-point" and "two-point" streets and buildings which, as Flocon and Barre show us, cannot be observed in nature. (Note that in figures A, B, C, and D, one-point becomes five-point and two-point becomes four-point in curvilinear systems. See Afterword.) From Giotto through Masaccio to Rubens and Claude Lorrain, the science of aerial perspective *and its* chiaroscuro *advanced with man's increasing worship of the material universe, and the work of Newton led to the* color *discoveries of Monet and Seurat. Today, however,* linear perspective *is still assumed to operate (that is, we assume that our eyes see) according to fifteenth-century rules formulated by Leon Battista Alberti.*

Alberti was one of the great Renaissance artist-intellectuals, a mathematician, writer, and painter primarily active as an architect. Painters before him had created bits and pieces of oblique foreshortening in architectural scenes in Classical Greece and Rome and throughout the Middle Ages and early Renaissance. When the fifteenth-century architect Brunelleschi painted two panels (since lost) expressly to demonstrate his observation of geometric perspective, Alberti, in his Della Pittura *of 1435, incorporated Brunelleschi's findings and cleverly restricted oblique projection to a* single central vanishing point. *His rule dictated that there must be* no distortion of straight lines and no foreshortening of any measurement parallel to the picture plane. *His mathematical formula regularized artists' earlier efforts at foreshortening but at the expense of what can only be called our* experience of diminish-

ing size visible on planes receding in all directions. (Although we may have to be trained to pay attention to our peripheral vision, curvature, once seen, is incontrovertibly constant.) His system is not a false formula that replaced the "truth" of earlier artists' images. It did replace other fragmentary conventions with a convention that was comprehensive, systematic, and relatively easy to explain and to use.

Within a few years Alberti's single vanishing point had conquered. With straight lines kept straight and frontal horizontals and verticals maintained perpendicular and undistorted by foreshortening, the only foreshortening remaining was now carried out by the obedient orthogonals radiating from that dictatorial central point. This ingenious system, engineered by architects, had simplified the artist's craft. Oblique two-point perspective virtually disappeared from painting. Alberti's powerful treatise had apparently become dogma by 1500 and remained inviolate for more than a century. When seventeenth-century northern artists abandoned this strict frontality, they returned to the more natural observations of the fourteenth century, when Giotto, the Lorenzetti brothers, Maso di Banco, and others had incorporated in numerous paintings two-point straight-line portions of the concave surface upon which we see the real world projected—a sort of transparent sphere surrounding our eye.

Only in the work of Jean Fouquet (1420?–1481?) are these adjacent sections of a painting allowed to fuse in a continuous curve, in both ceiling and floor of the Annunciation of the Death of the Virgin *(Musee Conde, Chantilly) and in the* Arrival of the Emperor at St. Denis *(Bibliothèque National, Paris) where pavement tiles behave in the visual way, curving up toward a horizon on both left and right, upon which, however, a procession marches in unyielding flat horizontality. And in another Fouquet manuscript illustration,* The Building of the Temple at Jerusalem *(Bibliothèque National, Paris) as well as in Donatello's relief rondo,* The Assumption of St. John *(San Lorenzo, Florence), verticals converge unmistak-*

ably toward a zenith vanishing point. To our prejudiced view, their curves and diagonals may look crude and unsure, but they must be seen as the expression of sensitive eyes not yet intimidated by formula. It is the extreme rarity of vertical convergence that makes these last examples astounding. Fouquet is the only artist perceptive enough to notice the curve forced on us when we pay attention while we move our gaze from the parallel verticals at eye level to the convergent verticals of the towers. Even the trompe l'oeil tours de force of the eighteenth century fall short of the vision of this fifteenth-century French genius, who reveals the curvature he sees in spite of the inconvenient adjustments necessary on a two-dimensional surface.

There was one other notable exception to the rule: Leonardo da Vinci. Although he did not advise painters to make use of these curves, we know from diagrams he left and from Cellini's description of a treatise on perspective by Leonardo, a manuscript book that has not survived, that he understood and saw the curves implied by wide-angle vision. In Manuscript A (1492) he diagrams the intersection of the cone of vision by a surface concave to the eye, where flanking columns appear smaller than the nearer central column, rather than equal or larger as in conventional plane intersection. There can be no doubt that Leonardo's surface "equally distant from the eye in every part" means a concave spherical surface, or that it provides a conceptual basis for Flocon-Barre and for any other curvilinear system. But the die had been cast. One-point perspective was law, and the development of "synthetic" perspective was never consummated. Leonardo himself seems to have counseled against depicting such close views that curvature would be difficult to avoid. He recognized the practical advantages of reasonably distant views and of the one-point system.

Similar observations have been reported occasionally from antiquity to the present, primarily by scholars concerned with Leonardo or with architecture, astronomy, or optics, not with

the problem of representational drawing. A debate continues about the curves discovered in the last century in entablatures and stylobates of Greek temples. Were they designed to counteract the effect of the "natural" curvature that Fouquet and Leonardo (and Flocon) saw in long architectural edges? A closely related conflict has been readily acknowledged in seeking solutions to another problem: for several centuries cartographers have devised ingenious strategies to accommodate the appearance of the terrestrial globe on plane surfaces, always recognizing the compromises inherent in the construction of maps, even those labeled "equal-area projections."

Drawing rules were also questioned. Traditional perspective has been found inaccurate and inadequate principally by architects and architectural scholars. As early as 1776, Thomas Malton, in reviewing current perspective texts by Brooks Taylor and others, declared that "it is evident that there is a manifest difference between the representation of an object on a plane surface, and its appearance to the eye" . . . *"[artists] would have all objects represented in Perspective exactly as they appear to the eye:* there is no such thing to be done. *It is not in the power of Art or Science to represent on a Plane, any single object,* as it appears" (A Compleat Treatise on Perspective, *Book II, sec. vi, p. 94).*

Acknowledging Malton's influence, William Herdman published an article in 1849 and a book in 1853 (A Treatise on the Curvilinear Perspective of Nature and its Applicability to Art) *in which he declared that "the principles of circular perspective" had been "put . . . beyond all dispute" by Daguerrotypes of architecture. He also refers to drawings and paintings that he had made as early as 1836 recording the visual appearance of wide-angle views of buildings and streets. The line drawings, derived from his paintings, that we see in his book, along with the derisive tone of his criticism of the standard attitudes toward perspective verisimilitude, make Herdman the only true predecessor of Flocon/Barre, the only earlier champion of a* drawing system *that reflects the natural*

curves of optical sensation. However, his principles are applied only to horizontal lines and edges. Vertical architectural lines remain straight. While he diagrams the principles of the spherical perspective that he believes governs our vision, he advises that curvature of verticals "will be found only when lofty elevations are depicted near . . . In all other instances in which pictures are usually drawn, the vertical altitude is so small as to make any deviation from a straight line either unnecessary, or so trifling, as to matter little whether attended to or not" (p. 100). His "circular perspective" is therefore cylindrical, not spherical. Like Flocon/Barre, Herdman speaks of his procedure not as the correct formula but as the necessary compromise arrived at by trusting the artist's eye.

In 1859 Jules de la Gournerie observed that only a circular wall can present the appearance of equal height at all points to an observer at the circle's center (Traité de perspective lineaire, p. 161). Painters, he noted, depict all figures as if they were projected on such a curving surface, but he found that writings on perspective drawing made no reference to this deviation from visual experience (p. 171). He added that a hyperbola is a curve that would accurately reproduce a frontal view of edges of a flat wall. But "these effects are not observable except by those who make a habit of studying them. . . . The problem of perspective is not susceptible of rigorous solution" (p. 175). However, because he insisted that straight lines must be preserved "in order to maintain harmonious composition," he devised oblique rectilinear formulas that avoid curving images (cited in Hauck, p. 243; see Bibliography).

Like de la Gournerie, a number of German and Austrian architectural scholars who have acknowledged the curvilinear nature of vision have limited their instructional diagrams to oblique views, applying retinal optics only to the foreshortening of straight orthogonal receding lines. In separate treatises by Julius Deininger (1914), Fritz Stark (1928), and Horst Hegenwald (1932), the curvature of a frontal view appears

only in a single example that illustrates "retinal picture perspective." In his Plate XV, Stark depicts a rectangular facade in consistently hyperbolic curves. Strict rectilinear perspective is nevertheless advocated for "practical" drawing. Stark characterizes both retinal and traditional perspective systems as approximate and conditional. "Direct projection cannot provide a 'correct' picture" (p. 68). Both de la Gournerie and Stark, as well as their followers and chroniclers, have agreed with Leonardo that artists must maintain a straight-line system and that a reasonably distant view should be used to avoid the wide-angle curvature of the near view.

Artists, however, finding no fault over the centuries with Alberti's straight-line formula, have taken little notice. Only in seventeenth-century Dutch interiors (see paintings by Steen, Ostade, Jordaens, and Brouwer) can separate details be found: two-point beds, stools, and tables in the corners of a room, that hint at different perspectives within the picture—furniture that, placed edge to edge, might describe a curve. Two-point perspective became commonplace by the nineteenth century, and twentieth-century illustration has made melodramatic use of three-point foreshortening. Ever since the time of Fouquet and Donatello, however, except for illustrators' bird's-eye and worm's-eye views, parallel verticals have remained conveniently sacrosanct, and there seems to have been no questioning by artists of the correctness of this fifteenth-century system. Except for Herdman, until Escher and Flocon, Fouquet's curves had not been seen again. While both artists and scholars have occasionally accepted frontal picture-plane curvature as natural, no one until Flocon and Barre provided step-by-step instruction in the drawing of two-dimensional images that record these spherical curves.[2]

[2]A more complete account of the history of linear perspective may be found in John White's The Birth and Rebirth of Pictorial Space, and in Samuel Y. Edgerton Jr.'s The Renaissance Rediscovery of Linear Perspective.

III

A nineteenth-century break from traditional artist conformity to Renaissance perspective can be found in Van Gogh's Bedroom at Arles, where curved bed and floorboard edges that are parallel to the picture plane appear to follow Flocon and Barre's arc connecting right and left vanishing points. The artist clearly saw the curves in his wide-angle view of this little room. (Skeptics should note that Van Gogh's meticulous application of conventional perspective to garden walls and room interiors throughout his painting career attests to his skill as well as to his concern for descriptive accuracy, in spite of his characteristic two-dimensional color and occasional flattening of perspective space in a few of his later paintings.) Similar bends and bulges can be found in a number of canvases by Cézanne, who, noting that the eye is spherical, insisted that the visual world is also fundamentally spherical and cylindrical or conical, but not cubical. "Bodies seen in space are all convex," he would say, and point to flat walls as well as to apples.³ Nevertheless, despite the enormous influence wielded by these post-Impressionist giants, we find no "natural" curvature in twentieth-century painting until the 1970s.

Of course, numerous twentieth-century movements have exploited expressive deviations from strict rectilinearity, notably in German expressionism and in cubist and futurist paintings, as well as in stage and film sets and in the decorative art that inevitably followed. Nevertheless, nearly all of these "distortions" are primarily poetic inventions offered as alternatives to literal imitation. Thus, Robert Delaunay's Saint Severin *of 1909–10 dramatizes expressionist response to architecture, but the inconsistent foreshortening only hints at the zenith and nadir vanishing points brought into play by his wide-angle view of the towering piers of the cathedral.*

³*See Norman Turner, "Subjective Curvature in Late Cézanne," Art Bulletin (December 1981):665–669.*

Rectangles reflected in spheres and convex mirrors have always tantalized us; they provide visual games within well-known Renaissance masterworks by Van Eyck and Parmigianino and in many seventeenth-century Dutch still-life paintings. A vast audience has been amused by the popular work of Maurits Escher, whose self-portraits in spherical mirrors include a woodcut and four lithographs, produced between 1921 and 1950. Spherical perspective is the foundation of almost all of Escher's entertaining architectural scenes, especially Up and Down (1947), House of Stairs (1951), and the most complex of all, the undulating multiple perspectives of Print Gallery of 1956. (Flocon tells us that Escher wrote that he found Flocon a "brother in spirit," one of the very few artists who shared his view of vision . . . and perhaps his playfulness as well.)

Until Photorealism and Pop Art in the 1960s, so-called modern art had virtually banned literal representation of space in order to maintain the "integrity of the medium": paint on a flat canvas or wall. Moreover, the window view seen through a picture frame, with its careful conventional straight lines, prevails even in the work of exceptional significant realists such as Edward Hopper and surrealists such as Salvador Dali. Dali even ventures a fourth-dimensional crucifixion without bending a single contour. More recently, since the 1970s, the work of Ron Davis has combined insistently planar color with elaborate abstract Albertian diagrams of dramatically foreshortened rectilinear solids, somewhat like Van Gogh's flat color within perspective contours. Victor Vasarely has also played with abstract mosaics of foreshortened flat-color tesserae, sometimes describing non-Euclidean bulges, but these patterns never depict real-world objects. The pluralist 1980s, however, have welcomed realists with a vengeance, and some curvilinearists have turned up.

By now Weegee's "fish-eye" lens photojournalism of the 1940s has evolved into the stylish wide-angle advertising close-ups of every TV screen. We are amused, but we do not

recognize in them our own human wide-angle world. Camera designers, it turns out, have always carefully calculated lens proportions expressly to avoid the "distortion" produced by short lenses. Moreover, artists and scientists as well as the lay public exhibit a virtually religious confidence in the camera as the arbiter of every kind of doubt about what we see and how we see. Photorealist painters have been especially docile, invariably mimicking the optics and surface effects of the photograph rather than the object that the photograph depicts or the evidence of their own eyes. Alberti thus still dictates our assumption of the universally straight appearance of straight lines.

An increasing number of artists, architects, and estheticians, however, have begun to see the curvilinear light. In addition to the French, British, Swiss, and Italian artists and architects mentioned by Flocon, others are bending their realist views around the sphere. They include painters of interior scenes: subtly rendered curves by Antonio Lopez Garcia in Spain and dramatic compressions by Jacqueline Lima in New York and Fernando Casas in Texas. Rackstraw Downes' extremely wide-angle landscapes inescapably require curving ligaments joining polar opposite vanishing points. David Hockney's photo-collages demonstrate the same curvilinear experience. Lima and Richard Termes of South Dakota paint on the exterior of actual spheres, much as Flocon did in his 1968 Tableau Sphérique for UNESCO. In New York, Lucien Day paints the urban scene on concave cylindrical surfaces, and Paul Smith shows three-dimensional photograph/painting constructions that emphasize the central bulge of flat frontal planes. In Great Britain, Alan Turner, John Wonnacott, Lawrence Gowing, Kenneth Adams, and Anthony Green have based figurative imagery on spherical or cylindrical projection. In addition, Casas and Adams have devised ingenious geometries—Casas's "polar perspectives" and Adams' "tetraconic projections"—that suggest fourth-dimensional spherical

images of architectural interiors.[4] In La Visione Sferica (Milan, 1973) Adrian Dan Elias, recognizing the sphericity of retinal vision, proposes painting on concave hemispheric surfaces as a new medium that can revitalize decadent art. And in Julio Fuentes Alonso's Solucion Lógica a la Perspectiva Natural (Madrid, 1975) he finds that Velazquez and Murillo depicted frontal walls in the subtle "curves that we see but do not think" when "we respect the natural unity of the view point," the rotating eye, rather than "the fictitious immobility of the view point" (pp. 47–53). These curves are extremely difficult to detect.

Inasmuch as books on perspective drawing always invoke Renaissance "laws" as the exclusive basis for instruction, Radu Vero's 1980 book, Understanding Perspective, is somewhat unusual, taking a hesitant step toward the sphere before retreating. While familiar formulas prevail, it includes a brief chapter called "Spherical Perspective." Vero provides a thorough, clear text replete with handsome diagrams illustrating the sphericity of vision ("how the eye works") but, like Herdman, he stops short of showing the reader how to draw objects in spherical perspective. Although the same Escher and Fouquet works that appear in Flocon-Barre are reproduced, the chapter's fourteen pages and twenty-six illustrations offer only one curvilinear diagram for constructing a drawing of a scene, and that is in cylindrical, not spherical, perspective. Vero offers the compromise of cylindrical perspective because it alone can be plotted on a plane surface that can then be bent around our eye.

Do these independent observations constitute a trend? An

[4]Many of these examples and similar ideas and images can be found in the pages of Leonardo, the international quarterly of art and science, which provides a continuous forum in which artists, psychologists, philosophers, mathematicians, and engineers argue a variety of picture perspectives.

awakening? Might artists eventually accept plural perspectives, a choice among standards of verisimilitude? Flocon-Barre alongside Alberti? Have Flocon, Barre, and Escher simply picked up where Leonardo and Fouquet left off when Alberti's formula took over? It has been assumed in too many academies, by too many artists, as well as by art historians and laymen, that the inherited system represents not merely propriety and practical metaphor but essential fidelity to ordinary vision. Constable and the Impressionists long ago shocked us into paying attention to the vivid colors that academicians had replaced with chalky highlights and brown-gravy shadows. Flocon and Barre are now the first to show us the real-life spherical views that the academies have ignored for four centuries. These curves that are basic to everyone's everyday looking-at-the-world have never been seen and understood so clearly and never presented systematically until this book appeared.

It seems inevitable that curves must eventually constitute the basic language for picturing our rectangular world of boulevards and buildings and boxes. Coming generations of artists may well look back to Flocon and Barre as the historic source of the challenge to depict the wide world as it turns.

Los Angeles, 1986 *Robert Hansen*

VANISHING POINTS*

AN ESSAY ABOUT SPACE EXPLORATION

A PERSONAL INTRODUCTION
TO **CURVILINEAR PERSPECTIVE**
WRITTEN ESPECIALLY FOR THE GERMAN
EDITION BY **ALBERT FLOCON**

TRANSLATED FROM THE ORIGINAL GERMAN
BY LELAND BABCOCK

*In German, "FLUCHTPUNKTE" (literally, "flight points")

While I would like to throw the gate wide open to individual freedom—in order to look at various perspectives—and wish that the artist might experience that Dionysian frenzy which reveals the miracle that is constantly before us, I would also like to gently reverse the process in order to invite his respectful involvement in that other side that can also open up new perspectives: the world of mass, number, and law. That other side is "strict regularity."

Oskar Schlemmer, in his lecture,
"Perspektiven," 1932

A most appropriate symbol of man in the universe (for he is the unit in which everything revolves and is reflected and reduced! . . .) In a unified sphere, one could indeed project a reproduction of infinite three-dimensional space.

Arno Schmidt, Schwarze Spiegel, *1963*

Hans Wingler asked me whether I would write for the German edition of *La Perspective curviligne* a supplementary essay on the debate about perspective as it was practiced by the Bauhaus.

I plunged into the theme immediately because everything concerned with perspective gets me going. Yet my thoughts go where they will; they take their own course, just as I imagine the inner projection machine works. Thus this text is not a clear, impersonal answer to a given question but an essay about looking through and looking into, about how perspective systems eventually turn out. Last but not least,

it is about how looking-through and looking-into incorporate a rather general way of thinking—indeed, a way of discovering. Perhaps the individualist, subjective coloration of my report is not without interest insofar as it becomes clear that even the most difficult circumstances cannot prevent the expression of irreverent thoughts. Quite the contrary.

Perspective at the Bauhaus was determined above all by photographic practice; everywhere corners and ends were cropped off. There was the old machine on its tripod, with its ground glass plate and black cloth, as well as the Leica at eye level, which was quick and unobtrusive. For economic reasons there was no filming, yet film was present in all deliberations. The great film events came from Russia and America; the indigenous expressionist film, from *Nosferatu* to *Metropolis,* was felt to be trash.

Photography solved in excellent fashion the problem of realistic representation, the problem of perspective. The traditional ceremonious methods with their artful poses, self-consciousness, and avoidance of movement (which frequently resulted in such impressive daguerreotypes) were snapshots, which now made way for rising and falling perspectives, ingeniously illuminated razor-sharp still-life studies, and the mobile camera of the dashing reporter. (Lux Feininger and Naf Rubenstein with their sport caps turned back to front might be mentioned here.) It would no doubt be worthwhile to investigate the influence of Russian photographic reportage on the worldview of the young German intellectuals of that time.

In any case, pictures such as Pudowkin's trembling chandeliers, the neglected baby buggy rolling down the staircase, and Eisenstein's peons with their heads buried under horses' hooves were some of the scenographic perspective shocks that impressed me. Add to them the houses of Buster Keaton, floating in the floodwaters of the Mississippi, and Harold Lloyd's struggle for equilibrium on the skyscraper para-

pet, followed by his eventual plunge—forestalled again and again—into the arms of his loved one.

The rectangular Bauhaus structure, made of piercing sharp-cornered masonry, smooth white walls, and a great deal of glass, was the ideal backdrop for inventive, unconventional photography and for bringing eccentric perspective lines and freely flexed mobile bodies into the clearest light: maskers and dancers seen from above on terraces, one over the other, improvised dances on the roof (always festive, always in celebration!). The Meyer slogan, "Junge Menschen, kommt ans Bauhaus!"[1] belongs here, and Hannes Meyer himself in his high, stiff Swiss collar and corresponding carriage of the head and his nice, somewhat wry smile. From Funkat, I believe, comes the picture of the entrance hall, its ceiling strewn with metal balls, in the largest of which is mirrored the entire scene, including the photographer, his assistant, and his apparatus: my first indelible impression of a spherical perspective within a central perspective.

I recall well the old engravings of an anamorphosis by Schübler (1719) and a geometricized crucifixion by Jamnitzer (1561), shown by Kallai in the Bauhaus journal. (In 1963 I wrote a long introduction for the new edition of Jamnitzer's *Perspektiva Corporum Regularum*.) And then, naturally, Schlemmer's spatial grids [*Raumnetze*] and the ironical perspectives of Paul Klee; and not to be forgotten, the metaphysical urban views of Giorgio di Chirico, with their handless and timeless clocks, their stone war-horses and monumental jointed dolls, all of which bring before my eyes like a kaleidoscope the experiences of a cycling trip of my youth to the Florence of Masaccio, Brunelleschi, and Uccello, the inventor of a silvery, luminous reborn world. This experience of the early Renaissance and its mannerist cultivation in later times still lingers today, although I now know better how cruelly

[1] "Young people, come to the Bauhaus."

murderous were those new worlds and times when they burst on the scene.

In these time-and-place events the theater plays a commanding role. I would have called this document "Kleines Welttheater" (Little Theater of the World) had the title not already been appropriated. The theater entered into my life quite early: the trembling walls and creaking stairs when the command, "Come down here, Remi!"[2] was given: Kasper and the marionettes' continually fluctuating little stages, to which imagination lent amplitude and mystery. Later then, as a sixteen-year-old in Haubinda, I staged "The Broken Jug,"[3] the Pirandellesque "Puss and Boots," and other plays under the influence of Tairoff's "*Unchained Theater*" [*Entfesseltes Theater*], in which he proposed diverse stage levels and simplified sets.

After I came to the Bauhaus, I threw myself onto the stage. As a preparatory student I had seen the first Schlemmer dances on the occasion of a festival. Did they not mean to shape space by moving in space, by quickly or moderately or slowly traversing the scenic parallelepipedon—step by step, corner by corner, edge by edge—and by exploring it, making it visible? Schlemmer had made a black picture-frame stage [*Guckkasten*] out of the Italian stage, wherein each white button, every spot of color, was highlighted—something like the camera obscura of a modern della Porta. This was my sphere of existence for a year and a half of the most intensive work: straight ahead, right, left, in a circle; yellow, red, blue; one, two, three . . . a dramatic exercise of scenic elements. Sweating in our divers' costumes, smelling of strong glue, breathing inside oppressive masks, we were the prototypes of Platonic ideas, a people from elsewhere, Kleistian marionettes without words, reduced to pantomiming. And our single word: cuckoo! was already almost a release

[2]From Schiller's *Wallenstein*.
[3]Kleist's *Zerbrochenen Krug*.

within the muteness. Self-denial belongs to that kind of theater performance. Being bereft of speech was all the more distressing because we were deeply convinced that we possessed the true word. Because we could not say it on stage, we did so in the canteen. (What researcher will someday describe the subversive function of the canteen?) This was the "Bolshevization of the House," flowing from many channels. *Ex oriente lux*: we were certain that we had the erudition that knows everything, were omniscient.

For the tour program that was slowly emerging, Schlemmer finally accepted the "Sketch," written by Feist, Hartmann, and myself in the Dadaist manner. It was eliminated from the program, however, after the initial performance at the Berlin Folk Theater. The audience whistled and protested when, at the end, the much-loved thief, wept for by the dancer and jeered at by the dandy, was led off to strains of the Hohenfriedberger march by a policeman wearing a pointed helmet on his bald head. On that account we bore a grievance against Schlemmer. We thought that he, along with us, could have quietly endured a booing audience and rotten apples. We were certainly successors to those young people who (as far as I know, even in Schlemmer's formulation) wanted "as heaven-storming believers in the future, to build a cathedral of socialism." We were pious zealots for the luminous house of the approaching future, cut in wood by Feininger.

Piscator belongs among the exponents of theatrical set design. It was Piscator who, through the gradual raising of the veiled projection surface that caused the scenery to look like a slowly lifting fog,[4] had imperceptibly migrated from the film screen to the stage, against a permanent musical background provided by Paul Robson, Sophie Tucker, and the Three Penny Opera. I must also not forget the "Totaltheaters" proposed by Weiniger and Gropius, in which the dra-

[4]In "Kaufman von Berlin."

matic action was to surround the audience and which were already close to the optical spheres which I later envisioned.

What poet will describe the Dionysian atmosphere of the Bauhaus fetes, where masked and costumed sarabands, circling through house and yard, over walls and ceiling, caused space and time to disappear magically, all this in order to produce a state of suspension, of exaltation, in which mind and body swayed equally, floated and danced in pure joy . . . ?

In the matter of architectonic representations, straight or oblique axonometry was resorted to in ground plans and vertical sections wherever spaciousness was needed. I recall no projects with central perspective. The rigid axonometries, however, built on a ground plan with verticals of about 30 degrees, impressed me greatly. Architecture exhibited in that way is shifted into the fanciful—indeed, into the plastic-poetic. It would be interesting to investigate the influence on architectural design of axonometric configuration. The removal of vanishing points, the strict parallelism of concordant straight lines, the regular and infinitely ascending terrain that overflows the edge of the drawing are perhaps an expression of consumer goods, running uninterrupted from the conveyor belt, which would unavoidably bring about a sense of well-being and ease. It was a question, as Gropius thought, of showing the scheme (project) not from the vantage of the consumer who is earthbound but from the helicopter perspective of the architect who controls everything (from *archos*: to command, and *techton*: worker). Naturally the danger too often arises that such control will become a tool of megalomaniacal speculators.

This much, however, is certain: my feeling for space was influenced less by Köhn's instruction than by what I have described above. Alber's preliminary course, however, in this respect was just as significant as Dada, Moholy, and, most of all, Heartfield—in short, every influence related to photo-mounting, collage, folding, unfolding, plastering, pil-

ing up, and filling space. The combining of images from remote sources, of various distributions of light and shade, and even different times, which caused new objects or situations to arise that were mixed with kitsch—cheap sentimental pictures, slogans, labels, pressed flowers, and other textured and colored materials—permitted the release of humor and satisfied the urge to shape and form. Finally, photography appeared to replace painting; the photographer was the new picture mechanic. Unsystematic experiments that took many directions led to the doctrine which implied that banal—indeed, lowbrow—elements, when combined in new arrangements, could attain sublime effects that had never before been seen.

Non scolae sed vitae discimus and other idiotic maxims were surely at work when the head of the school condemned me to a "foreign semester" in a hostile environment for his own political peace of mind as well as that of the institution: all this a euphemism for being kicked out! Thus I became, first in Berlin and then in Frankfurt-am-Main, an amateur agitator, amateur graphic artist, and amateur family man (note that the word "amateur" comes from *amare*, to love).

1933: the thunderclap of the thousand-year Reich, which one had considered impossible. There was no longer more than one language and one taste, which made my hair stand on end: the *Hohenfriedberger March* through thick and thin . . . therefore into exile I went with my whole family, with our vanishing point, Paris!

What followed was not the simple new life in "vieille France," the well-preserved, middle-class-commonplace France where everything offered itself in beautiful-artful equilibrium, cool colors, as regular and improvised and unsullied as the Louvre itself (which afterward was turned completely upside down). In the Parisian view Germany's madness appeared psychotic. At first it was a matter of incorporating oneself into the street life of the metropolis, where pairs of lovers embraced continually and everywhere, where

street singers and itinerant vendors, sightseers, and Camelots (from camel), who to my ears spoke an extraordinary French, prowl about. There were the banks of the Seine, the boutiques, and above all countless coffeehouses where one could spend hours in conversation for the price of a *crème*. All in all, a tolerant, rather reserved country with an anarchical-conservative background and the motto "Everyone for himself, and God for us all."

Thus the life of the refugee, the exile (from the Latin *exsilire*, to jump out, to be shut out). And suddenly one sees everything inside from the outside. A radical change of view occurs. The winter's tale that was Germany becomes a *temps des cerises*. Living in Paris does not immediately make one a Parisian. My grandmother Flocon had perhaps sung into my ear with her fractured German something of the music of the French language. In any event, I learned the language easily and with pleasure. My French years as an apprentice and then as a journeyman were to last until after the Second World War. My uneasiness in the culture was tightly bound up with my extensive searching, with a profound alienation, with my extroversion and introspection, with interior and exterior, this-worldly and the other-worldly, with my personal Diaspora. The Gordian knot did not untie so easily, and the violent solution by the one in power was not for me. Only now can I say that vanishing points and vanishing lines and planes have their good sides. It was also good—and I am grateful to a kindly fate for it—that the police inspector from the Montparnasse station who was familiar with my "case" had as a "client," as he put it, Kurt Tucholsky, whom I much admired and thought to be an intelligent man.

Seeing-through and seeing-into: perspectives—with them one can create, one can construct. Yet, as I said, this seeing-into [*Einsicht*] only came after a number of years. The world went on revolving. On February 11, one read: Popular Front, Spanish Civil War. Was there a chance for the cathedral of

socialism? Not, at least, at that time. Is the purchase of a paintbox worth mentioning in these times of tragic crises?

It was a genuine dovetailed wood box, lined with zinc, with paintbrushes and wire brushes, spatula, palette, and the best hand-ground oil colors, Lefèvre-Foinet. Armed with easel and canvas, I went in search of subjects and soon noted that drawing belongs to painting—not outlining and filling in, but putting the brush exactly where it must go. This certainly could be achieved only with much practice—and oil paints were so expensive, whereas pencils and pens were cheap. And so I went into the Academie de la Grande Chaumière to practice drawing nudes in my free hours, instead of having discussions in the adjacent Dôme.[5] In any event, my painting and drawing interested me more than the commercial work of applied graphics, although that work (often felt to be trivial) presupposes neat and accurate execution. The advertising clamor (I had finally settled in Paris in order to hear less of it) was still in its infancy.

I soon found out that the interplay between the reality of a tree, a house, a naked woman, the sky (with or without those fleeting forms, the clouds), and the developing picture—that this complex relationship, the immeasurable and incalculable difference between the things themselves and the painted objects that one can carry under one's arm, rings true when it divests itself of the clichés and the do's and don't's that one encounters everywhere. I could see with my own eyes and feel with my own hands, so that I found that I was capable of portraying and setting down in color on a perfectly flat surface graphically modeled opaque or transparent objects, derived from viewed experience yet quite different. Not as well as Rembrandt, simply because the relationship to reality and to dream is now less direct and is burdened with large question marks about their meaning.

[5]A well-known artists' cafe in Montmartre.—TRANS.

The martial sounds, booming ever louder, reminded me often of Rome and Syracuse—Please don't disturb my meditations!—A blow on the head, and it's over! Since my high school days I had been unsympathetic to the warlike, quarrelsome Romans who were bent on conquest. Libido dominandi is a mental illness that is difficult to cure.

Everything that has to do with sight and seeing is drawing: looking at, looking into, and being on the lookout. From window display (Schlemmer's window pictures) to stage play. Everything concerning light and eyesight, prospect (Newski, for example) and perspective (= telescope = seeing far, seeing through, from *spicatus,* pointed)—basically all phenomena that, like light beams, go through the eye of a needle, intersect there and produce images and thus pictures (picturae artificialis, as Kepler says)—amount to drawing, delineating, painting. And this includes what dictionaries express in these various realms of words: seer or voyeur—filling the eyes, treating the eyes, feasting the eyes . . . Dürer called it "nourishment for the young painter." *Das Mahl und der Maler, ein Mal und Abendmahl* [meal and painter, mark and evening meal]. I had to catch up on everything that was nearly omitted at the Bauhaus: elementary drawing, history and art history, the look into the past.

At this point one might contemplate the relationship (if there is one) between language and drawing. In my case the matter is complicated by the second language, the language of my grandmother's side of the family that began to mute, obscure, and suppress my mother tongue. What would the apt word be? Do languages affect the style of drawing and painting? I often read German, French, or Italian experts when a learned gentleman has nothing more to say about an anonymous print or drawing. I regard this vague realm with mixed feelings, vacillating between Privy Councillor Menzel (my name except for the "t") and Edouard Manet. I prefer the beautiful Olympia (about whom Michel Leiris writes in a melancholy poetic way, as only a few older people still

can) with the black necklace as her only article of clothing, to old Fritz with his frivolously trashy Sanssouci, although the young Menzel in Paris made marvelous unpretentious sketches full of feeling.

It is incredible what can exist and occur within a single field of vision—and there are four billion of these at a given moment. The eye—one does not say "eyes" inasmuch as something is wrong when one sees double—can to an infinite degree tie together impressions and ideas: from thumbtack [*Reisszwecke*] or rice kernel [*Reiskorn*] to the eternally raging traffic congestion under my window; from mayfly to rocket; from a point to an entire surface; from surface to corpus; from corpus to space; and from space to time. Groddeck says: "Existence forces us to associate with geometric figures." The great world theater in the little social circle, as in the living circus and the life cycle.

In a certain way seeing is a passive event. "You have eyes, and do not see." Observing, "looking into," is still better; gazing, casting a look at, is an act issuing from the observer, an act of making desirable objects and persons one's own. The gaze investigates the space, probes its depths, examines it, and takes pleasure in it. Worldviews are philosophies come into being like mosaics, in that one (to speak with Dürer) extracts pieces of nature one way or another, observing and recording, then filtering and distinguishing between that which is taken and that which is left, weaving and knitting back and forth, in order to put them back together in a new way. The flickering disorder of countless impressions is thus slowly brought into order, into form, into chiaroscuro, into tones of color. The observer translates a three-dimensional happening, sensed by the retina and elaborated by the brain into a flat structure, a picture, a scene, what today we may call representational form [*Gestaltung*]. Neither the image on the retina nor the image in the brain has ever been seen. One must be content with what every kind of image maker achieves. Every image contains a part of

reality: the reality of the representer and the reality that is represented. It is never complete. Images also belong to the material world and are perhaps to be allied with the few objects that are not wholly intolerable, as reality may be.

1933: We are on our summer holiday at the peaceful Lac d'Aiguebelette. I am helping with the scattering of hay for drying when a boy from the village comes racing up out of breath with Job's news: war has been declared! Warriors are lovers and patrons of art. A painter is released from service so that he may depict sleeping quarters, soldiers' homes or theaters, or soldiers' portraits—all directly from nature, or from photographs in which subjects at least hold still. The non-military painter, perhaps even the painter-soldier, succeeds in depicting the Algerian country and people, a whole portfolio full. In essence it was no doubt applied art with many ups and downs, until the stockade, and then release from the foreign legion in 1941.

It is scarcely believable how much a painter must digest and integrate in his little upstairs room. So, for example, the so-called free life of a picture-framer and painter in the village of Pibrac, around whom the war and the cries of war raged from 1941 to the beginning of 1944. (The lawyer and poet du Faure de Pibrac had absolved the Protestants during the religious wars in the sixteenth century, and his descendants still lived in the castle.) It is unbelievable, too, what one can produce when one lives a monotonous life under strong external pressure. When a unit of the Reich division occupied the village, we went to Toulouse where Flocon, my name as an artist, turned up on our identity cards. I was arrested there at the end of May 1944 while at my easel, as well as my daughter, who happened to be at home. And my wife at her workplace in the airplane factory. Thus the air force police.

In the German section of the St. Michel prison my military painting started up again and sustained me to the time of deportation (which almost all arrested persons wanted because we thought that forced labor in Germany was to be

preferred to severe interrogation and hunger). But more about that in another place. In short, walls, fences, barricaded windows, reverberating hallways, overrunning buckets, the noise of boots and clanging doors. Because of all this, we dreamed of the far-beyond. Soon there were pencil and paper and a cell for four (instead of fourteen), and the command to pursue portrait painting. Portrait after portrait, painted with the subject present or from photographs, and even a drawing of the chief sergeant-major, which showed him hand-in-hand with his wife in his homeland, seated at the table and looking devotedly into her eyes. For weeks, from the first lieutenant down to the corporal (were there any privates in the S.S. post?), again and again portraits with wife and child. Sentimental oaks, as Heine said . . .

Brunner from the air force police had told me at the conclusion of an interrogation (he addressed me with the formal "you"): "You have a courageous wife. Your daughter can stay with her." And then the Silesian S.S. guard, who wanted to convince me to escape with him, mentioned casually: "You won't see your wife again, anyway: there is a difference of blood." I ascribed this to his stupidity and simply would not believe it. He knew how things went, however, at least long before my mind had to accept cold-blooded murder, the unimaginable, the final solution. In Auschwitz the wind blew them both away. There are still people who maintain they knew nothing about it, or say plainly that it was all invented. Where, then, might your brother Abel be?

I sat in that hole with my dreams of escape and drew scenes on the scanty sheets of paper I could set aside, scenes breaking through the walls into the far-beyond, my first attempts at perspective drawing. The pleasure was to last, so I laid out points and lines slowly and as precisely as possible with a sharpened pencil, going into the infinite depths of the surface of the sheets of paper. One of these drawings, in quarto format and precisely copied, was later to appear as an engraving in my first book, *Perspectives*.

This drawing, *Hommage à Gutenberg,* is a variation of the laugh-onomatopoeia ha-ha! but also an expression of astonishment or of triumph "ah!" or "aha! I have you!" or "there you are!" to quote Knauer. A and H, also a and h, float freely through space, circle, form rotating figures in locomotion, appear in relief printing [*Hochdruck*] and in intaglio, in positive and negative, in folding [*Faltungen*] and in reflection, in the form of printing plate and rubber stamp. Not until many years later did it strike me that A.H. was also the monogram of the maniacal monocrat who at that time still had almost a year to live and who had cold-bloodedly reduced my native land to smoke and ashes. In any case, amid the unbearable conditions in prison a lifesaving role was played by the prestige of the artist, this hackneyed and for me ridiculous bourgeois requisite of the magician and his magic art, this archaic-superstitious conviction that the glance of the portrait painter brings bad luck if one does not treat him well.

In Malraux's memoirs one can deduce how release from prison came from the vision and tone of the bard. The picture-painter saw the event infinitely more prosaically, without the growling of tanks and the clanking of weapons. Art is also dramatically exaggerated. Recollections of war are therefore mostly not much truer than Karl May's Indian stories.

Now I was free, but I was also dejected for many reasons. In the atmosphere of "liberation" with its new fables and myths (Why do people not put up with the sober truth?) perspective helped me over many an oppressive dark hour. There arose the twelve engravings on the theme of perspective, which I was just studying at the time. I soon found out that the prevailing system, long regarded (by what or whom?) as outmoded, led to astonishing discoveries that resulted in a kind of freedom, a freeing of the sense of space and a freedom to shape space, as they constituted a joyful expansion of delineative possibilities. Later, as I was studying the

history of perspective, I found in s'Gravesand (1711) a wonderful remark about the usefulness of perspective: "Whatever is said against it by certain painters is a consequence of the widespread maxim that whatever they ignore is not worth the trouble of being known." I could, for example, repeat forms infinitely until they reach the vanishing point, cut the receding line and return from infinity on a different path, hold the heaviest bodies in suspension, bend planes and bundles of lines [*Geradenbundel*], indicate the furthermost distance within the confines of the paper, lend an abstract geometric figure measurable size by inserting familiar objects (a person, cow, or flower), even invert a rather beautiful construction by making receding objects larger rather than smaller.

I discovered—for myself, at any rate, others having certainly known about it for a long time—that classical perspective, through its logical order, offers an outstanding principle of composition. For it is a building-box devised for the flat surface equipped with every spatial ornamentation in order to shape and articulate the picture within the frame that has been drawn. The execution of my drawing with the greatest possible exactitude caused me to look for a graphic means that made it possible to draw lines of differing strengths up to a hair-fine point, sharper and above all blacker than with an H7 pencil. Thus it was quite natural that I hit upon the engraving burin, undoubtedly the most intractable medium of expression that can be imagined, although also the simplest. Its variants are hairline, tapered, and swelling strokes, straight or curved, parallel or crosshatched, as well as points or stippling. The instrument limits the means, and it seems to me that this very paucity of means is the cardinal virtue of the gravestone cutter's chisel (as perhaps also of the four strings of the violin). Years later I wrote and engraved in copper my experiences on this road to salvation.

Copper engraving proceeds slowly. One's thoughts can wander while working. Corrections are laborious, as mis-

takes must be hammered out and repolished. Cutting into copper detaches the engraver from all disturbances in the world around him, creates in him a quasi-heavenly peace amid the hubbub of the outside world. Paul Eluard wrote such beautiful as well as sensitive poems about my ten engravings that were rendered in strict geometry:

> Simulacre sans vérité bien nommée
> Aux ailes exaltées aux pattes engluées.

Thanks to the famous name, a gallery owner and publisher brought out the poetically illustrated engravings in two hundred hand-printed copies. The late Dadaist Pierre de Massot wrote an inspired introduction in which Kandinsky and Piranesi were discussed. Nevertheless, one cannot say that the exhibit at Colette Allendy and at Maeght created a great stir.

After the war "Tout Paris" discovered the splendor and excellence of abstraction and as a consequence had little use for perspective and the like. The Bauhaus had come directly from New York to Paris. Concerned art lovers whispered that a whole freighter of Kandinskys was on the way. Everywhere the Bauhaus style blossomed, which earlier had so often been supported in vain until, twenty years later, the great 1969 Bauhaus exhibition displayed the by now historically established, if perhaps not yet final, image of the movement. Movement is the sign of life.

The adaptability of the visual apparatus and the power of imagination and neuronic phantasms that go with it are true marvels. In the eye, on the retina, the world is upside down. Of course the brain sets what is seen on its feet again. The one who sees has no idea of this double gyration. If glasses that reverse the image are placed on his nose, he sees everything upside down for several hours (tactile and visual experience are completely opposed to each other), until he again gets the ground under his feet. If he lays the glasses aside after a few days, the world is at first still upside down. Not

to mention the blind spot in the eye; we had to wait until the eighteenth century for Mariotte to prove that there are no optical cells present in the retina where the optical nerve branches off. In general, however, the brain knows how to compensate for this blind spot. Anyone can duplicate Mariotte's simple experiment.

What does the artist experience? He sits on a tree stump in the middle of a clearing in the Fontainebleau forest (which at that time was not yet cut to pieces by a noisy freeway) and draws the surrounding trees to the edge of the paper. The trees, however, don't stop because of that, and so he puts a fresh sheet of paper on top of the first one and draws diligently until at the fifth he notices that he has drawn the last tree on this sheet of paper once before—in fact an hour before. His panoramic picture is finished, and he needs only to fit the sheets together in cylindrical form to be able to construct a genuine panorama. For him that is a useful rediscovery.

If one now applies the same method of representation vertically, one soon arrives at more interesting discoveries. Right and left, even top and bottom and front and back, become relative concepts. It would be better to make the whole drawing of the observer's visual environment on a sphere rather than on a flat surface. This plane surface is a constrained frame that deforms, that reduces the scope of the world to picture-frame images. Perhaps I recalled the Totaltheater, maybe also my musing about what may emerge from bundles of parallel lines in these special orblike circumstances.

Unconsciously, my childhood remembrances of the stall at the fair called Diorama certainly also played a role at this time. I couldn't get enough of the scenically depicted land and marine battles such as Tannenberg, Waterloo, and Skagerrak that I observed through the big lens. For me they were the absolute high point of a dramatic occurrence. The lack of movement was not disturbing. On the contrary! The at-

tacking and falling warriors, the exploding grenades, and the sinking ships could be studied in peace.

Today one page is sufficient for me to describe the slowly emerging lights. But the psychological-cultural bonding to the right angle and the spatial directions that follow are firmly at work to make parallelism and verticality in thought and feeling appear to be something naturally given. Oblique straight lines often present great difficulties. Do these lines run slightly up or down near the horizon?

Other experiments followed. In 1950, a copper engraving of a wide geometrical stage-set landscape that bends to the left in such a way that its horizontals become verticals. The eye follows obediently and finds pleasure in the resulting oscillation. Further efforts led to the determination that one's own body supplies a not inconsiderable part of the field of vision, that in fact every observation arranges itself in relation to it and that, as a consequence, the attempt to portray this relationship could be interesting.

Geometry is for the draftsman—at least for me—a strong, lasting, and often emotionally charged relationship between form, expression, and object. Bodies are legible, measurable by hand and eye, and thus capable of reproduction.

In French [or English] one says "descriptive" geometry; in German, "representative" geometry. Between the two expressions of one and the same content yawn philosophical chasms. The difference between description and representation is comparable to that between word and image. In any event, it is so constituted that in the first case it is a matter of the relationship of the individual parts to each other; and in the second case, it is a question of the total aspect, the Gestalt, of the object concerned. In both cases it concerns one and the same object, irrespective of whether described or represented.

To do geometry "with compass and ruler, in lines even and solid," as Dürer put it, is an unconditional compulsion for creators of every sort, except in the case of those few who

work on a purely emotional basis, because the simplest forms contained within the most complicated can be mastered by geometric methods—also because the thinking faculty constantly geometrizes. To abstract means to use geometry, to survey terrain and field, to guide the accidental to the universal, when one is lucky, and thus become master of protean nature. Mechanization, so popular at the Bauhaus from Schlemmer's Golem to the mechanical play of the sword-maker, and to the tenets of the "power of a point" or of a geometric locus, is connected with "artwork in the age of technical [I would like to say geometric] reproducibility" (Walter Benjamin).[6] It is the power of attraction, of precise separation, of repetition, of growing proportions and legible figures, and the satisfaction of comprehending all the qualities and relationship of metrical, geometrical, arithmetical, even topological nature. Work in this direction also permits one to become master of everything that tends to fall into confusion. The "it" does not consist only of geometry. Topology in this sense is the most attractive science of forms, since it studies the transformations and variations of similar figures at that point where, for example, the handle of a cup relates to a nodal point, but has nothing to do with a glass; where a cross section does not always cut a ribbon in two, but lengthens it; or where it is forbidden to tear up things in order to remove a point or where trousers with inverted legs can even represent a Klein bottle, and even more of the same kind of exciting manipulations.

Recently the "Hirnschleifer" (Albertus, Munich, 1652) fell into my hands, a whetstone [*Schleifstein*] as in the copper engraving but long-winded and wordy in order to sharpen the intellect emblematically. Like every profound meditation, geometry leads to more acute, more penetrating experiences than the customary approximations. Geometry is a good brain stimulator [*Hirnschleifer*] even if it is not the last word

[6]Bracketed phrase is Flocon's.

in formative work. Physical nature can be comprehended and represented only through its transmission. The schemata thus established are then to be filled in; but, conversely, the fullness is to be made simpler, to be made lucid by means of geometry. The danger is that nothing may remain and, inversely, the superabundance that comes from constant additions becomes as meaningless as emptiness. To rediscover the tenets of geometry, instead of cramming them into one's head, is also as satisfying for the intellect as their discovery itself.

In the period from 1952 to 1961 there appeared others, three books that are the expression of these connections: *Paysages* (1949), landscapes of anthropomorphic nature; *Chateaux en Espagne* (1953), castles in the air in broad, geometrized space, bearing comments by the philosopher Gaston Bachelard; and, finally, *Topo-Graphies* (1961), descriptions of places in word and picture, from my hand. A French proverb says mockingly, "On n'est jamais si bien servi que par soi-meme" (one does it best oneself).

I was successful with my commentaries in relating word and image, descriptive and representational probings of land and people, pictorial geometry and geometric pictures. Their poetical or philosophical texts were for me unexpected views from outside of what I saw from the inside. They flattered my self-esteem but were not congruous. Thus it became more and more clear to me that with illustrated books, too, interlacing, texture—the vessel of the text in the chain of images, as Plato said—should best be woven by one and the same hand. (See examples of that in *Entrelacs* [*Interlacings*], 1975.) Because the things of life are also interlaced, it is not always easy to pick them apart. As always, congruity of picture and text is an unattainable requirement, since the structure of words and the structure of things are too different to make them coincide precisely. At most they have a common psychic primary cause and stimulus, but otherwise they are reciprocal likenesses rather than bilateral figures.

How do forms arise from the unformed? This is a question

to which I have no answer. I often think of Dürer's *Melancolia* with the compass in her lap (what will she bear?) and of Botticelli's *Derelitta,* abandoned before a locked door in a windowless wall (will it open?). To create, to bring to light, to let mature, to ponder is at least an ambivalent, if not feminine, way of acting. If all goes well, is it not sufficient that as I gaze at a wide seascape and as it penetrates me, horizon, ocean, beach, dunes, and clouds join in forms that grow on all sides into a picture?

My teaching activities from 1950 with Johnny Friedlander in the atelier of l'Ermitage and from 1954 in the Estienne printmaking school established the necessary balance between the eccentric ways of the "artist" and the pedagogy of the teacher. I had to learn to explain, which is the best way to learn something oneself and to emerge from haphazardness. With my pupils I learned the history of art and the book and I learned freehand drawing. With them I learned to teach, to lecture, and to write. To be an administrator is not always easy for an anarchistic intellectual, but it is to be preferred to the art racket, mundanely directed toward "success." To reflect on one's own "worth" is a waste of energy. To acknowledge what is necessary and to adapt to it leads to true freedom.

In 1959 Escher's *Grafiek en tekeningen* came into my hands. The exchange of letters that followed and a personal meeting in Paris contributed much toward solidifying my ideas. Escher had also shown curvilinear spatial form in his so refreshingly uncontemporary works that in the essentials revolved around inverting, wrapping, and packaging. He wrote to me on 9 April 1965: "Now I don't intend to wait any longer to write to you, since I have just finished an attentive reading of your 'Topo-Graphies.' One so seldom meets a kindred spirit [*ein Bruder im Geist*]. No, more than that: it is happening to me for the first time. Your ideas are remarkably akin to my own, and the reading of your book has frequently inspired me."

From 1956 I began to attend the well-equipped workshop

for cutting punches and dies which André Barre directed at the École Estienne. He stood by me with word and deed during my experiments with the technique of wood carving. Barre had highly skilled hands and the experience of the working technician whose philosophy was in harmony with his activities. Frequent conferences, agreement on many questions of opinion, and a deep mutual sympathy soon led to a true friendship.

It was therefore quite natural that I showed my friend my first sketches and experiments that had already occupied me for some time. The visual sphere was already clear before my eyes, also its "unfolding"—better said: the projection of the great circle through the radii of the spherical picture (image). The application of the system to perspective needed thorough investigations, however. André Barre even built a machine to delineate curvilinear perspective, functioning as a spatial translator. In 1960 the theory seemed to be logically completed in sketches and notes, and we decided on a joint publication. In 1962 I wrote a first text about curvilinear perspective in *La Perspective* (Presses Universitaires de France, 1963) in which were presented the history, practical applications, and mathematical principles of central perspective, worked out by the mathematician René Taton. In 1964 there followed a scientific publication, signed by the mathematician G. Bouligand, Barre, and me, in order to assure us our prior rights (see appendix). In the same year I was called to the École des Beaux Arts as professor of perspective, but my collaboration with Barre in no way stopped. In those years I painted numerous landscapes and figure paintings in the new perspective.

In 1967 our book was ready for printing. On the occasion of the exhibit of my works in the Bauhaus archive in Darmstadt in 1966, we both spoke about our new method of representation before a Darmstadt audience. At the beginning of 1968 a beautifully organized exhibition in the gallery La Hune brought us esteem—that is, a certain public success.

Appreciative letters from Lévi-Strauss, Etiemble, le Ricolais, and somewhat later the blessing of Gropius, too, were really encouraging. By and large the world did not stop turning; Paris had other concerns.

When I returned from the opening of the great Bauhaus exhibition in Stuttgart, where curvilinear perspectives hung on the walls but also where the Bauhaus students of Ulm protested against the closing of their school (heretical schools are perhaps a contradiction in terms), Paris streets were reeking of tear gas: May 1968, once again "le temps des cerises . . ."

I had announced a program of reform for the antiquated École des Beaux Arts a short time before; it was taken up by the supporters of the May revolution but was rejected just as vehemently as it was defended. I regret nothing, but nevertheless I must say that I worked intensely for three years on plans and efforts to launch something similar to the Bauhaus, without being able to assert later that I had accomplished much. By and large, the old routine had regained lost ground. As a single remnant of my intense hopes, a certain freedom of speech was perhaps preserved in the authoritarian structure.

Things went similarly for Barre at first. When the continued operation of his school was no longer possible and the old authorities had crawled under the table, as in the Rue Bonaparte, he took on the almost impossible role of director of the school and managed, after much backing and filling, to put in operation a newly organized teaching service that proved capable of functioning. In 1972 he died the death of an overworked manager, and we still had so many joint plans . . .

Nevertheless the new perspective had spread despite the ever more exasperating Pavlovian conditioning via television and the information industry. The little Renaissance picture frame obstructs one's own direct vision of things and makes indifferent Philistines of the public. In addition to Escher, two leading figures are known to me who concern themselves

with curvilinear perspective. Pietro Sarto, without submitting to precise geometrization, which is oppressive to him, paints Lake Geneva with all of the surrounding mountains at whose feet it lies, the expanse of water as far as the eye can see, and the entire firmament of finely nuanced colors: a cosmically expanded Courbet. We are of one mind about Soutine's "distortions," which are probably more the result of the shoulder-to-shoulder all-around view than an expression of vigorous activity of the mind. A friend of his, the architect Ragno from Grenoble, composes curvilinear photomontages in which he photographs architecture with a camera that swings in many directions. He has even poured in bronze a three-dimensional model of a curvilinear colonnade. The architect Jacques Harmey has been teaching the new perspective for years in the seminar for advanced students at the architecture school in Versailles. In Italy and America works on this theme have been published (see bibliography).

In 1969, on the occasion of the thirtieth anniversary of the world program for human rights, UNESCO contracted with me for a two and one-half meter high spherical figure. It encompasses almost twenty square meters and is a carefully delineated spherical image (see illustration). The exhibition was organized by former Bauhaus member Jean Weinfeld. After the exhibition the sphere ended up in the architecture school housed in the Grand Palais, where I saw it (it was covered with graffiti) for the last time some years later. I dare say that the worldly have blessed it. The short-film director Samson took his camera around the sphere and made a twenty-minute film.

Let me say a brief word about the spherical projection screen on which the architect Philippe Jaulmes from Montpelier projects his experimental films photographed with a fish-eye lens. The viewer has an impressive experience of space. If film directors were not so intellectually indolent, they would long ago have eagerly embraced this incomparably new and impressive production medium. On the occa-

sion of a seminar on the theme "L'ecran total" ("The total projection screen"), curvilinear perspectives drawn by me were projected. The arcs appeared straight on the spherical surface, and the spaciousness of the designs was surprising.

In summary, I would like to remark that training for long-sightedness (*Weitsicht*) forces one to a broad configuration of the image, to depth and height (purely philosophically colored words), to useful simplifications, and beyond that toward an awakening to a new sense of space, and a new sense of well-being. In the future the uncertain, the ambivalent, and the relative will be our lot. We can no longer confidently bring anything home as absolute truth. Nature no longer allows herself to be imitated by godlike genius. We can only project upon our perspective surface representations of quickly changing—indeed, fleeting—objects. What is essential, the best view point—the best point for viewing the stream of time—we must find for ourselves, and that means to act and not to despair.

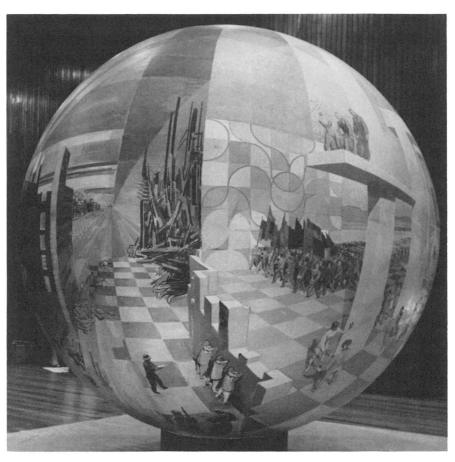

*Two views of "Tableau Spherique," by Albert Flocon,
painted for the UNESCO Human Rights Exhibition,
Paris, 1968, then reinstalled at the Grand Palais.
(Oil on plaster; diameter: 250 cm.)*

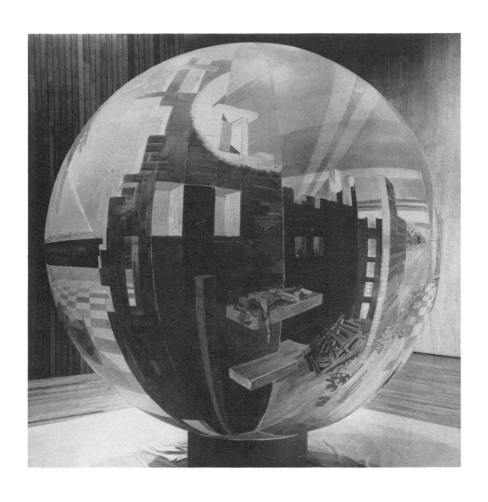

CURVILINEAR PERSPECTIVE

FROM VISUAL SPACE TO THE CONSTRUCTED IMAGE

ALBERT FLOCON & ANDRÉ BARRE

TRANSLATED BY **ROBERT HANSEN**

What does nature look like?

One might ask whether nature really "appears," or whether the universe offers a stable appearance. It may be that the eyes project into the darkness a grid that, because man has created it, renders the world perceptible to man. The objective substance of the world escapes apprehension by the senses.

Painting is the rule of vision.

<div style="text-align:right">

—*Willi Baumeister,*
Das Unbekannte in der Kunst,
Stuttgart, 1947 (p. 18)

</div>

He had sketched a refutation of rectilinear perspective and the lineaments of a new system: for unlimited straight lines that the imagination extends beyond canvases or frames (with the result that pictures seemed to overflow), he substituted finite curvilinear segments, whose arrangements transformed each work into a single space, curved like ours, and which in the end perfected our vision, enclosing it within an absolute sphere. Borromini held that his idea, if only a painter would consent to try it, might be as important for the future of painting as the experiments and labors of Uccello had been for centuries past.

<div style="text-align:right">

—*Etiemble,* Peau de couleuvre,
Nouvelle Revue Francaise, 1948

</div>

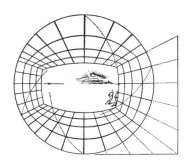

INTRODUCTION

What does "curvilinear perspective" mean? Everyone has a more or less exact notion of what perspective is. Emotionally, the word generally provokes a feeling of boredom and, with those more involved aesthetically, a feeling of marked hostility. We proceed because we think that the term encompasses an interesting problem to explore.

On the rational plane, we propose to turn away from dictionaries and to give as general a definition of the word PERSPECTIVE as possible: A WAY OF COMPOSING VISIBLE ELEMENTS ON A FLAT SURFACE, FORMING AN IMAGE THAT STIMULATES IN THE OBSERVER IMPRESSIONS EQUIVALENT TO REAL VOLUMES AND SPACE.

Putting anything in perspective takes many factors into account:

1) Experienced spatial reality (directly apprehended by the senses of sight and touch, even hearing, or by conscious memories or unconscious memory traces).

2) An observer and organizer (painter, draftsman, photographer).

3) A flat surface (the image, the work of art).

4) A method of transformation of spatial reality into a flat image (an organizing system).

Contrary to accepted opinion, no method of transformation can be taken for granted. As we will see, it depends on what one wants to transform; for no single method of transformation can correspond to spontaneous perception, which is total and disorganized. On the contrary, each method corresponds to a certain kind of image, thus to a sorting out of the perceptual chaos. The mode that we propose has a great number of advantages, but we must learn how to use it. The epithet "curvilinear" was chosen among other equally suitable terms, such as total field, multiple vanishing point, and analytic transformation. The term will be clarified in the course of this book.

In the fifteenth and sixteenth centuries artists took geometry out of its element by using it for concrete pictorial ends. Along the way they laid the foundations for the projective geometry of the following centuries, in which they played no further part. What was fruitful (at first for themselves) in this work was their systematic effort. Here we invite those who enjoy reflecting on experience to make a similar effort with us, not in order to advance geometry but to give to painting a new grasp of the concrete, a new access to reality.

In the notable quarrel between ancients and moderns, between academicism and the avant-garde, defenders of the old rule and protagonists of the freedom of creative instinct have proved incapable of taking clear positions. The confusion of vocabulary demonstrates this failure. Each side has so successfully appropriated opposite weapons that the academy is now avant-garde and the avant-garde is academic. And the artist rushes to his personal shelter, constructed from the debris of the battle.

Yes, we are free—hopelessly free. Shall we blow up the world? Or should we rather immerse ourselves in the introspection to which we are forever invited? Are we really nothing more than those aesthetic clowns for millionaires that people say we are? Should we, in the name of this liberty

without risks, refuse to participate in the vast movement of knowledge that, in other respects, engages in such a prodigious adventure?

After we reflect on it, the ineffable aspects of art notwithstanding, isn't the work of art debatable in many aspects, such as the craft of art (about which at the present time there would be so much to say), the subject (if there's a place for it), the structure (always)? Indeed it is precisely the structure of a work, even with no other evidence, that permits us to situate it in space and time, to assign it an author.

Whoever speaks of structure speaks of organization and rule. In order to be fully effective, the rule should be freely accepted. The common rule brings to the creator a possibility of constructions richer than those he would have been able to find on his own. It also brings him a wider communication with others, because communication tends to become more shared. The perspective of the Renaissance was such a rule, at once supple and rigorous. It literally opened doors and windows onto the visible world.

Abandoned in the course of the last century by important artists, Albertian perspective today[1] is the exclusive domain of photographers. Ever since the invention of photography, painters have turned away from rigorous descriptions of real space, because photographic realism seemed to resolve to perfection the problems of classical drawing. Abandoning documentary descriptive work, that distinctive bit of bravura among photographers, painters thought they could tackle only the problems touching their art, outside of any kind of contingency. They adhered to the common opinion that "objective" representation of the visible world had been resolved once and for all. This opinion, however, presumes in effect that the photographic lens responds to a vision and produces

[1]Until about 1960, when realism began to return to painting.—TRANS.

ART CENTER COLLEGE OF DESIGN LIBRARY
1700 LIDA STREET
PASADENA, CALIFORNIA 91103

an image that we call normal, objective, or true, to the exclusion of all other possible images.[2]

How can we defend today the thesis that we might see a normal image when the psychology of vision proves the conditioning of images, not only by quite variable individual determinations but also, and above all, by education and tradition? Man sees what he has learned to see. Such learning is without end. Moreover, science calls mental images that stimulate the act of vision ILLUSIONS.

Now the most banally realistic image that a camera might provide, created by any photographer, is still an image conceived according to tradition. For the lens with which the camera is equipped is precisely corrected in such a way that the image might appear "normal." That itself is finally nothing more than an image constructed according to Leon Battista Alberti.

Contrary to accepted opinion, we think that reality, even that visible to the naked eye, offers numerous aspects that have never before been given form. These new aspects cannot be revealed except by establishing a law of construction acceptable to others. The universality of a law is preferable to a personal system, however ingenious.

The moment seems to have come when new rules more in conformity with our total feelings should be able to elicit new pictorial research centered on the representation of the inexhaustible visible world. Concerning those rules, as in the scientific approach, it is no longer a question of representing the world as it REALLY exists but, rather, as it can be observed under certain conditions.

We do not wish to shock or even to astonish, but to rehabilitate our thinking about space and different ways of making use of it. Although we no longer can declare with the zeal of the convert that we have discovered the sole "con-

[2]Think of the current variety of photographic lenses, among them the astonishing lens called "fish-eye."

struzione legittima" permitting the infallible "imitation of nature," we are convinced that curvilinear perspective will yield images more exciting to the mind and generally more significant than classical perspective, which has become a particular case. And we think that the new rule, however relative, demands here a structuring of images, with the final result that our knowledge will be closer and thus more faithful to what we see.

How do we see what is visible? How can we represent what we see? We have tried to forget everything, to take a new look, to conquer four centuries of visual habits. We have placed ourselves, as far as possible, in the conditions of a rigorous experiment. As for the proposed solutions, we think of artists, draftsmen, and their equipment: ruler and compass. Our constructions remain within the framework of Euclidean geometry, although our perspective is non-Euclidean. We do not assert that the only salvation is in a rigorous realism, even one founded on new rules. We know that art is exercised in restrained freedom. We also know, however, that the liberty one takes with the rules one understands has nothing in common with the pretended liberty of one who ignores them.

PART I

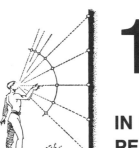

1

IN SEARCH OF THE
PERFECT IMAGE

NATURE, OBJECTS, AND CONTOURS

Our first impression in attempting to define what we see, in order to draw it, is extreme perplexity before the inexhaustible swarm of sensations that nature provides: each fragment of space that we isolate seems to be divisible into a multitude of ever smaller fragments. This feeling of perplexity derives from our habitual attitude when confronting visible space, profoundly different from the attitude implied by its representation. Normal perception is not contemplative but deliberate. It detects the new phenomenon within a known field, or it inventories the known in a new field. It is a behavioral perception: to external stimuli filtered and controlled by consciousness, we react in such or such a manner, or we do not react, depending on the meaning that we might attribute to them.

The perceptive attitude of the artist is entirely different. Here space is no longer the field of possibilities of phenomena that are menacing, attractive, or indifferent; space becomes spectacle, an ensemble of observable phenomena. The artist no longer submits to the conditioning of his visual milieu: he tries to SEE. In order to draw he must be receptive to appearance, and the appearance of nature denotes nothing; it is nothing but itself. It is at this moment that we discover its chaotic complexity.

The raw appearance of nature is interpreted in our consciousness by more or less intense sensations of light and by extremely varied color sensations: from deep dark to light and from violet to red. Moreover the two orders of phenomena interfere with each other. Light sensations are always more or less colored and color sensations are of variable light intensities. Conversely, light or dark, red or blue are only relative. A dark beside a black becomes light and beside a white becomes black. A white often finds a white whiter than itself, and then it ceases to be white. Certain colors enhance or weaken one another by juxtaposition or by succession, for it is not necessary that two colors be contiguous in order to influence each other; it is sufficient for our glance to jump from one to the other. We must add here the effect of accommodation. When we stare at a colored surface for a certain time, the sensation of color is weakened and modified; in a dark environment, our visual acuity is sharpened and more details eventually appear. Or, again, shock may occur that, by contrast, gives opposite results. Let us add that except in the case of a rigorously controlled artificial source, ambient light, on which everything depends, is never constant and that this light is reflected or diffused, modified by things that create multiple secondary illuminations.

If only nature—town or country—were made of materials that were well painted and rigorously polished! There again, however, profusion prevails. Even under a magnifying glass the red of an apple is not completely revealed as a mosaic of granules, each a different red. The granular dominates the smooth; and to the eye the grain is a juxtaposition of granules of different luminosity. And then even a smooth surface shines or reflects irregularly. Nothing is simple; nothing appears truly defined. The appearance of things, if we wish to comprehend it integrally, evokes a dizzying pointillism (fig. 1).

Our normal reflex in response to this vertiginous profusion consists in seeking stable elements, fixed points that may at

IN SEARCH OF THE PERFECT IMAGE

Fig. 1. *The artist, facing visual chaos.*

least be localized with certainty. If light, the phenomenon that reveals the world, translates it in our consciousness into a prodigious intangible sum of fleeting and uncertain sensations, then matter, the real support that provokes these sensations, might be considered relatively stable and immutable. Whoever speaks of matter speaks of form. A certain quantity of matter that is considered homogeneous is characterized by its form, and when this form is sufficiently rational and definable, it becomes an object. Here is the visual invariant that stabilizes perceptive thought: the object.

Even though the light may vary and the color may be modified, the object, even if its aspect changes, remains immutable in form. This form, which we know is invariable, we have obviously never perceived in its entirety. From a fixed view point, the form of an object is defined by its contour. The contour is a frontier. It delimits a certain fragment of space, inside of which a certain type of perception is possible; that

is, the contour delimits a definite material or phenomenon. The notion of contour, however, can be applied as much to the complete profile of an object as to a fragment of it. An undifferentiated surface also can have a contour that coincides with contours of things that limit it. This notion can be extended further to a shadow or a spot of color, on the condition that one objectify or circumscribe them. Indeed, in appraising spatial detail more or less precisely, all observation amounts to mental delimitation by means of contours of the form of objects or of objectively perceptible phenomena and to the abstraction of them from the general field.

In order to draw from nature, therefore, it is necessary to begin by discriminating among things that occupy a portion of the imagined visual field, then to try to reproduce their contours. It goes without saying, and we have already said it, that any fragment of nature furnishes inexhaustible possibilities of formal definition. The observation of this fragment with the purpose of graphic reproduction is thus essentially a simplifying operation. This selection or sorting is at once voluntary (choice of subject) and unconscious; for the artist, as soon as he looks, projects onto the perceptual chaos the selective screen of his own mental structures (fig. 2).

CONTOUR DRAWING

To reproduce what we see is therefore first to trace the contours of forms that we perceive and have selected to draw. These contours will not necessarily be defined by one stroke; a difference in value (light or dark) or in color delimits forms just as well. But in order to simplify the expression of problems that we want to solve, when we speak of sketched contours we always imply a linear drawing.

Given our dominant preoccupation when we intend a drawing from nature to be as faithful as possible to the appearance of observed forms, it is important that the representational system be particularly rigorous. For the artist the

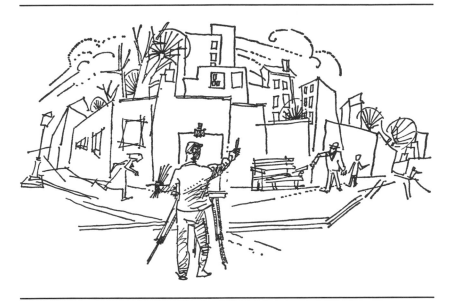

Fig. 2. *Chaos clarified.*

perfect image implies a perfect mechanism and execution verging on automatism.

Can one apprehend at a glance the contour of even a simple form, and then record it on paper with sufficient precision? An able artist can, of course, obtain an apparently satisfactory image, but exactness is not necessarily demonstrated inasmuch as it is judged by the eye, independently of any objective system of control, its form by definition being beyond measuring instruments such as compass, rulers, and metersticks. Now it is easy to see that when one observes the contour of a rather important object, the eyes follow a very complex course, jumping from one point of the shape to another, as if they were touching its proportions. They are attracted and return particularly to points that are characteristic of this form, such as angles and extremities, and compare them with one another. Such a visual gymnastic is more subtle when the observed form is more complex. This assumes an effort and thus a risk of error. In reality is it possible to

create a very precise mental image, even of a simple sinuous line? As a consequence is it possible to draw that line directly with some precision? Even in limiting the task to the appreciation of the appearance of very simple objects isn't our visual perception uncertain? Can we assert that it is not warped by certain mental or visual habits? Rigorous, objective vision is a phenomenon difficult to control. Thus the artist who makes the drawing must be able to rely on a precise method of observation and transcription, independent of all emotional or intellectual influence.

Precision begins with measuring, but how can one measure a form? What units and quantities are to be employed to characterize a contour or a line in real space? The question is greatly simplified if we consider that the contour of the observed form can be reduced to an infinite number of points. If we can locate these points exactly in space, in relation to a fixed system of reference, comparing one point with another, it must be possible to transcribe the reference system and the dimensions onto the drawing. We would naturally select a relatively limited number of characteristic points that would serve as references and would permit us to interpolate the drawing of contours with even greater ease, inasmuch as they would have been located with precision. We can now consider things in space that we want to draw with the hope of finding some certainties there: points of reference that will be located in our drawing according to measurable observations.

MEASUREMENTS OF SPACE

There are two kinds of possible measurements of space:

1) The person who measures moves with a ruler and progressively notes the assembled quantities by establishing a triangulation system. The surveyor works with metric geometry. He proceeds by means of plan, elevation, and cross section. The result of his efforts is not, properly

IN SEARCH OF THE PERFECT IMAGE

speaking, an image of space but an inventory that only someone experienced in the rules of surveying would know how to interpret correctly.

2) The measurer occupies a fixed position, the spot from which he observes, and notes his observations. For him the objects are beyond reach, and he infers their position, their relative sizes, and even their shapes only from what simple observation reveals to him. He finds himself, all things considered, in the situation of the astronomer who observes the universe without being able to apply to it a line segment serving as a unit of measure. This observer essentially notes directions, recorded by means of points, whose ensemble constitutes the skeleton of an image.

Our study bears on the work of the artist, and we must keep from confusing it with the work of the surveyor.

Therefore what must be measured are the distances that separate the guide points from each other and those that separate them from a place of reference: not real distances (and this is very important) but the apparent distances that one can assess from a fixed point of view. It must be understood that they do not take into account different distances of observed points from the observer.

As for that restriction, there are two reasons:

First, the paper or canvas on which the drawing will be realized is a two-dimensional surface; it is not a question of trying to introduce on this surface a real third dimension. Nevertheless if an impression of depth is given by the finished drawing—and that is one of the goals of perspective—it can only be the result of a mental interpretation.

Second, although we exist in a three-dimensional space, vision must be considered a two-dimensional operation (it does not penetrate opaque objects). The third dimension (distance, depth) is an experimental given the meaning of which is learned through displacement. The visual sensation of distance is based on the association of certain perceptual modifi-

cations with certain modifications that we experience in the relations of position. For example, whatever comes nearer increases in size. The binocular apprehension of distance implies a muscular and nervous effort of coordination between two different perceptions, to the degree to which we attribute, through experience, a value approximating the distance. Even when the objects observed are close to us, the visual sensation of distance is much too vague for us to be able to attribute a three-dimensional character to vision.

Thus when we consider two points in space, we must ignore their distance from us and consider exclusively their apparent lateral separation. It is the measure of this separation that will be transferred to the drawing following a certain method. Briefly, this method comes down to defining points in space no longer by their positions but by their directions. There again, however, which measurements are important? In what units can we define them? In order to understand this we must know how an observer might determine such dimensions. We will then see with which instruments or by which procedures we can obtain sufficient precision.

The eye can be considered a sphere pivoting at the center of its orbit in all directions, obviously within certain limits. Luminous rays penetrate this eye through the pupil—that is, by a small focusing aperture—before being projected on the retina, which has the form of a hollow hemisphere. We have already noticed that when one observes a shape or a contour, the eyes move rapidly, as if to examine the characteristics of that form. We can note that when we examine an extensive field, we also move the head. It is possible to observe space while keeping the eyes immobile, however.

In order to define from the outside the separation of two points with respect to an observer—that is, in representing both the observer and the points—it is sufficient to imagine two line segments beginning at the observer's view point, each one ending at one of the points. The length of each line is equivalent to the distance from each point to the observer.

The distance between the two points is ultimately defined by the angle formed by the two rays. For the observer, when the eyes pivot from one point to the other, the distance is estimated by the muscular sensation stimulated by the pivoting. As this involves rotation, it is indisputable that one should attribute an angular value to the separation. If the head itself pivots, again a particular angular value corresponds to this pivoting. When we keep head and eyes immobile, the interval between the two points is determined from their projection on the retina. Because the retina is hemispheric, the separation of the two points is materialized as an arc. It is therefore not contradictory to attribute here again an angular value to this separation.

Under normal conditions of observation, different modes of perception that we call to mind are closely associated, and the determination from a distance of the spatial dimension proceeds from a fairly complex mechanism. In any case, it is certain that when an artist estimates directly by eye or with an instrument or geometrically the relative position of different points in space with respect to his own view point, he estimates and compares the angles between them (figs. 3 and 4). These angles are formed by the rays issuing from a common vertex that we locate, in a manner of speaking, at a fixed point in the interior of the eye. These straight line segments, which in pairs form the visual angles, are commonly called *movable visual rays*. Thus it is essentially a question of the transformation of the sizes of these visual angles into linear dimensions. This transformation is not automatic, however. We need only consider the opposite angle of one side of a triangle to understand that there is a problem. That side is not proportional to the aperture of the angle in question. The linear distance proportional to that angle is an arc of a circle of which the center is at the vertex of the angle.

In order to locate points in space exactly in his drawing, the artist should attribute to their distances from one another the linear values proportional to the observed angles. The

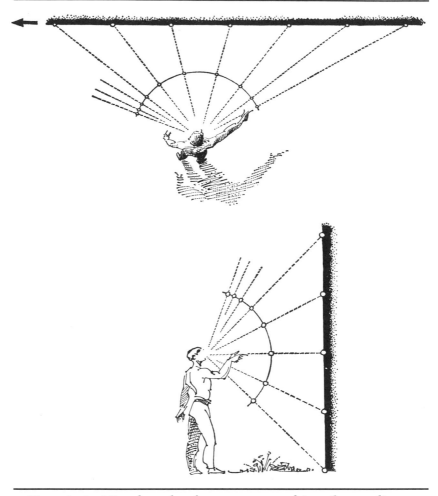

Figs. 3, 4. *Visual angles decrease as an object (here a line segment) recedes, no matter in what direction.*

relationship between the measured angles and the corresponding lengths in the drawing could thus be established in terms of the size of the drawing and the extent of the visual field envisioned. For example, if we wanted to reproduce a subject occupying a field of 120° in width and which we might conveniently arrange as a picture 1.20 m wide, we would make a length of 1 cm in the drawing correspond to

IN SEARCH OF THE PERFECT IMAGE

each degree of real angular measurement. Two points separated by 15° in space would be placed under these conditions at a distance of 15 cm from each other in the picture. If, however, we have a picture 90 cm wide, the value attributed to each degree would be equal to 90 cm/120 = 0.75 cm; in that case, the two points would be placed at 0.75 cm × 15 = 11.25 cm from each other. The precision of the drawing would depend entirely on the precision with which the separating angles would be measured.

PRECISION AND THE SYSTEM OF REFERENCE

We have seen that a direct and purely psychological determination of angles of separation is always rather sketchy; in order to mitigate this uncertainty when comparing proportions, artists often use a stick (a pencil or handle of a brush) as a measuring device. Squinting one eye and extending the arm, they interpose the stick perpendicularly to the axis of their line of sight, between the eye and the subject, making one of the ends coincide with the straight line that connects one of the observed points to the observing eye. Then, sliding the thumb along the stick, they make the thumb coincide with the line of sight that defines the other point. This measurement, equivalent to the portion of the stick marked by the position of the thumb, can be compared with others, always keeping the arm extended. In this way, one roughly compares angles of separation, starting with the first one measured, which thus becomes the standard.

In addition to the inconvenient absence of a unit of measure and the imprecision of comparisons, it must be noted that through this system the measurement of an angle is confused with the measurement of the tangent of this angle. The error is compounded when the angle is large, for the difference between the angular measure and the linear measure is accentuated as the angle widens. Thus in order to arrive at a satisfactory degree of precision, we must either use instruments

of angular measurement or have recourse to geometry, which permits exact calculation of angles provided that the actual coordinates of the points and the observer are known. The measuring instruments can be those of land or sea, theodolite or sextant, if one wants to measure angles directly in real space. The geometric method will emphasize trigonometry. A third procedure would consist in drawing precise diagrams representing the situation to be analyzed in a certain scale, on which we might mark the angles with the aid of a protractor. This last method conforms most closely to the spirit of the draftsman. Readers will always be able to use it for their own tasks if they should feel disheartened by the use we sometimes make of trigonometry. In fact, trigonometry will be considered here only as a provisional means of demonstration, and we will ultimately arrive at purely graphic practical methods.

Now that we have discovered methods permitting us to determine the direction of points in space and have established the relationships between observation and representation, it becomes necessary to organize these measurements and linear relationships. With which point should we begin, for example, and where should we locate it in the drawing? Until now we have considered the distances between distinct real points without being concerned with the position of the entire set of points either in space or in the drawing. It goes without saying that a position can be defined only relative to a region or to a system of reference; it is thus necessary to imagine a system of reference applicable both in space and on the plane of the drawing.

In order to locate a point on the drawing, two measurements are necessary, inasmuch as the sheet of paper has two dimensions. In space there would have to be three, but we have seen why one of these has become useless. We will naturally think of using the system of reference with which we are the most familiar: Cartesian coordinates. On the

drawing one traces a vertical axis and a horizontal axis, from which we can locate points in the directions of width and height. In the particular case of a drawing from an observed scene, it seems preferable to draw the two axes in such a way that their intersection marks the observer's central line of sight. In the mental image these axes will then coincide: the horizontal with the line of the horizon and the vertical with an imaginary vertical line that would cut the observed scene in half. If, from the outside, we consider the observer and his subject in space, we can define the first reference as a horizontal plane located at his eye level and the second as a vertical plane passing through the observer and cutting in two the field of space that he is examining. These two planes intersect in a straight line that marks the principal axis of vision.

The vertical axis will pass through the middle of the drawing. Nevertheless, as the subject will have been selected with the horizon in the center, or with more of the field below the horizon or more above, the horizontal axis will be situated either in the center, above the center, or below the center of the drawing. Henceforth the procedure is very simple: in order to place a point in space, and therefore to place it on the drawing, two angular measurements and two transformations are necessary:

FIRST, a measurement in order to know at what distance the point is found above or below the horizon. The angular value transformed into a linear value in the chosen proportion permits us to trace on the drawing a line parallel to the horizontal reference at a distance and in a direction corresponding to our observation.

SECOND, a measurement that locates the distance of the point to the right or to the left of the imaginary vertical plane and that permits us to trace a vertical line at a distance and in a direction corresponding to our observation. The placement of the point on the drawing is found naturally at the

intersection of the two lines. The draftsman can thus be compared to an astronomer defining the position of stars in the sky by their azimuth and altitude.

A WALL

In actual drawing, following the method defined above, we will be able to place exactly on the drawing the reference points that, joined together, will permit us to trace the apparent contour of the forms. Precision will be a function of the number of points chosen. It is true that such a method, if it is effective, runs the risk of being very fastidious, even in the case of uncomplicated figures. It is therefore necessary to seek simplifications that might limit the number of steps to be taken. We can ask ourselves, for example, if it really is useful to execute several measurements for a line that we know is straight in real space. A priori, one is tempted to believe that the position of the observer will modify only the apparent slope of the line; in that case it would be sufficient to situate only the two extremities of this line in order to obtain a correct diagram.

But we do not trust the evidence. To begin, we diverge from the learned rules and wish freely to verify the different hypotheses. Nevertheless one can easily confirm that there are at least two types of lines that need not be verified: those that coincide totally or in part with the reference lines, the X-axis and Y-axis of the drawing, the horizon and imaginary median of real space. These two types of line will naturally be straight, because the reference lines are drawn straight by definition. Only their length would have to be determined. For all other types of straight line, several cases can be envisaged: they depend either on the real slope of these lines or on their apparent obliqueness. Let us make the first experiments with lines within a vertical plane perpendicular to the visual axis of the observer. To employ a term from classical perspective, we will say that these lines are contained in a frontal plane.

We will begin simply with two horizontals, one situated above the horizon and the other below. They can be materialized in the representation of a wall facing the artist: one as the top of the wall, the other as the base. In order to satisfy the conditions defining the type of line that interests us, we must decide that this wall is perpendicular to the principal visual axis. We will suppose that it extends beyond the width of the envisioned visual field, and we will select a height of 4 m. We will assume that our eyes are found 1.5 m above the ground and that we are positioned 3 m from the wall. Because our measurements will be angular, we will define the visual field in degrees; for instance, 120° in width and 90° in height. In order to simplify the calculations, the dimensions of the drawing will be fixed at 1.20 m by .90 m. We will also decide that in regard to height, the horizon line will be found in the middle of the field of vision.

On the paper we first draw the two reference lines. Each line divides the sheet in two. Their point of intersection constitutes the principal axis of vision. Two measurements will permit us to calculate the height that we should attribute to the wall at its center, where it is closest to us. The goal of the first measurement is to determine the height above the horizon of the top of the wall at the spot where it cuts the vertical reference plane, or, again, what angle the line that leads from that point to the eye forms with the plane of the horizon. This angle, of which our eye is the vertex, can be measured with one of the instruments using the methods we have cited. Through trigonometry one finds it in the following manner: if we consider the shortest distance from our eye to the wall—that is, the distance found in the plane of the horizon and in the vertical median plane—as the radius of a trigonometric circle, then the height of the wall above the horizon in the section considered becomes the tangent of the desired angle. The real height of the wall above the horizon being 4 m – 1.5 m = 2.5 m, the value of the tangent is 2.5/3 m = .833 m, which signifies that the angle is 40°. In our

drawing the corresponding point will thus be situated on the vertical reference line 40 cm above the horizontal reference line.

In the same way the second measurement will permit us to find the location of the base of the wall, perpendicularly below the first point. The tangent of the new angle is equal to 1.5/3 m = .5 m; thus the latter has a value of 27°. The corresponding point therefore will be situated on the vertical axis, 27 cm below the horizon. The height of the wall directly in front of us is thus represented by a linear size of 40 plus 27 = 67 cm.

Common sense and the laws of classical perspective suggest at once that we trace two horizontal lines, representing the base and the top edge of the wall, passing through the two points previously determined; the job will be done and the drawing will be correct. Let us look at things a little more closely, however, and, after having considered the height of the wall in the section nearest us, observe what happens at the right and left extremities of our field of vision—that is, at 60° to the right and 60° to the left, these observations naturally being the same on each side. It is evident that the points will be found situated on two vertical lines precisely 60° from the vertical reference line—that is, at the two lateral edges of the drawing. It remains to determine their distances above and below the horizon.

First point: it describes the top of the wall, at the extreme right or at the extreme left. The real height of the wall above the horizontal plane is naturally always the same: 2.50 m. In trying, as before, to calculate the angle that defines this measurement, we now establish that the radius of the trigonometric circle is no longer equal to 3 m because the distance that separates us from the wall has varied considerably. We must begin by calculating this new radius in order later to obtain the value of the tangent of the desired angle. In other words, we must first know the real distance, on the horizontal plane, from our eye to the part of the wall that interests

us. This complication could be avoided were we to use an instrument of angular measurement. After calculation or reconstruction on a sketch, one finds that this distance is 6 m. It follows that the angle within which we view the crest of the wall from the horizon to that spot is equal to tan = 2.5/6 = 0.41—that is, 22° (refer to fig. 6). Similarly, below the horizon the base is perceived at tan = 1.5/6 = 0.25, or 14°. Consequently on our drawing, at 60 cm to the right and to the left of center, the top edge is defined by a point situated 22 cm above the horizontal reference line, and the base by a point situated 14 cm below. The apparent height of the wall at these places is thus 36 cm, or a little more than half the height at the center. Thus it is impossible to represent this wall by two parallel horizontals. This assertion is not surprising in itself; in effect it is normal that the extremities of the wall more distant from our eye than the central part should be perceived as smaller.

Should we now be content with the points that we have located in order to obtain a correct sketch of the wall? If we join these six points by straight lines, we will obtain a contour in which the wall edge will be depicted as a line broken toward the base. This drawing is hardly satisfactory; if, looking right and left, we really see the wall recede, diminishing in height toward the horizon, the fracture in the center does not correspond to our observation. We must then undertake another series of steps to locate other points intermediate between those already established. With an infinite number of points, we should be assured, as we have said, of an indisputable outline (fig. 5).

Let us now seek the apparent height of the wall, in the sections oriented 30° to the left and right, relative to the axis of vision. Proceeding as before, we will see that the new distance from our eye to this part of the wall now being examined is 3.48 m. The tangent of the angle corresponding to the height of the wall is equal to 2.5/3.48 = 0.716; thus the angle is 36°. For the base one finds 1.5/3.48 = 0.43 and an angle of

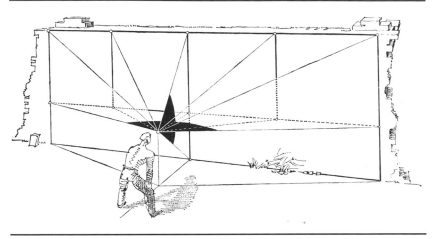

Fig. 5. *Angular measurements of a wall.*

23°. In our drawing 30 cm to the right and left of the median of reference, the crest of the wall should be found 36 cm above the horizon, whereas the base will be situated 23 cm below. The apparent height of the wall here will thus be 59 cm. We now have ten points we can connect with straight lines. In placing many other points and in connecting them in the same way, one will obtain a broken outline formed by shorter and shorter segments, resulting finally in two curves converging toward their extremities (fig. 6).

Here, then, is the contour of the wall defined by two curves that represent two straight lines in real space. This representation, as shocking as it might appear, is nevertheless logical: we repeat, the wall in its central portion, thus the closest to us, appears highest and at its extremities, more distant, it appears smaller. The passage through the central area from one side to the other is gradual and without a break. In addition, note that the top contour, farther from the horizon than the base line, is more concave. In extrapolating with more horizontal straight lines of the same sort, one could confirm that this observation generalizes and that the more such lines diverge in angle from the horizon, the

IN SEARCH OF THE PERFECT IMAGE

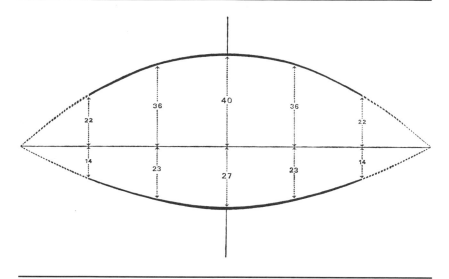

Fig. 6. *Diagram of a wall according to angular values.*

more their contour is found to be concave; inversely, the more they approach it, the more they recover their straightness, in order to blend eventually with the horizontal reference line. After this first experience, a multitude of comments and objections come to mind, but we continue to the examination of vertical lines.

A TOWER

Suppose that we now draw a vertical wall 4 m wide, oriented in the frontal plane and found to be at its closest point 3 m from us. Grant that our principal axis of vision passes through the middle of the vertical axis of the wall that is materialized, for example, as a rectangular tower. Suppose, in addition, that we are placed at a certain height—on a balcony, for example—and that the tower is very high, of such size that its summit and base are found outside our drawing. Let us decide, for example, that the tower is 14 m high and that the balcony is 6 m from the ground. We will choose a surface equivalent to that of the preceding drawing, 1.20 m by .90

m, but for its largest dimension oriented vertically. The observed real field will consequently be 120° in height by 90° in width. These unusual conditions are obviously chosen in order that there be a strict correlation between the drawing of the tower and that of the wall.

Let us sketch on paper the two lines of reference. Note now that the vertical reference, whether real plane or drawn line, cuts the tower into two equal parts, whereas in the above case the wall was unequally divided by the horizon. It is enough, then, to define, for example, the outline of the upper right half of the facade, to continue it symmetrically to the left and to do the same toward the bottom, in order to obtain the general contour desired. We will employ, as always, the same method of measurement.

FIRST, measure the apparent lateral divergence of the point of intersection of a vertical edge with the horizontal plane: tan x = 2/3, where x = 34°. To the right and left of the vertical reference line, two points will be placed on the horizon line, each 34 cm from the center. Consequently the width of the tower, in the part closest to us, is figured at 68 cm. This width is slightly greater than the height of the wall, although of an equivalent dimension and placed at the same distance. The difference is explained by the fact that the plane of the tower is situated in the center of the visual field, whereas the wall, in the vertical direction, was slightly offset toward the top; it was then slightly skewed in relation to the axis of vision directed toward its center, which diminished its apparent dimension.

SECOND, measure the divergence from the vertical reference plane of one of the points of the edge, situated at the high or low extremity of the visual field—that is, at 60° above and below the horizon: tan x = 2/6 = 1/3 and x = 18°30'. At the upper and lower extremities the tower is pictured with a width of 37 cm, a dimension reasonably equivalent to the height of the wall at its right and left ends, a divergence that we have already noted was diminished by distance.

In continuing the measurements and the marks, we obtain finally an outline very close to the contour of the wall but oriented vertically, symmetrical in height and width and slightly broader than the first. Other experiments would confirm that the tracing of the verticals obeys the same laws as that of the horizontals, particularly in regard to their curvature, a function of their angular distance from the visual axis.

A SQUARE FACADE

In our first experiments for purposes of simplification we deliberately chose situations in which in each case we had to draw only a single type of line.

We must now make a drawing of a subject that might be included entirely within the visual field, in such a way that the two types of line come into play and form the complete contour of a given object.

In order to preserve strict relationships with the preceding experiments, let us consider a square facade 4 m high by 4 m wide, still placed 3 m from us and perceived from a point 1.50 m above the ground. It appears immediately that it is unnecessary to effect even the smallest maneuver inasmuch as the lateral edges of this facade are identical with those of the tower, whereas the top edge and base are identical with those of the wall. In order to obtain a correct contour, it is sufficient to superimpose the two drawings and to delete the unnecessary lines from the facade thus defined (fig. 7).

This representation of a square set in a frontal plane is characterized by curvilinear sides and by angles greater than 90°. On the paper this square facade is higher in the vertical median axis and wider at eye level than at the edges. The right and left sides are symmetrical, and the top edge, farther from the center, is slightly more curved than the base. This new drawing presents the same idiosyncrasies as the previous ones; it does not conform to traditional representations and does not satisfy the laws of classical perspective. Nevertheless

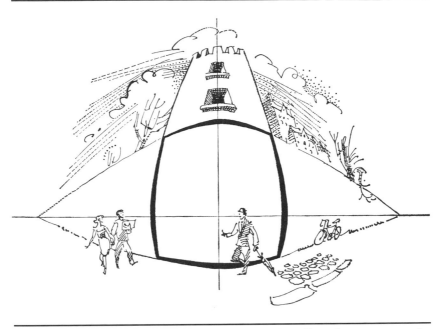

Fig. 7. *The shape of the intersection of wall and tower may be a quadrilateral with convex sides.*

it respects a fundamental law of visual perception: the farther an object of a given size moves away from a stationary observer, the smaller it appears. This does not necessarily mean that the apparent diminution should be directly proportional to the distance of that object.

We might continue our investigations and again discover many other discrepancies between our drawings and those of classical perspective; it would suffice to make some sample drawings and to compare them with traditional drawings of the same subject viewed from the same observation point. The field is vast, and we have limited ourselves thus far to verticals and horizontals placed on a frontal plane. But the results are already surprising enough to require us, provisionally, to interrupt our practical experiments. The essential task now is to elucidate from our three simple examples the con-

tradictions that appear between the results of our method of drawing and those of classical perspective.

From now on we can say that the transformation of objects belonging to tridimensional space into objects drawn on a bidimensional plane is not as simple an operation as it might at first seem; that it depends on making choices; that the type of image obtained (as "objective" as it might be) will be profoundly influenced by an informed choice that we will study further.

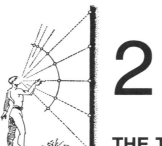

2
THE TRADITIONAL IMAGE

CLASSICAL PERSPECTIVE

In classical perspective all real straight lines are represented by straight lines. Those which, as in our example, are parallel to the frontal plane are represented by parallel straight lines.

In the final analysis classical perspective today is a minor branch of projective geometry, which is one of the most important components of mathematics. Indeed, it preserves the rectilinearity of straight lines, whereas the other properties of figures, such as their angles or their areas, sometimes the sequence of points, are more or less markedly altered. That is why rectilinearity is called a projective property.

In employing our method, one can see on the contrary that on the frontal plane only the straight lines that pass through the visual axis preserve their straightness: all others are found represented by curves that are all more concave the farther they are from the visual axis. In classical perspective the wall would have been represented by two parallel horizontals, just as we know them to exist. It follows that at the right and left extremities, the height of the wall would have had the same value as at the center, which is somewhat absurd, given that the center is much closer to us. By our strictly pragmatic method, the straight lines indeed become curves, but the wall remains highest where it is closest, and logically, it proportionally diminishes in height as it recedes.

Where does the truth lie? Of course straight lines are straight lines, but do we always see them thus, and can we always represent them as such without sacrificing certain laws of spatial perception? The apparent decrease in size of objects in relation to their distance is obvious. Moreover, classical perspective takes this into account, inasmuch as parallel straight lines that are oblique with respect to the frontal plane converge as they recede, only to meet at the vanishing point. Why is this evidence not respected in all cases? And if we respect it, are we led to a kind of absurdity? In order to find the cause of these contradictions, we must resume our experiments, but this time following the methods of traditional perspective. In comparing the two approaches we should discover the reason for such different results.

Classical perspective is essentially a geometric system of projection of real space onto a plane surface, the eye of the observer being the point that controls this projection. From our experience it is necessary to enter into the details of the procedures of geometry that apply to perspective, for there is a practical and particularly rigorous means of demonstration that permits us to avoid them. It consists of interposing between the observer's eye and the subject a transparent plane—a sheet of glass, for example—on which one can sketch the subject directly.

The observer's eye being fixed, each point of real space included in the envisaged visual field can be connected to it by a straight line. The glass intersects the visual cone constituted by this bundle of lines. The image of the point in real space—its perspective—is found at the intersection of each straight line with the glass. This procedure is ideal in its simplicity and rigor, on the condition that the artist's head remain immobile. The distance from the glass to the eye with respect to the particular visual field naturally determines the size of the drawing. Dürer and other draftsmen developed an apparatus known as a gate, which, based on these principles, permitted them to trace drawings on traditional opaque

supports (paper, canvases, etc.) in proceeding systematically toward reconstructions of points in space.

Armed with a sheet of glass or some such transparent support, let us place ourselves again facing the wall, in the same situation as before. At what distance from our eye should we place the transparent plane in order to have a drawing of a size equivalent to those in the preceding chapter? In terms of vertical dimensions we have chosen a visual field of 90°, which we wish to reduce to 90 cm. It is easy to determine, by experience or by making a small sketch, that in these circumstances the glass ought to be placed about 45 cm from our eye. Note, however, that for a field 120° wide, reduced to a linear dimension of 120 cm, the glass must be placed about 35 cm from our eye. This difference in distance comes from our having used angular values in our first experiments in order to define our measurements, whereas in inserting the glass, we refer to a trigonometric value of these angles. In order to resolve this difficulty, we are led, if we keep the same visual field, to change the proportions of the drawing. We shall decide to place the glass 45 cm from our eye. Thus we keep the height at 90 cm, but we are then led to enlarge the drawing to approximately 1.50 m in order to maintain the same width of the visual field.

In making the drawing on the glass, we will see that the outline of the wall is, in fact, composed of two parallel horizontal lines placed 60 cm apart, the top line 37.5 cm above the horizon, whereas the base is situated 22.5 cm below. It is in geometrically verifying this result that we can come to understand the reason for it.

The point closest to us on the top of the wall forms, with our eye and with the point where the principal visual axis reaches the wall, a right-angle triangle that has a base of 3 m and a height of 2.50 m. On the glass the point of intersection of the line that goes from the wall's top to our eye forms, with our eye and with the point where the visual axis crosses the glass, another right-angle triangle similar to the first. The

base of this second triangle measures 45 cm, so that its height is equal to 250 × 45/300 = 37.5 cm. This value corresponds in the drawing to the distance from the horizon to the point observed on the top of the wall. In considering now the wall below the horizon line, the first triangle is reversed. Its base remains 3 m and its height becomes 1.50 m. In the drawing the corresponding dimension then will be 150 × 45/300 = 22.5 cm, which is the distance from the point on the triangle's base to the horizon. The total height is, of course, 60 cm, as we have ascertained experimentally. It remains now to verify the height of the wall at its right and left ends, to see whether this value remains constant and, if so, why.

We know that the distance from our eye to one end of the wall is 6 m on the horizontal plane. Therefore, on the vertical plane the triangle eye-wall top-horizon is always 2.5 m high but now is 6 m long at its base. Conversely, when we consider the projection system from the outside, we notice that, still on the horizontal plane, if the distance to the wall is increased, the distance from the eye to the glass also varies on the visual trajectory that leads to the ends of the wall. This new distance is 90 cm. The triangle formed by the eye and the height of the wall projected on the glass thus has a base of 90 cm. As it is similar to the previous triangle (base 6 m; height 2.5 m), its height on the plane of the glass is thus equal to 250 × 90/600 = 37.5 cm. This value is the apparent height of the extremities of the wall depicted on the glass. In the same way, one would find that the base is 22.5 cm below the horizon and, consequently, that the total height of the wall is 60 cm; that is, equivalent to its height at the center.

One now can understand why the drawing of two parallel lines on the frontal plane is materialized as two straight parallel lines on the glass or on the paper, following the laws of perspective. When, to the right or left, the plane of the wall extends away from our eye, the plane of the glass also extends away in the same proportion. Two points situated on the glass, images of two real points of the frontal plane, diverge

from one another proportionately to the distance from the glass to the artist's eye. If the apparent height of the wall diminishes following the lateral recession on the plane of the glass that also recedes from the artist, the diminution is found to be compensated automatically and the height remains the same (fig. 8). However—and this is very important—the tracing on the glass being more or less distant from the artist's eye, this height should be perceived differently at the center and at the edges of the drawing. Thus the two lines that are drawn parallel cannot be perceived as such if either the artist or the spectator remains immobile at the precise point from which the tracing of the real subject has been made (at the view point).

THE VIEW POINT

As in our method, classical perspective thus assigns to the artist a precise point of observation, but in addition it requires that the spectator take the place of the artist in order to view the drawing. In the case of a drawing executed on glass, the exact position is that occupied by the artist. In the more

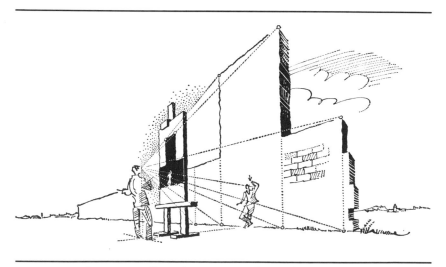

Fig. 8. *Wall and tower in classical perspective.*

common case of a diagram on an opaque surface, the position is theoretically defined by the geometric construction created in order to obey the laws of perspective (the view point). There is a fundamental difference between the two methods that results simultaneously from the techniques employed and from the purpose assigned to them.

We have attempted to create our diagrams with very rigorous observation and transcription: each point in real space has first been situated with respect to a reference system constructed from a fixed view point and placed on the drawing with respect to the graphic equivalent of that system. We have observed, as proof of the coherence of our constructions, that as soon as a dimension recedes from us in reality, it diminishes logically in the drawing, but we have never caused the position of the viewer of the drawing to intervene as a determining factor vis-à-vis the drawing. In fact, we have implicitly suggested that this position was without importance for a correct perception of the drawn image, which assumed that this position tended to be confused objectively with the mental image of the real subject that we would have been able to form from direct observation.

On the contrary, in classical perspective, the drawing conceived from a certain point of view should be viewed from the same spot, at the risk of losing all qualities of fidelity relative to the real subject. Certain dimensions that apparently diminish as they extend into space remain constant once they are put in perspective but must appear to diminish, relative to the spectator, following from the receding of the parts of the plane surface on which they were drawn. The definitive mental image—in other words, the general perception of the observed visual field—thus tends not to be actually recorded on the drawing; the drawing is merely one stage in its formation. It tends to place the spectator, thanks to an artificial intermediary, in a perceptual situation almost identical to that in which he would find himself when confronting the real subject.

A perspectivist work is thus an analogue of reality conceived to be viewed under precise conditions. Its dimensions, its graphic quality, and its position are the inseparable components of its value as a system of illusions. If the spectator moves before it, whether receding from or approaching it, clearly this change in point of view does not bring about the same modifications of the interrelationships between the represented objects as those that one would have been able to ascertain relative to the objects in actual space. The relative positions of the representations with respect to these objects remain invariable; they are profiled one beside the other, always in the same order, for they are flat images; but these images lose the correct proportion that was assigned to them in order to provide a plausible representation of reality. It is clear that the more the viewer departs from the position assigned to him, the more the mental image, the formation of which was anticipated from the drawing, is found altered (fig. 9).

For the classical system that assumes a strictly defined position of the viewer with respect to the drawing, can we substitute another system in which this relationship would be more flexible? It is patently absurd to claim that this relationship is absolutely without importance. If one looks obliquely at any image placed very close to the eye, for example, its normal appearance is undoubtedly distorted; its outer parts can be found at very different distances from the eye. In fact, we have clearly implied that the spectator's position should be roughly on a perpendicular axis and quite far from the drawing, so that the differences in distance from his eyes to different parts of the picture should be practically negligible. Nevertheless it is necessary to be more precise. The several diagrams that we have made are sufficiently novel that we might be tempted to take advantage of our method. Again, we should not misunderstand the importance of the spatial relationship between drawing and viewer.

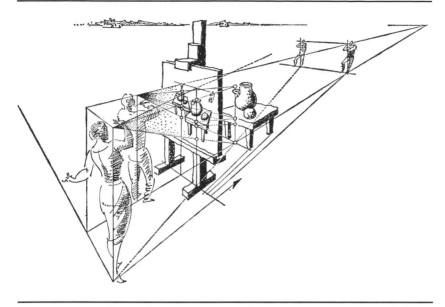

Fig. 9. *In classical perspective, when the artist steps back from the drawing surface, the image must be larger; when the artist moves laterally, the alignment of objects changes.*

THE LIMITS OF CLASSICAL PERSPECTIVE

Let us return to classical perspective. We have seen that the distance from artist's eye to picture is the fundamental convention of this system that one can compare to a geometric projection. This projection has an exact meaning only if perceived from a position identical to that occupied by the artist's eye. Is this condition always completely fulfilled? Is it truly acceptable in practice?

Interpreted in classical perspective, the plane of the wall measured 1.50 m in width by 0.90 m in height. In order to trace it on the glass, our eye was placed about 0.45 m away on the central axis. Therefore it is at this spot that the spectator should be placed in order to view our work correctly. Experiencing that position is sufficient to convince one that

this point of view is much too close to permit comfortable contemplation. If our drawing were half as large, or about 78 cm by 45 cm—this is again very important—the viewer would have to see it at a distance of 22 cm. If it were reduced to the size of a postage stamp, about 25 by 15 cm, it would be necessary to bring it to within 7 cm of our eyes, which is completely absurd. If we envisage a smaller field of perception, naturally we would move farther away from the drawing. A larger field, conversely, would oblige us to approach even nearer. It follows that in classical perspective the breadth of the drawn field is very important. Too wide, and it obliges us to stay very close to the drawing; too narrow, and the drawing obliges us to stay far away. Moreover the treatises on perspective advise us never to exceed a visual angle of 40°; under this condition the drawing should be viewed from a distance one and a half times its largest dimension (fig. 10).

One can conclude from these remarks that perspective is a method not applicable in practice to visual fields larger than 40°, which is quite narrow, and that it has the same effect for very small fields. For example, a picture 80 cm wide representing a field of 5° should be viewed from a distance of 10 m. Thus there remains a very important domain for which, classical methods being inadequate, our investigations are justified. Moreover remaining within the limits assigned by theory, are we quite sure that a drawing or a painting could in practice be viewed from a good spot? It is already necessary

Fig. 10. *A figure represented according to the rules of classical perspective. Its width increases indefinitely as it is moved laterally.*

THE TRADITIONAL IMAGE

for the viewer to be able to locate the exact point of observation, which is not always so easy, and which demands in any case an effort of reflection that strongly risks distracting his mind from aesthetic contemplation.

In fact, the position of a person who looks at a drawing or painting depends on entirely different factors, such as the size of the work, its construction, and, above all, the personality of the art lover. As a rule he stands far enough from the work to be able to scan the entire surface easily. Thus this distance is not at all dependent on the perspective construction; it is, rather, a function of the work's format, the viewer's visual acuity, his psychology, his perceptual habits. It is difficult to attribute a precise value to this distance; it is generally about three times the largest dimension of the drawing.

The view point is an important element of the satisfaction that one can derive from contemplation of a drawing, independently of its intrinsic qualities, for there is a particular kind of pleasure inherent in the perception of pictures. This pleasure is physiological. It is born of the sensation of ease that one feels on perceiving the picture plane of a certain visual field—that is, of the absence of effort to accommodating the eye to the distances, of the easy, slightly modified adjustment of convergence of the two eyes on each fragment observed. There follows an impression of relaxation and repose, as one's gaze runs over a smooth, flat surface. Again, it is necessary that this surface not occupy too great a portion of the visual field; otherwise the oblique perception of certain areas might become disagreeable.

When perspective assigns a distance one and a half times the width of a drawing representing a field of 40°, it ignores the peculiar and essential character of graphic representation; it requires the viewer to perceive an image field equal to the real field; and it deprives him of his liberty vis-à-vis the image field. Inasmuch as the concern for pleasure necessarily prevails over rules, there is little chance that the laws of perspective should, in the end, be observed by those who look at

pictures. It is, of course, possible to choose viewing conditions that would permit us to reconcile the pleasure of looking with respect for theory, but in the end this would impose unacceptable limitations on artists that, in addition, would in no way guarantee comfortable perception of pictures to anyone looking at them.

A DELUSION

To criticize as we have the obligatory view point of classical perspective is to admit, in spite of all, that an ideal perspective exists for each drawing and for each viewer, yet one that only rarely coincides with that of classical perspective. One can easily go farther and assert that it is absurd to speak of a fixed view point in perceiving a picture. If a fairly large distance is agreeable in itself for the perception of a large pictorial space, it facilitates appreciation of the composition, of the major structures, and of graphic rhythms and cadences. Either before or after the whole work is seen, however, details may require closer observation, even closer than required by perspective theory. This depends in large degree on the part taken by the artist and by the way he executes his work. We must admit in the end that it is impossible to deprive the viewer of his liberty of movement in compelling him to remain at a precise spot that is supposed to be the best. There is no single point of view; there are many.

Confronting a drawing, the art lover stands at a proper distance. First, not moving for some time, he isolates the work of art from the real world. He applies himself to the challenge of entering into the imaginary. He examines the whole attentively. He becomes acquainted with the image. Nothing should hinder him. His perception should be at ease, so that no physical needs bring him back to reality; the controlled reverie is a fragile equilibrium. Then, when the viewer has acknowledged the space that the artist proposes, he explores it, he scrutinizes it, he makes elbowroom, approaches it, backs off, returns, and surveys the surface at

close range. He both dominates this illusory reality and at the same time loses himself in it. If it is a true work of art, each approach or retreat reveals it to be different, and when the viewer returns to his first position, he rediscovers the identical work of art but now charged with more meaning. Such a work presents itself from afar as an architecture, dynamic or serene, of lines, values, or colors; up close the lines and spots become persons or objects. Another work, on the contrary, close up is nothing but a shimmering of abstract strokes that from far away becomes objective and reasonable.

From another angle, a postage stamp is regarded at arm's length, or closer, or very close, but never with only one eye and from one preestablished point. There is another factor, arbitrary in this case, that bears on the art lover's attitude: lighting. It is particularly decisive in the case of paintings. There above all, distracting reflections must be avoided. In a poorly lighted place it even runs the risk of becoming the most important factor (fig. 11).

What remains, finally, of the famous view point? In practice, nothing. When perspectivists have wanted to create experiments of pure illusion, they have nevertheless taken care to deprive the viewer artificially of his freedom of movement. Such is also the case with Brunelleschi's box, with anamorphoses, and with the 1937 experiments of Tastevin. In the end it might be possible that the objectivity of perspective is nothing but a delusion. And this has consequences beyond the domain of art.

It has been demonstrated that our perception of space is essentially perception acquired through education, and moreover that it is constantly warped by our intentions, consciously or not. Now although this is a special category, aesthetic contemplation usually participates in perception. It is certainly conditioned, but it is also one of the visual components of education and tradition. As a result, the classical perspective that structures the majority of images is a determining factor in learning to see. As a rule of drawing it leads

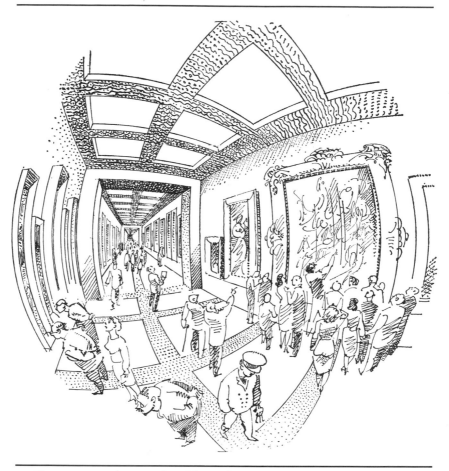

Fig. 11. *Art lovers should not be required to search for a "view point" or to stay there when they find it.*

us, among other things, to consider straight lines to be represented as such, for we forget the imperative of the fixed view point. In this way we have adopted the habit, in looking at these drawings at our convenience, of agreeing that straight lines should always be perceived as straight lines, and that one should represent them as straight lines. In the same way the parallels of the frontal plane always remain regularly spaced in our mind, whatever their distance relative to us,

and so we draw them that way. Almost all of these lines, however, logically should appear concave to us if we were to observe reality naively—which we never think of doing.

Learned from childhood, familiar for four centuries, the traditional image passes finally as the true image. It is perhaps nothing but a fraud . . .

THE DRAWING AS OBJECT

In attempting to understand the importance of spatial relationship between viewer and drawing, we have been led to declare that this relationship was completely falsified in the practice of classical perspective, and that it might then be a disturbing element in the acquisition of our so-called normal perception. That is a negative statement that in no way resolves the problem that is posed. Meanwhile it encourages us to persevere in the search for a procedure by which a viewer might preserve his freedom of movement. Of course once again we grant in advance that this freedom is admissible only within certain limits, but it is enough for us to decide whether these limits are compatible with those normal conditions of viewing by the art lover that we have already described.

The shape of a drawing or a painting is generally rectangular. This shape is perceived differently depending on the place from which one gazes at it, and naturally the modifications of its appearance have repercussions in the contours of the drawing. Theoretically the rectangle could not be perceived without distortion unless viewed on the perpendicular axis at the center of its surface and from an infinite distance. This remark implies that theoretically we can never perceive as such either a rectangle or a square or a triangle or any other regular figure except a circle. In fact, and even though it would be geometrically impossible, we have the feeling that we see figures there. Education and habit stimulate the desire to see reality correspond to concepts. Our eye and our brain rectify distortions, to the extent that this can be done without too much violence to verisimilitude to real space and to the

coherence of our spatial logic. In visual perception there is a very complex and flexible play among the object, its retinal image, and its mental representation. Certain compensatory mechanisms intervene and give us a more stable representation of objects in nature than that implied by the laws of geometrical optics. For example, the dimensions of a well-known object seem to us to be changed very little, in spite of relatively important differences in distance. When one looks at one's own hand at 30 cm, then at 60 cm, it appears palpably the same size, even though the angle within which it is perceived is reduced by half. This explains why, as long as it occupies only a small fraction of the visual field, a rectangle is perceived psychologically as a rectangle, and as a result its sides are perceived as parallel straight lines.

In the case of looking at pictures, especially if one clings to an analysis of the rectangle and if one is positioned obliquely enough, it will obviously be possible to affirm that the angles do not appear as right angles and that the four sides are not equal, two by two, but it requires a special effort of attention to break the visual routine and appreciate the deformation. Besides, this special attention does not correspond at all to the kind of attitude that characterizes our contemplation of a drawing or painting. We repeat, the viewer in this case tends to deny all the variable aspects of his perception. The plastic space in which he delights is understood and conceived as a rectangle and is seen as such. Even when placed under the worst conditions, the viewer sees as he wishes to see.

One may think, after these last remarks, that there is a flagrant contradiction between them and the observations we made apropos of the wall, the tower, and the facade. We have demonstrated that we could not represent them by rectilinear figures, and now we declare that within certain limits and under certain conditions the rectangle of the picture is perceived without distortion, when that rectangle should be subjected to the same laws of perception as are the objects of

our experiment. Are we going to be led to draw real shapes according to certain laws that we will later deny, while perceiving a drawing that itself also will have become a real shape? Are these irreducible contradictions between the way we see things and the way we can represent them?

3

THE VISUAL IMAGE

THE PERCEPTION OF FORM

Remaining on the plane of very simple experiments, it is necessary, to resolve the dilemma, to know whether or not all straight lines in real space are perceived without deformation—that is, without appearing to lose their straightness. It therefore becomes indispensable to specify the particular visual mechanism involved in the perception of shapes. For example, when we look at the two real straight lines that define the wall, independently of all care for graphic representation, do we see straight lines or curves?

If we look at the top of the wall, it is obvious that we see a straight line. If we look at the base, there again we see a straight line. And still the two lines tend to approach each other at right and left, and would meet at the horizon if the wall were extended far enough. The explanation is simple; we look first at the top and then at the base. Observed independently, the two lines appear straight enough, but when we focus on the top line, if that line appears straight, the base should appear curved, and vice versa. Moreover when we fix our gaze at mid-height, both lines should appear curved and concave toward the center.

During the experiment, these inferences do not appear so obvious, for the good reason that when one looks at the top

of the wall, one does not see the base, or at least one sees it very poorly; and when one focuses on the base, it is the top line that becomes indiscernible. One would not be able to perceive the two lines accurately at the same time unless they were close together, and even then it would be necessary to shift the eyes in order to scan a very long wall. Looked at another way, we have seen when estimating distances that the eye might be considered a pivoting sphere, inside of which are projected the images of objects we are looking at. We have also seen that the spacing might be estimated by the brain, beginning either from the image projected on the retina when the eye is immobile or from the muscular sensations caused by its pivoting when the eye moves from one point to another. There are thus two ways to perceive, with an immobile eye and with eyes in motion. Perception by the fixed eye would obviously be the most relevant to drawing, for it involves a static image projected on the retina which in principle the brain would be able to analyze at leisure. Unfortunately those ideal conditions are very different from real conditions. For example, we have said that two lines would have to be very close to each other if we were to be able to perceive them simultaneously. Is our field of vision thus so limited? To what degree?

In reality, the field of vision is quite wide. It can span 150° laterally and 170° vertically, and binocular vision can extend laterally to 210°. We must distinguish, however, between two very different types of vision: central vision, called "foveal vision," and lateral vision. This dual function of the eye is very important and causes our perception of space to be very precise and at the same time very relative. It explains our ability to perceive fine details; however, we are never sure of the exact definition of even simple shapes, although the entire space might be visible. To a certain degree this duality explains the contradictions that we encounter in trying to represent the shapes we perceive. Then what do we understand by the terms *central vision* and *lateral vision*?

FOVEAL VISION AND
PERIPHERAL VISION

The retina is an expansion of the optic nerve that lines the back of the eye. The optic cells, which are the elements of that surface that are sensitive to light, are of two types: cones and rods. Cones are activated in normal conditions of light and are sensitive to color. Rods function when light is very weak (as at twilight), but they do not permit color differentiation. The distribution of all optic receptor cells on the retina is of extremely variable density.

Central vision is more exactly designated by the term *foveal vision*. What we call the fovea is the area of the retina that includes the projection of the focal point. In other words, the fovea lies on the central axis of the line of sight. It is in this region that the density of receptor cells, particularly the cones, is by far the greatest. Ten degrees away, their density is already about one hundred times less than at the fovea; 40° from the center, it is almost two thousand times less. It follows that visual acuity varies considerably from one area of the retina to another, with great superiority in the foveal region. It is tiny, subtending a visual angle of about 2°. Outside this small portion of the field of perception that permits a subtle appreciation of reality, what we call peripheral or lateral vision has different characteristics.

Simple tests, the separation of two points or two strings, for instance, enable us to compare the acuity of the two types of vision. By these procedures, and attributing a value of one to foveal acuity, one finds acuity to be ten times weaker 10° from the center and one hundred times weaker 60° from the center. These considerable differences are a function of the average spacing of the cones, depending on the region considered. This variable cellular density triggers a complex mental mechanism of interpretation. Moreover it is easy to confirm through experiment that peripheral vision is rudimentary.

This does not mean that it is useless; on the contrary, one can even say that if we had to choose between foveal vision and peripheral vision, the latter would be more useful for our normal activity than foveal vision. Limited to a field of 2°, we would be disabled; we would have no consciousness of space. We would, of course, be able to discern very fine details, but we could not localize them. Only with great difficulty would we be able to find them after averting our eyes. It follows that we never observe an object intensely with peripheral vision unless we force ourselves to do it inasmuch as foveal vision is incomparably better. We cannot study an object, however, unless we have already acknowledged its existence—that is, only if it has first appeared, even indistinctly, in the general field.

Conversely, peripheral vision is rather sensitive to movement and change. In this case the eye moves rapidly and brings the object or the new phenomenon into foveal field. One can therefore say that our eyes behave like mobile controllable receptors that can explore the general field in minute detail. Our immediate total perception of the whole field is quite vague, however. Let us repeat that this sweeping glance we have already referred to could not be systematic or controlled if we were to be limited only to foveal vision. It is nevertheless only because of foveal vision that we are able to have a precise image of reality. Now the fovea's 2° field represents about a ten-thousandth of the total visual field of the eye. Wide-angle perception, when the eye does not move, is thus a delusion from the point of view that values precision. Finally, the mental image of such a vast field cannot be formed except by a succession of separate perceptions and by the general integration of a considerable number of small perceptual fragments.

Do we now have a sufficiently clear idea of the nature of vision to permit us to state that straight lines in real space are perceived in such or such a way?

OUR PERCEPTION OF STRAIGHT LINES

When we look at the line of the horizon and follow it with our eyes, we perceive it clearly as a straight line because the pivoting of our eyes produces the sensation of a rotation within a plane. If we keep our eyes motionless, the line continues to appear straight to us, although it may be indistinct in the periphery. In fact, when we focus on it intently, the straight line is projected onto the hemisphere of the retina as a great-circle arc because it passes through the fovea, which is approximately at the center of the hemisphere. A great-circle arc is the shortest route from one point to another on a spherical surface; it is plausible that it should produce the sensation of a straight line in the mental image.

For the same reasons—the pivoting of the eye and the projection onto the spherical retinal surface—when we consider a vertical line before us, we acknowledge a straight line.

In fact, under normal conditions of observation all straight lines appear that way to us for the simple reason that looking at them successively, we place ourselves in the conditions that are necessary for the apparent conservation of their straightness. That is, in the case of a horizontal line on the frontal plane placed above the horizon, for example, we raise our head mechanically, following the line with our eyes in such a way that the pivoting sensation is the same as in the case of the horizon, because the ocular movement remains virtually identical. In keeping the eye motionless, our perception is like that previously described, given that in focusing on the line we make its projection pass through the foveal region. In the case of vertical lines placed to the right or left of us, the results are similar. Instead of raising our head we turn it to the right or left, which produces the same result.

It is easy to see that in a general way, as soon as we orient our head toward any straight line, the pivoting of the eyes necessary to perception of the entire line is within a fixed plane. Similarly, from the moment we focus on that straight

line without moving the eyes, it is automatically projected as a great-circle arc of the retina.

It is no less true that if one perceives these lines as straight and considers them separately, therefore obliterating all the rest of the visual field, they cannot be integrated as straight lines in a general context, and even less can they be perceived as straight lines in a global perception of the visual field, or of something very large and near. In principle it should even suffice that one straight line be perceived in relation to another, parallel, to cause one or the other or both to lose their appearance of straightness. Let us try that experiment.

If, placed before a wall, we force ourselves to keep our head motionless and turned toward the horizon, while we follow the top line of the wall by looking alternately to the right and to the left, the apparent curvature of the wall's top edge becomes noticeable, for our eyes pivot in an inclined plane. From one side we raise our eyes, which are highest where the wall is closest to us, and then lower them progressively to the other side. The muscular sensation that these movements involve corresponds to that involved in the perception of a curve. We would come to the same conclusions if we observed the base of the wall under the same conditions, as well as if we looked at verticals placed to the right or left of our head, as long as we did not move it. There is another way to become convinced that these statements are correct. Let us place ourselves at some distance from the wall, in order to see easily the top and bottom edges of the wall at the same time. On the right, at infinity, the top edge and the base meet on the horizon; they diverge progressively toward the center but converge again at the extreme left. The curvature of the two lines is undeniable.

In keeping the eyes motionless, however, it becomes very difficult to estimate the curvature of the straight lines when their retinal projection does not pass through the foveal region. For as we have said, peripheral vision is rather uncertain, and our visual habits resist a mode of perception that

contradicts the way we have been taught to form these habits. Nevertheless, with a certain amount of training it is possible to sense that straight lines that one does not look at directly are curved. For example, in focusing on the center of the wall, we can acknowledge this curvature if, without shifting the eyes, we attend to the top or to the base, or to both at the same time. The results are rather variable depending on the observer and are generally favored by dim light. In nocturnal vision (called *scotopic vision*) the cones give way to the rods, which are more sensitive to weak lighting. Rod vision is obviously less precise, as details disappear along with the colors. Because the distribution of rods on the retina is very different from that of the cones and of more even density, their acuity is much less variable from one region to another. The role played by the foveal region disappears almost completely at night. Such conditions favor the immediate perception of a broad field and consequently the simultaneous viewing of several lines in motionless fixation of the eyes. In any case, one must recognize once more that peripheral vision remains rudimentary and that it permits only a vague estimation of shapes. Under such conditions mental prejudice tends to determine our perception.

So one might ask, apropos of immobile fixation, how the general image of several lines is projected on the retina, an image that we have so much trouble defining directly. Let us again take the example of two parallel horizontals on a frontal plane. In a camera equipped with a normal lens, which too often is incorrectly compared with an eye, the two lines are projected onto a plane surface. They are reversed, but they remain straight and parallel, for the projection plane recedes proportionately from the lens and in the same way as does the real plane, outside the camera. This phenomenon is similar to that which we have noted in relation to the drawing on glass, and for analogous reasons. The back of our eye is not a plane, however, and we know that the images are projected onto a hollow spherical surface. We have also seen

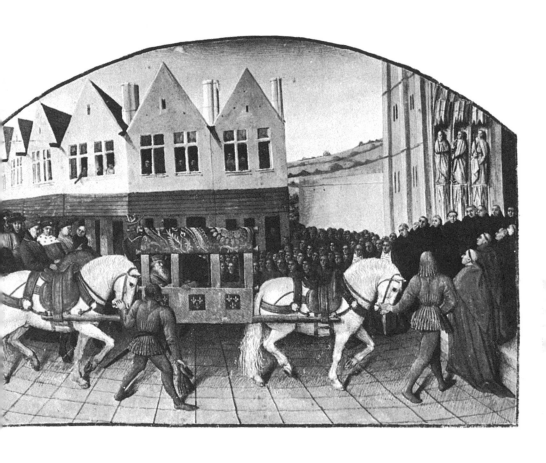

Jean Fouquet, The Entrance of Emperor Charles IV into Saint-Denis. *A miniature of the Great Chronicles of France, c. 1460. Bibliothèque Nationale.*

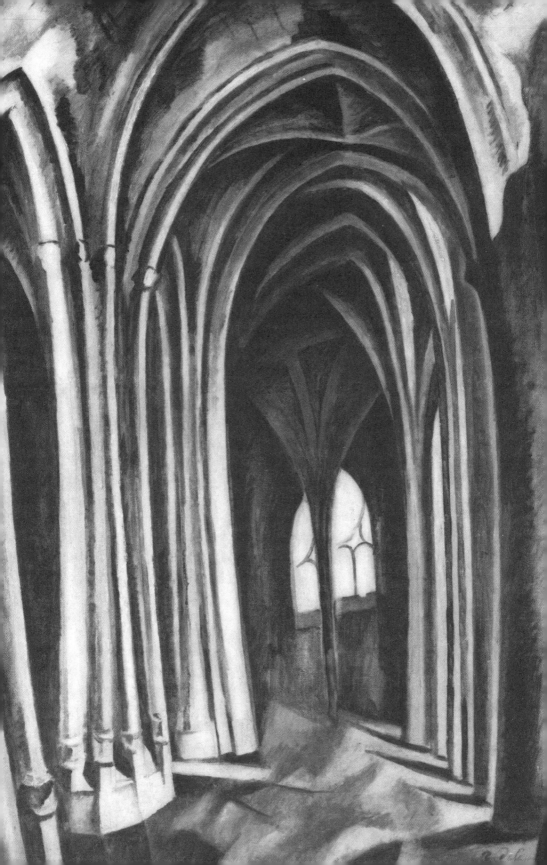

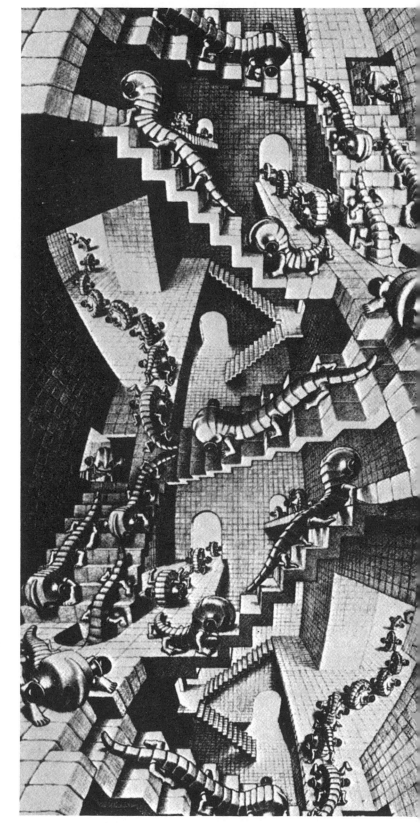

Robert Delaunay,
Saint Severin
No. 3, *1909–10,
the Solomon R.
Guggenheim Mu-
seum, New York.*

*Maurits Cornelis
Escher, Stairwell,
lithograph, 1951.* ▶

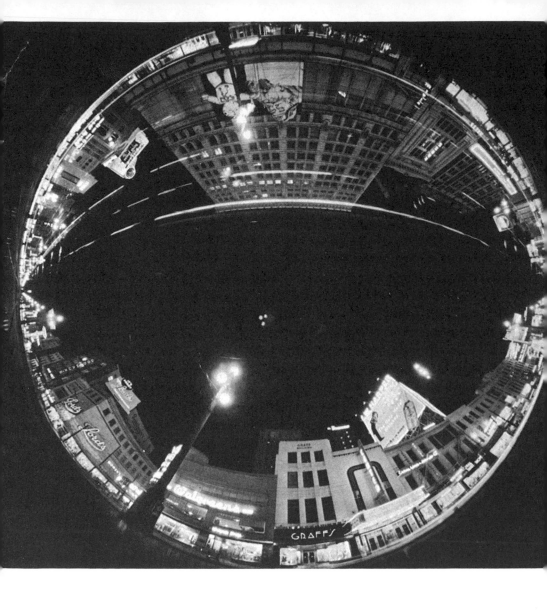

Street in New Orleans, *photographed by Émile Schultess.*

that the straight lines viewed directly are projected as a great-circle arc passing through the central region, the fovea.

If the focal point of the light rays were found at the center of the eye considered as a sphere, all straight lines would be defined as great-circle arcs. In reality, as this point is found in front of the center of the eye, it follows that a straight line outside the central visual axis is projected following a small-circle arc and differs more from a great circle the farther its center is from the center of the sphere and from the visual axis. Consequently when we fix our gaze on a point equidistant between two parallels on the frontal plane that are quite close together, the two lines are projected on our retina virtually as two great circles, with their divergence greatest in the vicinity of the fovea; they approach each other near their extremities and would intersect if one could extend them. This aspect of the projection of two parallels on the retina especially conforms to the results obtained in our experiments. Above all one should not conclude that we have here absolute proof of the validity of our diagrams. First, the retina was not made in order to be looked at, and furthermore, the brain can interpret the intervals differently, according to the region of the retina where they have materialized (fig. 12).

AN ILLUSION

The preceding observations concerning the physiology of vision are obviously rather elementary, but they suffice to demonstrate that nothing in the mechanism of vision is opposed to the conclusions one may reach from our drawing experiments.

Note that in the course of this brief presentation we have employed the expressions "movements of the eyes" and "immobile fixation of the eye." It is not a question of careless expression or of a misunderstanding of the differences that exist between monocular and binocular vision. Rather, it must be understood that when we think of scanning as a way

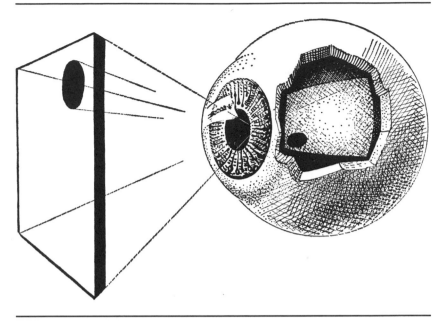

Fig. 12. *The retina is a spherical screen.*

of perceiving real space, one can conveniently speak of two eyes, inasmuch as the goal of scanning is to bring the details to be analyzed successively into the foveal region and to concentrate the attention on the fovea. Consequently, from the convergence of the eyes and the minute size of the relevant region, it follows that the foveal images are practically identical and that the brain can merge them. In the case of immobile fixation, however, the attention focuses on a field wide enough for different orientations and positions of the two eyes to imply a noticeable difference between the two retinal images, which coincide only in the foveal area. It is therefore impossible to superimpose them without creating considerable confusion. Moreover the brain automatically makes a selection and, when the difference is too great, takes only one of them into account. Besides, in respect to binocular vision, we would derive no advantage from finer lateral perception. It is for these reasons that when we consider a

stable retinal image and one of large scale, we think of an immobile eye—or at least nearly immobile, for the eye is always subject to movements of very weak amplitude, involuntary and imperceptible.

From the outset of this study we have drawn attention to the problematic character of the perception of space and to the very large part of perception that belongs to habit and above all to our education in the formation of mental images. We have then ascertained that this aspect of vision is confirmed by experiment, and we encountered great difficulties trying to define with precision what we see.

An example connected with the anatomy of the eye will confirm one of the artificial aspects of the formation of the mental image. It concerns the blind spot. One calls the blind spot the region of the visual field that corresponds to the place where the optic nerve is attached on the retina. There are no optic cells in this region, which consequently is insensitive to light. The blind spot is found on the temporal (nearest the temple) side, about 20° from the fovea. It has roughly the form of an ellipse with a relatively large surface, 7° to 8° vertical diameter by 5° to 6° horizontally; in other words, an area ten times as large as that of the fovea. Normally this gap in our visual field is unsuspected, for in binocular vision the two perceptions complement each other. Nevertheless even in monocular vision, when one should become aware of a dark spot, one notes practically nothing, because this lacuna of the visual field is unconsciously filled in. The lines that intersect it are continued quite rationally without our suspecting it. And yet this spot occupies a portion of the visual field equivalent to the diameters of twelve moons. Seen from two meters' distance, a human head easily fills it. Nowadays it is very easy, by means of well-known tests, to ascertain the reality of the blind spot. Nevertheless it was not until the seventeenth century that Mariotte discovered its existence. It is thus not surprising that perceptual habits should be so little questioned in the matter of spatial vision.

One should not be astonished by certain ambiguities of our senses. Vision, for example, is not necessarily destined to give us an exact representation of reality; generally it enables us to adapt our behavior to external stimuli. In addition, the selective and constructive capacity that is revealed in the most ordinary perception brings stability and permanence into the chaos of visual stimuli that without it would be insupportable, even maddening, because of the continual impression of flickering uncertainty that they would provoke.

Some remarkable studies have demonstrated how the child, first delivered into the shapeless world of raw sensations, progressively acquires an awareness of a universe of stable objects maintaining their individuality in spite of changes in perspective, movements, and so on. The same phenomenon occurs with those blind from birth when a surgical operation gives them sight.

In delving into these questions even more deeply, we would only verify the observation that vision is an essentially psychic phenomenon and that the images we form of reality are illusions that escape direct investigation and really cannot be proven.

REALITY, DRAWING, AND THE MENTAL IMAGE

After having tried to surmount separately each of the obstacles we have encountered, it is necessary to summarize all of our steps in order to see how we might be able to resolve certain contradictions and to give more precision to the results obtained.

It is evident that all real straight lines are generally perceived as straight lines, for we unconsciously meet the conditions of observation required for seeing them straight. These conditions ensure the most accurate and most comfortable perception requiring the least effort for pivoting the eyes and for foveal fixation. It follows that owing to the characteristics of our sensory apparatus, these lines are isolated from the

ensemble of the visual field during their perception and thus isolated from each of the other lines.

When one draws according to the laws of classical perspective, the straightness of the lines is preserved in the drawing; but if one respects rigorously the view point position that that theory implies, these lines should be perceived as curved. Because this obligatory predetermined view point is practically never respected, there is confusion in the way we look at the drawing, and the apparent curvature of the straight lines escapes us. This confusion is nevertheless acceptable when the drawing represents the contents of a rather narrow visual field, which presumes a relatively slight curvature of the lines.

When representing a wide field of vision, however, the straightness of certain lines disturbs the coherence of the depicted space and collides with our spatial logic, particularly our thinking about the apparent shrinking of objects in proportion to their distance from us. While systematically and objectively measuring space and transcribing the measurements on a plane surface according to a reference system, one obtains drawings that fulfill logic and preserve a certain coherence but which lead us to represent certain straight lines as curves.

If we check this phenomenon in direct vision, we observe that it is verified by our experience, as long as we force ourselves to try to perceive the straight lines—in the case of scanning, by keeping our head motionless and oriented toward the principal line of sight; and in the case of static vision, by keeping our eyes oriented along that line.

Drawings are traditionally made on a rectangular surface; this surface also is an object that is subject to the laws of perception, as is every other object. The problematic nature of the perception of this rectangle therefore implies a distorted mental representation of it that must have repercussions for the drawing. But the normal position of the viewer vis-à-vis the rectangle presumes a field of vision so narrow

that the deformation is hardly noticeable. Besides, this position is variable depending on the viewer, who seeks to understand the image as best he can. In addition, our awareness of perceiving an imaginary form and the compensating mechanisms that tend to stabilize our mental representation of reality irresistibly correct the distortions that ought to affect it, within certain limits, of course.

Consequently one can agree that in the final analysis there is little difference between the drawing and the psychic image that one forms of it when one looks at it as an art lover would—that is, when one agrees to enter into the game.

It is therefore acceptable to try to make a drawing, aided by an objective system of transcription, of a certain real subject perceived from a fixed view point without having to introduce into the drawing process any thought of the future position of the person who will look at it.

4

THE IMAGE IS RELATIVE

A NEW PERSPECTIVE

Can we now define the general principles of the drawing system that we have sketched and thus establish a new perspective? It is necessary that this new system escape the paradoxes of classical procedure, but it also must be easy to do. The main obstacle encountered stems from the tedious difficulties of defining directions and point-by-point transcription. From this process derives the common use of curves that are as difficult to draw as those that have allowed us to represent the wall or the tower. These already complex lines represented only the straight lines that could be defined simply, because they were contained within a frontal plane, vertically and horizontally. Within the framework of our method, are there procedures that would permit a more rapid analysis of all the elements of real space?

In order to demonstrate classical perspective, we have carried out an incontestably elementary experiment: a tracing on a transparent support from a fixed view point. A similar operation, subject to the rules that we have established, ought to permit us to generalize easily about the new perspective. In other words, because we know the reasons why a drawing on a transparent surface does not provide entirely satisfactory results, it should be possible to modify the experiment in

order to fulfill certain requirements. Two parallel straight lines on the frontal plane keep their straightness and their parallelism on the transparent plane because it recedes from the eye in a manner directly proportional to the corresponding recession of the frontal plane. The bundle of light rays that defines a certain real dimension can be cut by the transparent plane at variable distances from their point of origin. Thus the angle that this measurement subtends is represented by a variable linear dimension depending on the area of the plane where it is projected. Now we postulate that to the value of each angle of direction should correspond a directly proportional linear value, in order to ensure more accurate representation. So it would be necessary, when tracing on a transparent surface, that all parts of that surface should be equidistant from the eye. That is not possible with a plane. Thus we must contemplate the use of a curved surface. There is only one such surface where all parts are equidistant from a given point: the sphere, or at least a spherical surface.

Let us imagine, then, a hollow transparent sphere, and at its center the eye of the artist or the geometer's reference point. Under these conditions we can trace real space without distortion—that is, with the certainty of seeing a proportional linear value, in the form of an arc of a circle that corresponds to each angular measurement or perception. From the beginning the new perspective is singularly differentiated from the old. The old is a projection on a plane surface; this new perspective demands a preliminary projection on a spherical surface.[1]

[1] We willingly concede to the mathematician, G.-Th. Guilbaud, an expert in the problems of space and its representation, who has offered the friendly observation that it must be possible to disregard the sphere with its projection of directions and consequently to inscribe the angles of rotation of the visual ray directly on a plane surface, following an arbitrarily chosen distribution system. One can in effect attribute to any visual angle a single point on a plane, without, of course, making the reciprocal location of these points directly proportional to their real

SPHERICAL DRAWING OF REAL
STRAIGHT LINES

Consider any sphere with its center at O, representing the eye of the observer (the view point, the apex of projective rays). The tracing on the transparent sphere implies that to each point M in real space, there corresponds point m, the intersection of the line segment OM with the spherical surface S.

Let us now consider any real straight line L outside the sphere. The line segment OM connecting O with any point M on this line becomes parallel to the line L when it reaches the "limit"—that is, when M is carried to infinity in both directions along L. These two extreme orientations merge into a line L' parallel to the straight line L we are looking at and passing through the center O of the sphere. The segment of this line L' that is intercepted by the sphere is a diameter D (parallel to the straight line L). Therefore any straight line L is always projected on the (visual) sphere as half of a great circle of which the extremities coincide with those of the diameter D, which is parallel to line L.

If we define a segment of the real line L, the collection of line segments by which any point of this segment is projected on the surface S forms a plane triangle with one of its sides opposite the center O. The intersection of this triangle with S determines an arc of half a great circle with its length proportional to the angle within which the segment is perceived.

Let us state a fundamental rule of spherical drawing:

EVERY STRAIGHT LINE IN SPACE IS PROJECTED ON A SPHERICAL SURFACE WITH ITS CENTER OF PROJECTION AT O IN THE FORM OF HALF OF A GREAT CIRCLE AND ITS END POINTS GIVEN BY THE DIAMETER PARALLEL TO

position. In order to infer this, it is necessary to understand the rules of transformation. This tricky exercise, however, is not within the intellectual reach of everyone.

THAT STRAIGHT LINE. EVERY STRAIGHT LINE SEGMENT
THEREFORE BECOMES AN ARC OF A GREAT CIRCLE WITH
ITS LENGTH PROPORTIONAL TO THE VISUAL ANGLE
THAT INTERCEPTS IT.

Under these conditions a total spatial representation is possible. The visual ray then traverses the entire space, and the usual designations such as left-right, above-below, and in front-behind become relative. When we eliminate these notions, space becomes non-Euclidean.

We are limiting our study, however, to the space in front of the observer and we are considering a visual field of 180° in all directions (in classical perspective that would mean an infinite drawing surface). It follows that we are going to utilize a hemisphere. The circular face of this volume will be oriented perpendicularly to the line of sight issuing from O that is presumed to be horizontal. As a result this face will be parallel to all frontal planes.

For the convenience of certain demonstrations, we are going to base our discussion for the time being on the projection of real rectilinear elements on a hemisphere without worrying about the inconvenience of such a support. Besides, we shall preserve as far as possible the vocabulary of classical perspective. From now on we will define different types of straight lines in terms of their position and their orientation relative to the viewer.

FRONTAL STRAIGHT LINES

These lines are always contained within vertical planes parallel to the circular face of the hemisphere.

THE HORIZON LINE—A horizontal plane P passing through O cuts the surface S into two equal parts. The intersection of P with S is half a great circle that corresponds to the half-equator of representations of the earth, the polar axis being vertical. The extremities of this half-great-circle are given by the horizontal tracing of plane P on the circular face of the hemisphere, with its horizontal diameter D. Let us

call this half-great-circle the horizon. It is the "vanishing line" of all planes, and therefore of all straight lines contained in them, that is parallel to plane *P*. This is the horizontal reference.

THE VERTICAL REFERENCE—We determine in the same manner, by means of a vertical plane passing though *O*, the vertical "vanishing line" of all vertical planes perpendicular to the circular face, and of all straight lines contained therein; the vertical reference plane cuts the hemisphere in two along a half-great-circle and a vertical diameter. The half-great-circle corresponds to a meridian and the diameter to the polar axis.

FRONTAL HORIZONTALS AND VERTICALS—The entire ensemble of line segments that are connected to a frontal horizontal line, situated above or below the horizon at *O*, is contained within an inclined plane *P'*, which forms a dihedral angle with horizontal plane *P*. *P'* intersects the hemisphere along a half-great-circle and along the horizontal diameter *D*, thus forming a spherical "spindle." The linear value of the dihedral angle would appear on the central meridian.

In the same way, a frontal vertical situated at the right or left of the vertical reference is projected as a vertical half-great-circle (meridian). A plane *P'* containing the frontal vertical makes a dihedral angle with the vertical reference plane *P*, and its linear value would appear on the equator-horizon.

FRONTAL OBLIQUES—The plane *P* containing an oblique straight line cuts the hemisphere along a half-great-circle and along an oblique diameter that is parallel to that line. Oblique lines parallel to the first line determine a series of spindles of half-great-circles, and their common diameter is parallel to those oblique lines.

SEGMENTS OF FRONTAL STRAIGHT LINES—As we have seen in the preceding chapter, the ensemble of line segments that connects all points of a segment to *O* constitutes a plane triangle whose arc of intersection with the hemisphere is proportional to the angle intercepted by that segment.

VANISHING POINTS OF FRONTAL STRAIGHT LINES—
Contrary to classical perspective, in which frontal straight
lines have no vanishing point, two vanishing points are estab-
lished for every straight line by projection on a spherical
surface. They are situated at the extremities of the half-great-
circles that are the projections of frontal straight lines and on
the circumference that constitutes the boundary of the hemi-
sphere of projection. They coincide with the extremities of
the diameters (of the sphere) that are parallel to those frontal
lines.

RECEDING LINES AND
VANISHING POINTS

IRREGULAR RECEDING LINES—These are the straight lines
that cut frontal planes at angles that are not right angles,
oriented in any direction. On the complete sphere these lines
would be projected in the same way as frontal lines.

On a hemisphere, however, these receding lines are oblique
to the circular face, thus situated partly behind the viewer.
Consequently one of the vanishing points falls outside the
perimeter of the image; the other, in front of the viewer, is
always situated inside that perimeter. This vanishing point is
given by the intersection with this hemisphere of a line radiat-
ing from O that is parallel to the oblique receding line we
are discussing. Just as in classical perspective, the placement
of the vanishing points is important, for they indicate the
direction of the bundles of parallel straight lines in space.

On a sphere, only one great circle can intersect two points,
unless these points are diametrically opposite, in which case
an infinite number of great circles can pass through the two
points. Thus given the vanishing point of a single receding
line or of a bundle of parallels, one can understand the per-
spective by constructing the projection of only one point of
each straight line.

CENTRAL ORTHOGONAL RECEDING LINES—These are
the projections of straight lines that run parallel to the line

THE IMAGE IS RELATIVE

of sight, thus also parallel to the horizontal and vertical reference planes. In the real world these lines can be illustrated by curbs and flanges at the edges of sidewalks, house facades, roofs, and the like or by the boundaries of a straight horizontal street as we perceive them when, standing in that street, we look along its axis. If we extend all of these lines to infinity, they meet at the horizon directly before us, at the extreme end of our line of sight. Now this axis crosses the surface of the hemisphere at its center, at the intersection of the equator that represents the horizon with the central meridian that represents the vertical plane of reference. Thus it is at this spot that we find the vanishing point of all central [orthogonal] receding lines. If they are infinitely long, they will start at the edge of the hemisphere and end at this central point, and each will be represented by one-quarter of a great circle (fig. 13).

LATERAL RECEDING LINES—Let us pivot now in the horizontal plane, so that our visual axis should no longer be parallel to the direction of the street. It is evident that the vanishing point of the lines parallel to the street is going to slide along the equator-horizon, in the direction opposite to the way we have moved because the hemisphere moves together with the line of sight. It is also obvious that the size of the arc that separates the new vanishing point from the preceding one (within the hemispheric picture) is directly proportional to the angle of our pivoting. Consequently, in order to locate the vanishing point of a horizontal line that is oblique to the line of sight, all we have to know is the angle that it forms with the line of sight. We will call this type of straight line a lateral receding line.

INCLINED RECEDING LINES—If we direct our line of sight along the axis of the street and then lower it toward the ground or raise it toward the sky, the vanishing point of the horizontals of our street will slide up and down along the central meridian. There again, the distance to the new vanishing point from the first one will be directly proportional to

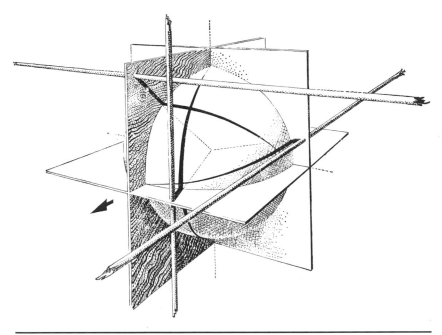

Fig. 13. *An orthogonal straight-line system (oriented at right angles) projected on a sphere. Each of the three lines has two vanishing points situated on a diameter parallel to it. The arrow indicates the main direction of observation. Each of the three orthogonal planes intercepts the spherical surface at the vanishing point of all straight lines parallel to it.*

the angle of inclination of our line of sight. It goes without saying that the result would be similar if, keeping our line of sight horizontal, we were to observe straight lines ascending or descending that are parallel to the vertical plane of reference. The vanishing point of such lines will always be located on the central meridian, at a distance from the picture's center proportional to their angle of inclination. These straight lines will be called inclined receding lines.

IRREGULAR RECEDING LINES—Analogous reasoning will permit us to understand how to locate the vanishing point of any straight lines that are at the same time oblique

100 THE IMAGE IS RELATIVE

to the horizontal and vertical planes of reference. Two angular measurements will define the obliqueness of the line relative to each of the planes. On the hemisphere the point we are seeking will be found at the intersection of two arcs, one oriented vertically and the other horizontally, which will be constructed in terms of the values of the two dihedral angles. These vanishing lines that depart from both reference planes will be characterized as irregular vanishing lines. One sees that it is relatively easy to determine the vanishing point of any straight line on the hemisphere (fig. 14).

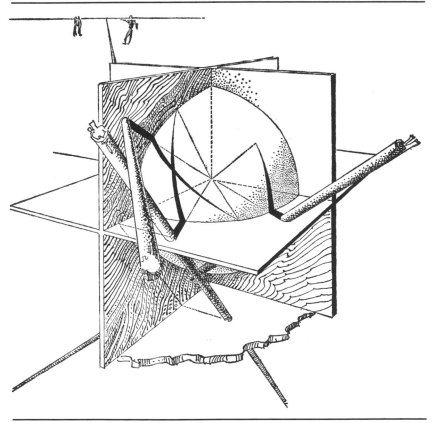

Fig. 14. *Irregular straight lines projected on the sphere. Their vanishing points are on diameters parallel to their directions; therefore one vanishing point may be outside the picture.*

It might seem that all definitions in this chapter are rather useless inasmuch as our problem was to transfer real space onto a transparent hemisphere, a process that eliminated all measurements and calculations. Recall that this transparent surface has been chosen by analogy with the sheet of glass of classical perspective. As with that device, this demonstrates in simple fashion the mechanism of a possible drawing system. Just as classical perspective is used on an opaque plane, however, we should admit that our hemisphere depends on materials one can easily draw on. In addition, it is important in order to follow our reasoning to understand the relationships between the simplest geometric data of space and a hemispheric projection picture.

THE WALL AND TOWER ON THE HEMISPHERE

Let us return to our wall. The horizontal reference line is traced: a half-great-circle (the equator); the vertical reference too—a meridian that divides the hemisphere into two equal parts. The principal line of sight passes through the intersection of the two half-great-circles. We have seen that the height of the wall in its nearest section was perceived at an angle of 40° above the horizon. When drawing on the plane surface, we had attributed to each degree a linear value proportional to the field represented and to the size of the drawing. We know that in the case of the hemisphere the angular value is identical to the value of the corresponding great-circle arc. Nevertheless the value of the arc can be defined in linear units, whereas the angle is always defined in degrees. The size of the hemisphere therefore determines the relationship between the two types of notation. For example, if we attribute to the hemisphere a diameter of 1 m, the length of the half-great-circle is equal to $1 \times \pi/2 = 1.57$, and thus the angle of arc is $1.57/180 = 0.087$ m. To simplify our figures, let us suppose that our experimental hemisphere has a diame-

ter of 1.27 m, which implies a half-great-circle of 1.27 × π/2 = 1.80 m, so that 1° = 1 cm of arc.

Thus we will be able to place the central point of the top edge of the wall on the vertical meridian at 40 cm of arc above the equator-horizon. At 90° to the right or left the top edge meets the horizon line. On the hemisphere these two points are located at the extremities of the equator-horizon. If we connect the three points that we have just located, we obtain a half-great-circle that meets the equator at the boundary of the hemisphere while intersecting the vertical meridian of reference at 40 cm of arc, above the center of projection. Proceeding in the same manner for the base of the wall, we will obtain another half-great-circle, also meeting the equator-horizon at its extremities, while intersecting the meridian of reference at 27 cm of arc from the center of the hemispheric picture.

The example of the tower will show us that in the same way, the verticals that coincide with meridians meet at two points, the north and south poles, following the diagram of half-great-circles that intersect the equator at 37 cm of arc from the center of the projection surface. The square facade, our last example, would be bounded by arcs of four half-great-circles that intersect at the four corners of the facade.

DEVELOPMENT OF THE SPHERE

It is remarkable that the drawing on the transparent or opaque spherical surface is absolutely coherent and that it does not contradict direct observation. This goes without saying; if there is no contradiction, it is simply because real space, which has three dimensions, is transcribed on a surface that is itself immersed in these dimensions and that is at a constant distance from the center of observation. In a certain way the viewer is himself integrated into a spherical space that is like a homothetic dilatation of his point of view (fig. 15).

We now run into various objections. For one thing, no

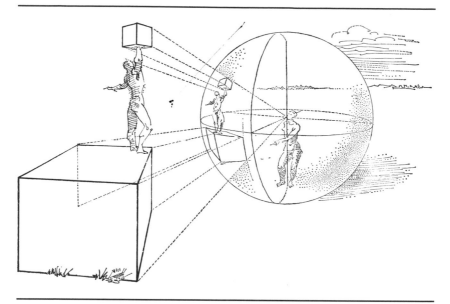

Fig. 15. *Angular values corresponding to the straight lines in space are easily assembled on the "visual sphere." All of them are located within planes passing through "the eye" (the center of the sphere) and appear on the spherical surface in the form of segments of great-circle arcs.*

one usually draws or paints on a hemisphere; one easily imagines what material difficulties this would involve. For another, even the shape of the image implies for the viewer an extremely specific view point; viewed from any other point, the deformation of the drawing would quickly become unacceptable. Now this last drawback is exactly what we have denounced in classical perspective. It is thus necessary, at the risk of contradicting ourselves, to return to the planar drawing, in which we have noticed, in analyzing the mechanism by which it is seen, that it avoided to a certain extent the distortion implied by all visual observation. We must come back to the plane, while safeguarding if possible the results that we have obtained on the hemisphere. Is this transcription conceivable?

Certain three-dimensional surfaces can be developed on a

plane. It is enough, for example, to make an incision starting from the apex of a cone, so that the cone can be flattened. Unfortunately a spherical surface cannot be flattened that way. To do that, it would be necessary to make an infinite number of incisions or make use of an elastic, deformable material. In fact, it is strictly impossible to develop a hemisphere. What then? Well, if it is impossible to create such a flattening, one has to conclude that it is impossible to make an exact graphic representation of real space on a flat surface. This conclusion, as unpleasant as it may be, is irrefutable. To pretend to resolve the problem would be as absurd as pretending to square the circle (fig. 16).

Real space, even when limited to its apparent contours, cannot be drawn on a plane surface without partially violating

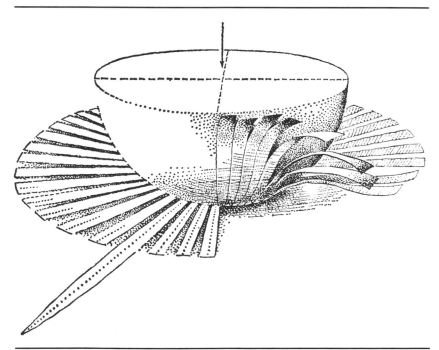

Fig. 16. *The development of a hemisphere is impossible because of the double curvature of its surface. Even an infinity of cuts will not solve the problem.*

its appearance. The problem of drawing from strictly objective observation, then, has no solution unless one is willing to compromise. Just as we have observed that the mental image we form of the real world is largely a construction of the mind, in the same way we must admit that the image of reality that we would like to construct cannot be created without a large element of artifice that entails deformations. But, one might say, is this difficulty really inescapable? If the drawing on a hemisphere leads to an impasse, it would be useless to continue in this direction. Nevertheless the attempts we have made in connection with the wall and the tower, by measuring the angles directly and transcribing them in linear terms, seemed to avoid this obstacle.

Unfortunately this claim is not defensible. We repeat, the spherical picture permits the exact description of real space. There is complete identity between measuring the angle that characterizes a real distance and measuring an arc of a circle on the transparent hemisphere. It is when we transfer the measurements to a plane that we betray reality, for we then create a pseudodevelopment. It is necessary to look at this more closely and to understand what errors we may have committed without noticing them.

We can, for example, go back to the drawing of the wall that we had diagrammed on the transparent hemisphere and instead of calculating the real angles, measure them directly on the curved surface in widths of arc and transfer these measurements onto the plane while paying close attention to the passage from one to the other. Because the arc measurements correspond to the angular values, their transformation into linear values does not seem significant. We are going to see that in fact the ambiguity comes neither from the measurement nor from its transformation into a linear value, but from the orientation when both measurement and transformation are made.

We have seen that the top edge of the wall was inscribed

in a half-great-circle that passed at 40 cm of arc above the horizon, at the intersection with the reference meridian. Therefore let us place that point on a sheet of paper 40 cm from the view point on the vertical reference. At 60° to the right or left, we see that the part of the wall edge we are looking at lies 22°, or 22 cm of arc, above the reference horizon. But in what direction are these 22 cm of arc to be measured on the hemisphere? In reality the angle has been measured in a vertical plane. That is why we have then raised a perpendicular to the equator-horizon, cutting it at 60 cm of arc, to the right or left of the visual center. But this perpendicular evidently does not correspond to a meridian that approaches the central meridian. To be sure, the perspective of this point is found at the intersection of this meridian with the great-circle arc representing the top of the wall at 22 cm of arc above the equator-horizon; one must note, however, that because the two meridians are not parallel, the point (its image) is less than 60 cm of arc from the central meridian. Now in the first drawing we measured the 22 linear cm along a vertical that was perpendicular to the horizon. Thus if in the second drawing our point is still situated at the correct distance from the horizon, it is no longer the same when we regard its distance from the reference meridian. Consequently the diagrams we made in the first part of this essay do not express the reciprocal situation of points on a hemisphere.

In observing the hemisphere, one notices besides—and this confirms the preceding remark—that the angle of intersection of the great-circle arc that represents the top of the wall with the great-circle arc that represents a real vertical is not 90°. Generalizing, one will see that the great-circle arcs that represent the horizontals never intersect at a right angle with the great-circle arcs that represent the verticals, except those that intersect the reference meridian. One can see that the divergence from the right angle is more pronounced the farther

these angles are from the central meridian. At the boundary they are zero, or 180°, and are identical with the perimeter of the image.

We now know the hidden flaw in the method we have employed, and we know why it does not escape the impossibility of the development of the sphere. We have, of course, preserved the value of angular measurements, but we have not been able to preserve the orientation of the arcs that we measured. There ensues a deformation of the drawing that, though hardly noticeable in the vicinity of the focal point (point of invariance), becomes progressively less acceptable as we consider a more distant region. In order to give an idea of this deformation, we will specify that if we were to draw the edge of the visual field at 180° by the method of the first drawing, we would obtain not, as one might believe, a circle but a square.

DRAWING AND CARTOGRAPHY

It should now be possible to describe succinctly the obstacles and impossibilities that interfere with the production of an absolutely planar image.

We know that in relation to a precise point of reference (view point), real space cannot be projected without incoherence or deformation except on a spherical surface of which this point would be the center of curvature. Moreover, geometry teaches us that it is impossible to develop a spherical surface on a plane surface. Therefore any transfer from one to the other implies modifications. Consequently one can conclude that any attempt to represent real space graphically on a flat plane is equivalent to transforming the projection of that space on a spherical surface into a drawing on a plane surface. This definition does not eliminate any of the difficulties, but it should keep us from losing ourselves in sterile quests and should encourage us, rather, to benefit the most from various procedures that might come as close as possible

to the solution of the major problem: the transition from sphere to plane.

One will object that if the absolute transformation or development is impossible, it might not be reasonable to study other methods, such as projections that finally will lead us only to imperfect results where either certain widths or certain angles will automatically be distorted. Doesn't common sense advise us to return wisely to classical perspective and to admit that this still is the least flawed system that we could use? To answer this objection, it is sufficient to refer to the preceding definition. According to that definition, classical perspective itself should be reduced to a certain kind of transformation from sphere to plane. Thus from this point of view, it loses entirely its privileged status and is nothing more, a priori, than one mode of transcription among others. To the question, should we return to classical perspective, we must respond with another question. Is it the best system—that which least distorts the spherical drawing?

The answer to this question will show us the real value of this method, which goes back five centuries. We will then understand whether it can be fruitfully replaced by another method that is more exact or better adapted to our actual view of the world. The domain that we ought to explore now is clearly defined. Moreover, it is not new and has been fully explained by geometers and mathematicians. Thanks to them we are going to discover many ways to transform a spherical surface into a plane surface, either by projective or analytic transformation. The specialists who will give us the most interesting answers are the cartographers. What do they do, in fact, but measure distances or angles on a quasi-spherical surface, the earth, in order later to transcribe their observations on flat surfaces and topographic reliefs, as well as on globes, celestial spheres, and so on? Our problems are identical to theirs, although our intentions might not be the same. Of course their drawing on a sphere is a given, whereas we must first establish ours. We have seen, however, that this

operation does not present a major difficulty and that the image of real space unfolds quite rigorously.

It is not necessary for us to study in its entirety the vast domain of cartography. We may establish a preliminary process of elimination in order not to scatter our investigations. The methods of producing large-scale maps, for example, are not very interesting to us because they represent very limited segments of the terrestrial sphere. Now we have seen that in the vicinity of our focal point (point of invariance of the transformation) that might correspond to the center of the map, distortions are relatively unimportant and that the larger the field, the more the difficulties increase. Thus we should stick to the representation of the entire terrestrial globe, or at least of a hemisphere, because we are tackling the representation of a large visual space, as large as 180°. If this is resolved, it also makes possible representations of the parts.

The conclusion to the first part of this essay is now apparent: any perspective method corresponds to a method of transforming a spherical diagram into a flat diagram. Thus an absolute image does not exist. Only a relative image is possible.

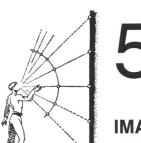

5

IMAGES AND THEIR LACK
OF SIMILITUDE

ANALYTIC TRANSFORMATIONS AND PROJECTIONS

The impossibility of developing a hemisphere on a plane results from the double curvature of its surface (curvature of the generator and rotation of the directrix). In reality this impossibility is easily noticed when one tries to wrap a sphere with a sheet of paper. Folds and overlaps are inevitable. Only in small portions of the paper can the two surfaces be made roughly to coincide.

Thus the passage from spherical drawing to flat diagram is rationally possible only by establishing a mathematical correlation or by a geometric kind of transfer. Two experiments will permit us to understand the difference between these two general methods.

If one imagines that the original hemisphere is made of elastic material, one is immediately tempted to flatten it out on a surface. In order to reduce the double curvature of the elastic surface, we will proceed then to stretch and compress it. But in what direction should we press and stretch? It is possible, for instance, to stretch it radially on the periphery of the hemisphere, the center remaining fixed. In that way one will obtain a circle the circumference of which will be

larger than that of the boundary of the hemisphere. Thus the deformations will be very evident in the areas near the boundary.

It is possible to stretch in two directions, pulling along two perpendicular axes until the hemisphere is entirely flattened. The hemisphere will then take the form of a square. In fact, in playing with this controlled stretching and compressing of elastic material, the experimenter is free to give the flattened hemisphere an infinity of shapes while respecting the prohibition against splitting the material, within certain obvious limits.

If now, instead of actually using an elastic support, we were to carry out these measurements on a rigid hemisphere and then transfer them onto a plane, in terms of certain mathematical laws governing extension or compression, we would obtain identical results. The procedures that permit us to establish this kind of correlation between a spherical surface and a plane are called "analytic transformations." There are as many procedures as there are possibilities of flattening. Their number depends only on the imagination of mathematicians.

Let us now imagine a rigid but transparent hemisphere that is tangent at the center of its surface to a plane (a screen). This screen is perpendicular to the line of sight, the pivot of the hemisphere. If we place a light source exactly on this pivot, the image of the initial drawing carried out on the hemisphere is projected onto the plane. The position of the light source determines the appearance of the projected drawing. If we consider that the light source can be identified with view point O, we can define this process geometrically as follows: to each point M on the spherical surface corresponds a point m, the intersection of the straight line OM with the plane P. It is clear that the placement of point O has little effect on the projection of the central regions of the hemisphere. Conversely, the appearance of the marginal regions is susceptible to great variation. Thus here also, the infinite

number of positions of O implies an infinity of possible images. This mode of transformation of a spherical outline into a plane drawing is called a "projection."

THE CHOICE

Which analytical transformation or which projection least distorts the spherical drawing? What type of image should be chosen? Is there one that might be preferable to the type that corresponds to classical perspective? In order to answer correctly, we must first establish norms.

We will call the alteration of the flat shape "lack of similitude."

Only the appreciation of this deficiency will permit us to choose a procedure in an objective way. Whatever the method used, this failure to match reality results essentially from modification of the value of the hemisphere's arc lengths, transformed into linear magnitudes. Moreover these modifications, variable from one region of the image to another, can depend on the orientation of the particular magnitude (length).

Certain transformations have special effects. We may arrange it, on the one hand, so that the orientation of the transformed magnitude should have no effect on its alteration. Consequently the angles of the figure will not be modified. The method will be termed "conformal." On the other hand, it is possible to maintain a certain relationship among the alterations of magnitudes around a point; as a consequence the proportionality of the surfaces of the figure will be preserved. This, then, is an "equivalent" method. Finally, it may be that the value of the arc lengths of the hemisphere can be preserved on the plane along certain privileged lines. One will speak then of "equidistant" transformation.

There is no norm that lets us determine definitively in absolute values which method permits us to obtain the plane image closest to the spherical drawing. But the questions change. Is it preferable to preserve the value of angles, even

if that implies a greater alteration of lengths? Is the correct relationship between surfaces an important component of the character of an image? Is it better to preserve certain equalities of length or to seek the least alteration of lengths? Of course, no definitive answer exists, but the discussion henceforth will be on a level that escapes tradition and the influence of lazy habits.

All perspective thus implies the choice of a type of image that depends on the mode of transformation that has been selected. We will see in any case that classical perspective, which is identical to a process used in cartography (gnomonic projection), cannot be considered a good solution to the problem.

One will find in the appendix the reasons that encouraged us to propose a method close to the so-called Guillaume Postel transformation as the basis of curvilinear perspective. BUT THE FREEDOM TO SEEK REMAINS INTACT. ANY OTHER PROCEDURE MAY BE UTILIZED, PROVIDED THAT IT SATISFIES THE FUNDAMENTAL AXIOM.[1]

Our choice therefore has above all a paradigmatic value. It demonstrates that it is possible to invent a new perspective that, though it is more objective, remains just as convenient as the old system.

It was tempting, of course, to enlarge the framework of this work and to show the multiple solutions to the problem of the representation of visible space that are allowed by the projections and transformations currently used most frequently in cartography. That, however, is the subject for another book, which might be enriched by singular imagery.

CLASSICAL PERSPECTIVE AND GNOMONIC PROJECTION

Classical perspective is identical to a well-known geometric system: gnomonic projection. Let us consider on the one

[1]See appendix.

hand the hemisphere on which the drawing is traced, and on the other the flat surface to which it must be transferred. In order to carry out a gnomonic projection, it is necessary to place the picture plane perpendicular to the line of sight and tangent to the center of the hemisphere's surface. The center O of the complete sphere is the origin of the line segments that project the points on the hemisphere onto the tangent picture.

Imagine now that the hemisphere and the plane are both transparent. If the artist's eye is at the center of the sphere and if the real subject is in front of him, it goes without saying that tracing the subject on the hemisphere in this way in order to transfer it from the same place onto the plane amounts to tracing the subject directly onto the plane by means of classical perspective (fig. 17).

Because the importance of the lack of similitude depends essentially on the alterations of magnitude, in order to evaluate it we must compare different values of arcs of the spherical surface with the projected linear values that correspond to them. Consider, for example, an arc oriented toward the center of the hemispheric surface. Two factors determine its transformation into a linear measurement: (1) the distance from that arc to the projection plane, and (2) its inclination with respect to the same plane. These two factors contribute to lengthening the projection of the arc, its perspective. The alteration of its perspective is greater the farther the arc is from the center of projection. It is not the same for an arc that is perpendicular to the first arc. In this case the (least) alteration depends solely on its distance from the projection plane. It follows that the deformations implied by gnomonic transformation depend at the same time on the position and also on the orientation of the pertinent dimensions.

From the table[2] that gives the extent of alteration of the corresponding projection, one can now judge classical per-

[2]See appendix.

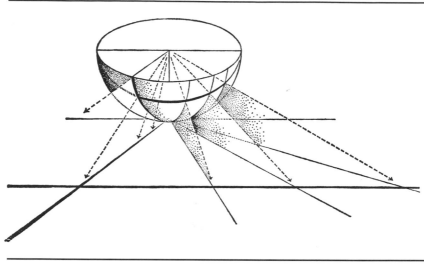

Fig. 17.

spective with complete fairness. Within the traditionally ad-
mitted limits of the visual field, 40° (20° + 20°), the change
in magnitude reaches 10%. It is remarkable that this deforma-
tion, valid also for photography, should pass practically un-
noticed. If we picture a field of 120°, as in the example of
the wall, the alteration might reach 280%. For a field of 180°,
the distortion is infinitely large. Let us recall that certain
authors have considered acceptable widths of field of 90°; this
means that they considered negligible discrepancies of 100%
between their drawings and the measurable appearance of
reality. Then again, inasmuch as the degree of alteration of
angles and surfaces can also be very high, it should be evident
that classical perspective's lack of similitude is extreme. In
fact, gnomonic projection is one of those types of projection
that imply the most significant deformations. Its sole advan-
tage for the artist is that the great circles of the sphere that
correspond to the straight lines of reality become straight
lines when drawn on the projection. We understand now,
however, how this practical advantage obscures the poor

quality of the system as a method of representing visible reality.

CURVILINEAR PERSPECTIVE AND POSTEL'S TRANSFORMATION

Because the alteration of dimensions is the major inconvenience of the transformations that interest us, we have chosen the transformation that is characterized precisely by minimal alterations. It concerns a variant of what is called "Guillaume Postel's projection."[3] The word *projection* is improper, although consecrated by geographers. One will find several characteristics of this system in the appendix. The comparisons with classical perspective (gnomonic projection) are particularly significant. For a visual field of 40° (20° ∣ 20°) the maximal alteration is 2%. The visual field must reach an eccentricity of 45° in order to attain the 10% alteration that is accepted in the classical system. This same percentage corresponds here to a drawn visual field of 90°. With a field of 120° (our examples), the deformation does not exceed 20%, and in the case of a total field of 180°, we reach a maximum of 57%. It is remarkable that these percentages are only relevant for dimensions oriented along concentric circles, the radial lengths being preserved intact.

The reader may have the impression that these comparisons of percentages carry him into a domain singularly different from that in which a drawing from nature is generally found. Still, he should not forget that the figures that we give define precisely the difference there would be between the apparent value of a real dimension and the value of that dimension in a drawing, in terms of its position and orientation, and in accordance with the type of projection used.

The differences that we have noticed between the traditional process and the one we are going to use flows obviously

[3]See appendix.

from their different mechanisms. Postel's transformation (see appendix) is carried out in the following manner:

Given any point on the hemisphere, from the center of the hemisphere's surface one draws a great-circle arc passing through that point; on the plane of the drawing, starting from its center, we trace a line segment with an inclination that is the same as that of the arc, and a length that is equal or directly proportional to it; the image of the point is situated at the end of the line segment (fig. 18).

One then understands why the radial dimensions are not altered in Postel's transformation: on the plane the distance from any point to the center of the system is proportionally the same as on the hemisphere. Besides its minimal lack of similitude, this projection has the advantage of easy manipulation. Nevertheless it presents an inconvenience that cannot be overlooked by anyone who uses it: certain great-circle arcs (images of real straight lines) are transformed into transcen-

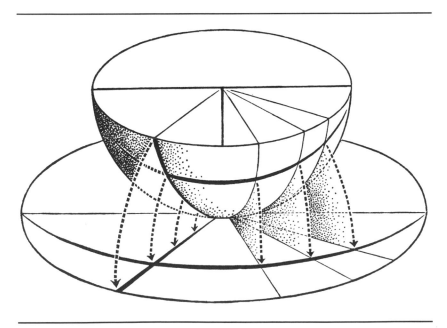

Fig. 18.

dental curves. That certain real straight lines should be represented by curves is acceptable, as we have demonstrated the validity of this mode of representation. The transcendental quality of these curves, however, is a serious obstacle to the use of Postel's transformation, for they can be precisely traced only point by point. Nevertheless taking a closer look, we notice that the difference between one of these curves and a circular arc is very slight, a few hundredths at most. So we will avoid the difficulty by neglecting this form deviation and will in effect draw circular arcs. At any rate, the variation between one and the other is without importance in comparison with the necessary alterations that the transformation itself implies (see appendix):

We are now able to enunciate the essential characteristics of curvilinear perspective (see appendix):

—The visual field of 180° is represented by a circular picture.

—All real straight lines that intersect the line of sight or are parallel to it are represented by straight lines (diameters or radii of the picture).

—All real straight lines that do not intersect the line of sight are represented by circular arcs; when these lines are continued, they end at the perimeter of the picture at two opposite points (extremities of a diameter).

—The curvature of the arcs that represent real straight lines is more noticeable the farther the lines are from the center; at the outer limit they are identical with the perimeter.

Drawings made in curvilinear perspective will thus be consistent with the conclusions drawn from the experiments made during the search for the perfect image.

From a strictly mathematical point of view, however, our method is different from Guillaume Postel's transformation. Although this slight correction of the curves modifies the

appearance of the drawing very little, the mechanism of the construction is significantly simplified. Instead of being viewed point by point, space is apprehended as an ensemble of rational elements (straight line segments) to which correspond circular arcs that are oriented and distributed in the drawing according to certain laws. We are then discussing another type of transformation, although in practice the difference in appearance would be indiscernible.

PART II

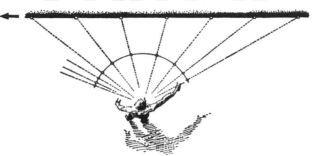

6

INTRODUCTION TO CONSTRUCTION

SPHERICAL SPACE AND
EUCLIDEAN SPACE

If it were necessary for each drawing first to make a spherical diagram and then to project it onto a plane, it is obvious that curvilinear perspective would be of very little practical interest. But we have seen that classical perspective itself is a projection system that can be derived from a spherical surface. Its proponents ignore such complications, however. Knowing the rules that govern the passage from lines in real space to lines drawn according to their characteristics, their position, and the laws of perspective, they apply these lines directly onto the plane from the real world. In order, then, that curvilinear perspective be easy to manage, it is necessary that we establish laws and rules that will permit us to construct drawings from nature in the same way. In order to establish these laws and rules, permitting us to avoid the double drawing process, it will nevertheless be necessary to review the chapter on hemispheric drawing and to reason as if the double drawing were really made.

We have implied that it would be preferable for the new perspective to permit the representation of a visual field of 180°. That is precisely the case with our mode of transforma-

tion. That does not mean, however, that this perspective is applicable only for fields of that span. If one of its goals is to expand space for artists, liberating them from the constraints of classical perspective, this is not in order to force them always to draw in its totality the space they see before them. Besides, from a purely practical point of view, the representation of 180° presents a certain inconvenience. The method that we have chosen transforms the hemisphere into a circle; of course circular paintings and drawings exist, but it must be admitted that a rectangular canvas or sheet of paper is more commonly used. Nevertheless in the pages that follow, we will always consider the total field in studying curvilinear perspective. We will see that under these conditions the constructions will be made much more easily. We will then be able to demarcate the parts that we would really like to draw.

Real dimensions are defined for any given observer by the angle from which they are perceived. It is necessary, then, we repeat, to begin by defining the angles that will presently be changed into linear values. If he does not make use of instruments for measuring angles, it would seem that the artist who uses curvilinear perspective would be led to rely on trigonometry. Although remaining on an elementary level within the framework of our basic study, this method nevertheless risks discouraging those who do not know the principles of trigonometry. Consequently we will develop two methods, one including some notions of trigonometry and the other based solely on diagrams and the principles of the square grid. We will see that in the end the second method is faster and more practical. To begin, we will systematically analyze the way in which simple straight lines in real space, taken either individually or combined in simple shapes, are transformed in a drawing. The tracing of certain lines—ordinary obliques, for example—presents rather difficult construction problems. In classical perspective, however, these difficulties would not be less serious. In fact, from some

painstakingly established guidelines, most diagrams will be developed almost automatically, following very simple laws of geometry.

Men and women, living beings built on a symmetrical scheme around a vertical median plane, have a tendency to attribute to their own organic constitution a preponderant role when they explore and interpret space. They take themselves as systems of reference: high and low, right and left, back and front (understood with respect to the self of the explorer). It is inherently much more difficult for them to determine directions for someone else, and they lose all sense of direction—they even panic—when caught in the simple play of mirror reflections.

The horizontal and vertical in particular are linked to the human condition, to gravity, to the constant search for equilibrium, to the apparently flat ground (as soon as man leaves the terrestrial surface, this system of predilections is not very helpful), and also to the difficult apprenticeship of the erect position. The visual field in its entirety is interpreted as something situated *in front of* the observer, but that is not true of the auditory field. Moreover it is perfectly conceivable (and we have done it) to represent a complete visual field, in the manner of the auditory field, where objects situated behind the viewer are also represented. Such a representation remains accessible to interpretation by ordinary logic. We thus project the situation of our own body and perceptual organs when we give structure to our elaborate sensory field.

Therefore although we may have been led to consider our perceptual field as spherical, or at least as hemispherical, and although that logically implies polar coordinates in order to define positions and spatial dimensions, it must be admitted that our familiar space is in fact Euclidean and is understood in Cartesian coordinates. It is articulated in three planes: a horizontal plane and two vertical planes perpendicular to each other, in which are inscribed widths, lengths, and heights (fig. 19). For the artist it will essentially involve the

Fig. 19. *The three reference planes.*

horizontal plane *C*, a vertical plane *B* oriented toward his eye, and another perpendicular left-right plane—that is, a frontal plane, *A*. The first two planes are identified as the horizontal and vertical reference planes that we have already utilized, and we will continue to employ them. The first will always be called the horizontal plane, the second the vertical "plane of sight." The principal line of sight, of course, is determined by the intersection of these two planes. In addition we must define the third plane; we will compare it to a frontal plane passing through the observer's eye. It will be called the observer's plane and corresponds to the neutral or vanishing plane of classical perspective.

In the circular picture, the horizontal plane will be represented by a horizontal diameter *C*, the vertical plane of sight by a vertical diameter *B*, and the observer's plane by the perimeter of the circle *A* (fig. 20).

Fig. 20.

METHODS OF DIAGRAMMING

A large number of straight lines will be represented in the drawing by circular arcs. In order to draw an arc, when the circle's radius is not given it is necessary to know the position of at least three points. Now the straight lines of the frontal plane will be represented by arcs ending at two opposite points on the circumference. As a result, when we know the position of one of these, the position of the other will be immediately defined. One will then be able to construct the arc containing a frontal straight line from two reference marks: one located on the perimeter of the circular picture, the other located inside it. One knows that the arcs represent-

ing the receding lines by definition end at a vanishing point located within the picture. If one continues them, however, each of them will also end at two diametrically opposed points on the circumference. There again one will be able to construct the arc containing any receding line from two reference marks: the vanishing point and the base point for the arc in question, on the perimeter.

We can picture making curvilinear perspective constructions either with compass or freehand. The drawing made with a compass will give the most accurate result. The difficulty will be to find the center rapidly for each of the arcs to be drawn. For that purpose it is necessary to connect the three known points by means of two straight lines, then to erect two perpendicular bisectors to the midpoints of these lines. At the intersection of those perpendiculars the desired center will be found. This operation is easily carried out (figs. 21 and 22).

One will see later that other simple procedures will be found with practice. For example, we will be able to show that all centers of circular arcs representing parallel straight lines are aligned. Nevertheless it is undeniable that certain practical difficulties will be inevitable when we tackle arcs having a very large radius. Their center will occasionally be found far away, outside the circumference that is the boundary of the visual field of 180°. It will therefore be preferable to avoid rendering a perspective drawing on too large a scale. One can always enlarge it later, either as a whole or in part (by applying a checkerboard grid).

Freehand drawing avoids the search for the center points, but if one desires a certain precision, it requires some skill and an unusually good eye. One can obtain excellent results, however, using a grid of precisely drawn circular arcs of different curvatures. This template should be prepared for a circle of the size of the circular picture. All of the circular arcs will have a diameter as a common chord. They should be drawn as close together as possible. Their curvature will

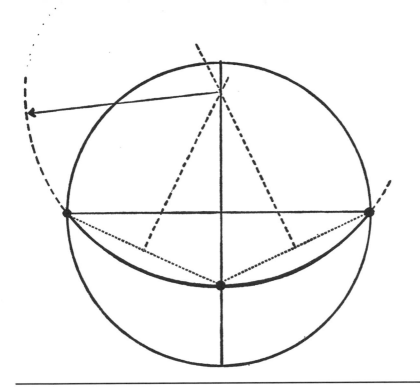

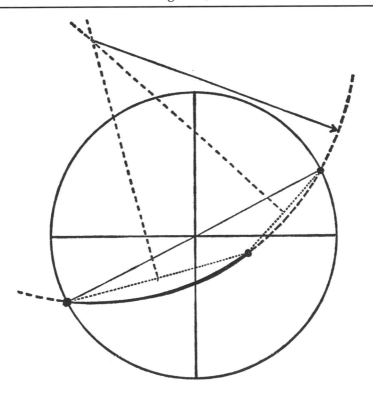

Figs. 21, 22.

vary between two limits: maximum curvature when the arc is identical with the circumference, and no curvature at all when it coincides with the diameter of the circle.

The perspective drawings will then be made on tracing paper. The center of the circle marked on the tracing paper will be made to coincide with the center of the circle on the template. After having located in the circle on the tracing paper any two points through which one should draw the arc, one must simply rotate the tracing in such a way that the two points are found on only one arc of the template. We will then trace the arc, all or part of it, freehand. If we are not able to make the two points coincide perfectly with one of the curves of the template, we will look for an intermediate position that will permit once more a fairly precise drawing.

The execution of our drawings and diagrams departs from the traditional conception of geometric or technical drawing. The artist habitually seeks to represent the one- or two-dimensional lines of the geometer, which are thus without thickness, by lines as fine as possible, sacrificing the legibility of his work to a very hypothetical precision. His rigor is entirely artificial, however, because no drawing or measuring instrument can achieve more than approximate values.

We have therefore deliberately given our lines a material thickness and made them strong and thick in regions close to the viewer and thinner in the distance. We believe that in this way we have augmented the legibility of our constructions. We repeat: the whole of our curvilinear perspective being based on approximate values (even in its conception), we see no inconvenience in proceeding in this way, all the less because in other respects we have executed our diagrams with the greatest possible exactness. Besides, our system involves essentially a method of representation whereby the rigor of reasoning includes recognition of the approximate value of all solutions.

When two thick lines cross, their point of intersection is found at the center of their area of superposition.

7

CONSTRUCTION OF STRAIGHT LINES

FRONTAL STRAIGHT LINES

We will continue provisionally to assume a horizontal line of sight. Later we will grapple with the problems of perspective that arise when the line of sight is directed up or down, corresponding to worm's-eye or bird's-eye views. In examining our ordinary perception, we find that lines on the frontal plane appear frequently. Every time we observe something, the best position is to face it; thus in viewing the plane of the object perpendicularly, we look at a window as a frontal plane.

HORIZONTAL LINES—The most significant of these straight lines is the horizon. We know that it is projected on the hemisphere as a half-great-circle, which corresponds to the equator of the globe, cutting it in two. Because it passes through the center of the hemispheric surface, this arc is transformed on the plane surface into a straight line, a diameter of the perimeter of the image, as the transformation implies. This diameter is naturally identified with the horizontal diameter representing the plane of the horizon. It therefore contains all of the real horizontals that are found at the height of the eye.

The frontal horizontals located above or below the horizon are represented on the hemisphere by great-circle arcs that

meet at the hemisphere's edge at the ends of the equator-horizon. These lines do not pass through the center; therefore they are transformed into curves that are nearly arcs of circles, which we represent as such. In the drawing these circular arcs end at the extremities of the horizontal diameter (the horizon), which will serve them as a chord. We can thus say that frontal horizontals have two vanishing points located at the ends of the horizon line.

Three points are necessary to define an arc of a circle. We know two of them, the vanishing points. Any point on a real straight line becomes the third. Its position on the drawing is determined by the laws of projection. It is nevertheless preferable for practical reasons to select this point at a spot where the real straight line intersects the vertical plane of sight—that is, at the spot where it is closest to the viewer. As a consequence on the drawing this third point will be situated on the vertical diameter. Its position on that line will be defined by the angular distance between the real straight line and the plane of the horizon.

Let us return to the example of the wall. Its top edge is found, for the observer, 40° above the horizon and in the direction of his line of sight. On the hemisphere it is thus represented by a great-circle arc intersecting the reference meridian 40° above the equator-horizon. We also know that in the transformation the distance from any point to the center of the projection is equal or directly proportional to the length of the arc that separates this same point on the hemisphere from the center of its surface.

To simplify the calculations, let us draw a circle 180 mm in diameter. It follows that in terms of radial dimensions, 1° of real space corresponds to 1° of arc on the hemisphere and to 1 mm on the plane drawing. Thus the point that we have selected on the top of the wall will be located, on the vertical diameter of the picture, 40 mm above its center. We therefore have at our disposal the three points necessary to construct the arc representing the top edge of the wall.

To draw the base of the wall, we proceed in the same way. We know that it was on the vertical plane of sight 27° from the horizon. Thus on the drawing the corresponding point should be placed 27 mm below the center, on the vertical diameter. In the end, the wall is represented by two arcs 67 mm at the maximum from each other which meet at the extreme ends of the horizon. It is obvious that the wall is thus represented as infinitely long (fig. 23).

CONCLUSION—In order to draw a frontal horizontal line, all one must know is the angular distance separating the horizon from this line where it cuts the vertical plane of sight. This angular value is then translated into a linear measurement along the vertical diameter measuring from the center of the image. It marks the characteristic point of this frontal

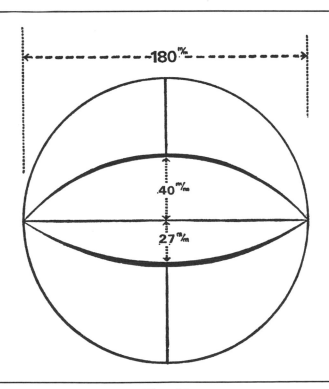

Fig. 23.

horizontal line, which, together with the two vanishing points, permits us to draw the corresponding circular arc.

VERTICAL LINES—The vertical lines situated at right or left of the vertical plane of sight are depicted on the hemisphere as great-circle arcs meeting at the two extremities of the central meridian, just as the terrestrial globe's meridians meet at the north and south poles. These lines are transformed into circular arcs that end at the extremities of the vertical diameter (the vertical plane of sight). It is clear that the problem of drawing these arcs is resolved in the same manner as in the case of the horizontals analyzed above. Vertical lines also have two vanishing points, opposite each other at their upper and lower ends. The third point permitting us to draw a vertical line is determined by its lateral distance from the central vertical plane, at the level of the horizon.

Let us go back to the example of the tower. Its vertical edges were at eye level, 34° to the right and left of the central vertical plane. It is necessary only to carry this measurement to each side of the center of the drawing, as in the preceding case, but this time along the horizontal diameter (the horizon) in order to locate the distinctive points of the two verticals. Once the two arcs have been drawn, one obtains the drawing of the tower, which is imagined infinitely large, extending both above and below the horizon (fig. 24).

CONCLUSION: In order to draw a vertical, all we need to know is the angular distance between this line and the central vertical plane at the horizon. This measurement from the center of the circle along the horizontal diameter (the horizon) permits us to locate the characteristic point of this particular line. The corresponding arc is based on this point and the two vanishing points.

Consequently the drawing of verticals and horizontals of infinite length on the frontal plane is extremely simple in curvilinear perspective. Note that the angular distance that serves to define the characteristic point of each line measures angular divergence from the principal line of sight, which is

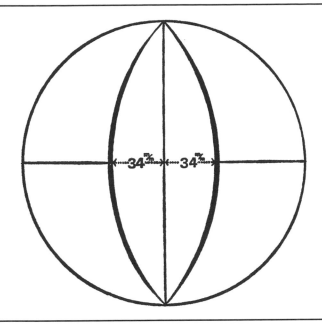

Fig. 24.

the central axis of the total visual field and which corresponds in the drawing to the center of the circular picture.

EXAMPLES: We have taken as prime examples the wall and the tower, where the angular coordinates were known. In order to understand fully how one can calculate in a simple way the angular distance that characterizes frontal horizontals and verticals, we are going to select examples of these straight lines where only the real linear coordinates, relative to the observer, will be known. Let us first agree in the beginning that the observer's eye is 1.5 m above the ground, which defines the height of the horizontal plane. Let us consider a frontal horizontal located 2 m in front of the plane of the observer's eye and 4 m above the plane of the horizon. The angle to be measured is bounded by the plane of the horizon and the straight line that leads from the observer's eye to the observed horizontal line, in the central vertical plane. There are two methods of determining this angle:

First, by trigonometry: the height, 4 m, can serve to calculate the tangent of the angle—that is, $4/2 = 2$; the angle is equal in round numbers to 63°.

Second, using a diagram and a protractor. It suffices to trace a very simple diagram, viewed in profile, representing the observer's position relative to this same straight line, naturally following the proportions of the given dimensions. By placing a protractor on the diagram and by making its center coincide with the point representing the observer's eye, we directly read the value of the angle (fig. 25).

Let us consider another example. A frontal horizontal line is located 10 m from the plane of the observer and 1 m above the horizon. The tangent of the angle is $1/10 = 0.1$; thus a 6° angle. The protractor applied to the profile diagram confirms this result. We then have two lines on the frontal plane, one appearing 63° above the horizon and the other 6° above it (fig. 26).

Let us take again a circle of 180 mm with its two reference diameters. It is necessary to put only two points on the vertical diameter, one 6 mm and the other 63 mm above the center of the circle in order, with the help of the two vanishing points, to trace the two arcs representing the two straight lines (fig. 27).

Let us now look at three frontal horizontals drawn on the ground, respectively 1.5, 3, and 4.5 m from the plane of the observer. All three are consequently 1.5 m below the plane of the horizon. The tangent of the characteristic angle of the first is $1.5/1.5 = 1$; the tangent of the angle of the second is $1.5/3 = 0.5$, and that of the third, $1.5/4.5 = 0.33$. These three lines thus appear to the observer 45°, 26°, and 19° below the horizon, respectively. A single diagram, viewed in profile, permits the rapid construction of the three angles (fig. 28). In the drawing the three horizontals, placed at equal intervals in real space, will be represented by three arcs intersecting the vertical diameter 45 mm, 26 mm, and 19 mm below the center of the circle (fig. 29). One can see by these

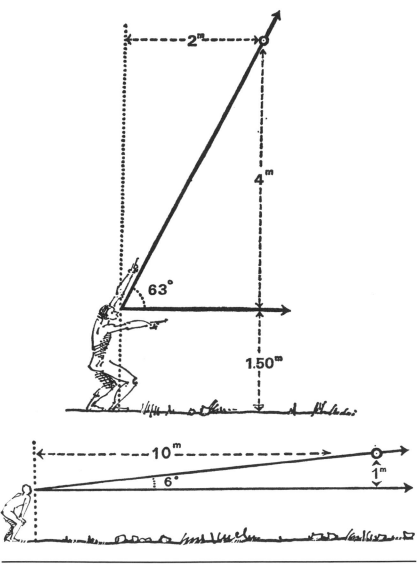

2ᵐ

4ᵐ

63°

1.50ᵐ

10ᵐ

6°

1ᵐ

Figs. 25, 26.

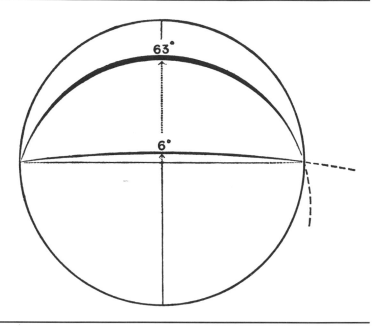

Fig. 27.

examples that if the trigonometric calculations are elementary, the use of a protractor on the diagrams is even simpler.

To draw verticals, the trigonometric procedures and the diagrams are exactly the same. Imagine a vertical line located 200 m from the plane of the observer and 126 m to the right of the vertical meridian plane. The diagram this time must be drawn as if viewed from above. The characteristic angle, either measured or calculated, is equal to 32° (tan = 126/200 = 0.63). In the drawing the corresponding point thus will be placed on the horizontal diameter 32 mm to the right of center (fig. 30).

Consider now five verticals, all situated 10 m in front of the observer. The first is 2 m to the left; the second is on the vertical plane of the line of sight; the third, 2 m to the right; the fourth, 4 m; and the fifth, 6 m to the right. With the aid of a single diagram, viewed from above, one can note the five

CONSTRUCTION OF STRAIGHT LINES

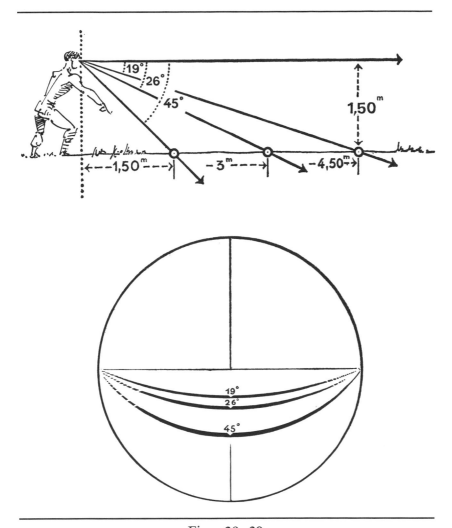

Figs. 28, 29.

angles, respectively 11°20′, 0°, 11°20′, 22°, and 31° (fig. 31). The arcs representing these verticals will intersect the horizon at distances from the center that are proportional to these angles. The second vertical on the vertical plane of sight coincides with the vertical diameter. Notice that in the drawing the arcs are not regularly spaced, although they represent

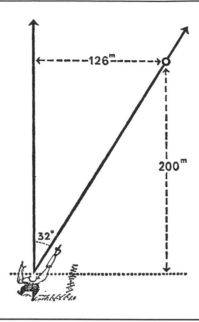

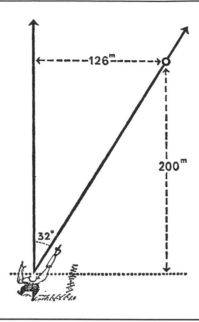

Fig. 30.

straight lines that are equidistant on the real frontal plane. In classical perspective this equidistance would have been preserved. However, the verticals that are most distant laterally must in reality appear less divergent because, being farther away, their spacing is perceived obliquely (fig. 32).

FRONTAL HORIZONTAL AND VERTICAL LINE SEGMENTS

Given a frontal line segment having a finite length, the circular arc representing it obviously cannot end at the perimeter of the picture. Consequently we will be forced to calculate the coordinates of each end of the line segment. The simplest procedure consists first of tracing the complete arc and then cutting it at two places that function as the extremities of the real line segment. We will see that in practice this procedure is valid for all types of straight lines.

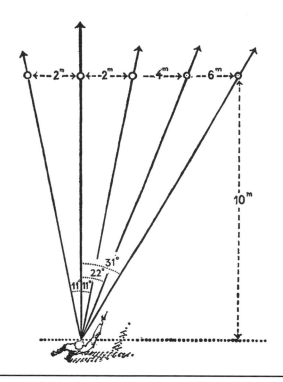

Figs. 31, 32.

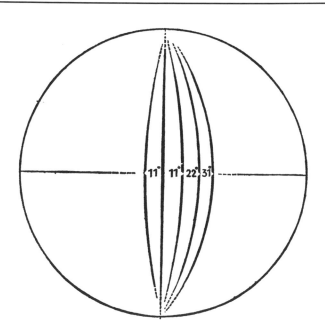

THE SQUARE FACADE— In this example the contour of the square is bounded by the superposition of the tracing of the wall and the tracing of the tower. It is thus composed of four line segments that will be transformed into four arcs. In examining the drawing of the facade closely, one can understand how easy it is to determine on a complete circular arc a segment corresponding to the precise values of real space. Let us look at the top edge of the square facade. A single angular measurement will suffice for drawing the complete arc within which it is inscribed: 40°. The right end of the top edge is bounded by its intersection with the complete arc that represents the right-hand contour of the tower; only one angular value is needed to draw this arc: 34°. In the same way the left end is determined by the left edge of the tower, whose arc, there also, has been constructed by means of a single angle. Therefore the arc that represents a line segment, the top edge of the facade, has been constructed from only three angular measurements (fig. 33).

CONCLUSION: To draw a frontal horizontal line of definite length, it is necessary only to know the angular values of:

(a) the distance of the line carrying this segment from the plane of the horizon;

(b) the distance from the vertical plane of sight of each of the verticals that one can draw through its extremities.

In the same way, to make a drawing of a vertical segment, one must know the angular values of:

(a) the distance between this line and the central vertical plane of sight;

(b) the distance between the plane of the horizon and each of the horizontals that can be drawn through the ends of the vertical segment.

EXAMPLES: Consider a horizontal line segment on the frontal plane situated 6 m from the plane of the observer and

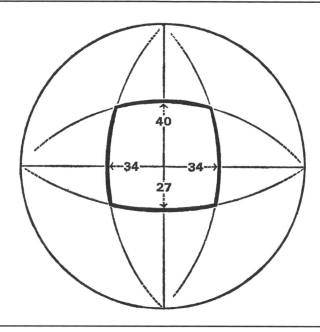

Fig. 33.

3 m above the plane of the horizon. This segment has a length of 4 m and its left end is 2 m to the right of the central vertical plane of sight. It is necessary to draw two diagrams in order to describe completely the respective locations of the straight line and of the observer. The first is a profile view; it permits us to define the apparent height of this line above the horizon; we will call the corresponding angle A, and it is equal to 27° (fig. 34). The second diagram is viewed from above; the line segment is represented here in its actual length, all proportions being retained. It permits us to measure the angular distance, at the height of the horizon and relative to the central vertical plane, between the two verticals that can be drawn through the ends of the line segment. We will call these angles B and C; they are respectively 18° and 45° (fig. 35).

In the diagram one first draws the complete horizontal cir-

Fig. 34.

Fig. 35.

cular arc that contains the prescribed segment. It naturally passes at the linear equivalent of 27° above the center of the circle. Then one traces the two vertical arcs that cut the horizon at 18° and 45° from the center of the drawing.

The frontal horizontal line that we have taken as an exam-

CONSTRUCTION OF STRAIGHT LINES

ple is represented by one part of the horizontal arc, the length and position of which are determined by the interval that separates the two vertical arcs. Thus it has indeed required three angular measurements to make the diagram of a line segment the length and position of which were strictly defined (fig. 36).

Imagine now another segment of the same length as the first and placed exactly above it, 10 m from the plane of the horizon. The two verticals that define the length and position of this line are obviously the same verticals as those that define the first. From a diagram viewed in profile, we ascertain a new value for angle A: 59°. This angle permits us to draw a complete horizontal circular arc on which the two vertical arcs intercept a portion that represents the new horizontal line. Notice that the latter is represented by a shorter arc than that which represented the preceding line. This shortening is

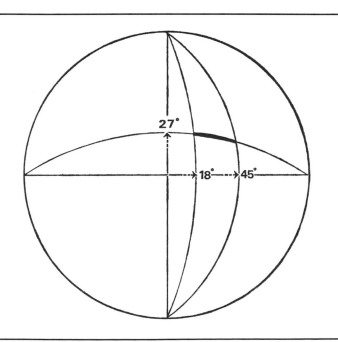

Fig. 36.

logical, for the second horizontal, although the same length as the first, is perceived as shorter because it is farther from the observer's eye.

To conclude, let us return to the example of this horizontal line 4 m long that we will place 3 m above the horizon as we did before but whose left end this time will be located 12 m to the right of the central vertical plane of sight. The complete horizontal circular arc that will contain this new segment will, of course, be the same as in the first case. A diagram viewed from above will allow us to define the new lateral position. Angle B equals 64° and angle C equals 69°. Note that the two vertical arcs that limit the length of the segment are separated at the level of the horizon by an interval of 5°, whereas in the first case they were separated by an interval of 26°30'. It follows that this third line is much shorter than the other two, although representing the same real length. Here again this size difference is justified by the apparent shortening of the real line that is farther from the observer than before and is simultaneously perceived more obliquely (fig. 37).

These three examples, based on the same segment of the frontal plane, varying only in their position on that plane, have had the purpose of familiarizing us with the manipulation of curvilinear perspective but also of making immediately visible the essential differences that distinguish it from classical perspective. In that system the horizontal line 4 m long would have been represented by a straight line the length of which as drawn would have been identical, whatever its position, as we have been careful to move it within the same frontal plane. In curvilinear perspective, however, a given real length, moved within the same frontal plane, is given variable lengths in the drawing depending on its distance from the observer. Notice, besides, that the horizontal line of our three examples tended to approach the vertical diameter as it rose (second example), while it tended to approach the horizontal diameter as it moved laterally away from the

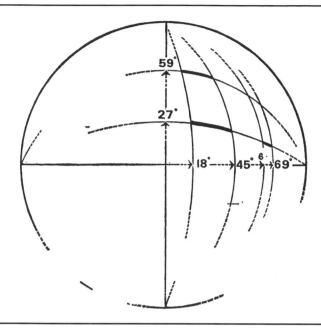

Fig. 37.

central vertical reference (third example). These phenomena are easily confirmed by direct observation.

FRONTAL OBLIQUES

Our understanding of space is formed from the earth as we easily move over its surface. Whatever we find there is intimately bound to our existence. People and things there can be touched, walked around, measured. Up to the height of a person, on all planes parallel to the ground, one can place a ruler, a meterstick, or a surveyor's chain. The ideal ground is a perfectly horizontal plane upon which gravity presses us.

Verticality already has another meaning, but it is quite simple—it has a direction that implies equilibrium. Whatever is standing or piled up must have a vertical axis. This is why our measurements and our constructions are articulated ver-

tically and horizontally. These directions are obvious evidence experienced by the artist; they do not need to be defined. Conversely, an oblique line is ambiguous; it leans on or is supported by something else; it suggests tension or pressure.

If we consider an oblique straight line on the frontal plane, we run into a special difficulty: how to define its slope (i.e., the way it is perceived) and how to project it in our drawing. The difficulty derives from the fact that the apparent inclination of a frontal oblique is modified when this line is shifted laterally or up or down. But frontal horizontal lines, for example, placed above or below the horizon, also incline when we move them laterally. Nevertheless these lines are easily drawn because we know that the arcs that represent them are articulated around the horizontal diameter that represents the horizon. The same is true of verticals the circular arcs of which are articulated in reference to the vertical diameter. It follows that in order to draw an arc easily that contains a frontal oblique, it is first necessary to draw the diameter at the ends of which this arc will terminate.

By definition, all diameters represent straight lines or planes [perpendicular to the frontal plane] that intersect the observer's line of sight. The diameter we are looking for thus will represent a frontal oblique, parallel to the oblique line that we are observing, which will intersect our line of sight. We will call this line the directional diameter. It goes without saying that the directional diameter of verticals in the drawing is the vertical diameter, whereas that of the frontal horizontals is represented by the horizontal diameter.

CONCLUSION: To draw a circular arc that contains a line oblique on the frontal plane, we must first determine the inclination of the directional diameter. Then the angular distance between the oblique line and the line of sight must be measured either on the horizontal or the vertical plane. This last measurement permits the artist to locate the third point that is necessary for the construction of the arc.

EXAMPLE: Consider now a frontal oblique of definite length for which one knows only the position of the extremities and which is located above the horizontal plane and to the right of the central vertical plane. The frontal plane that contains it is 10 m in front of the viewer. Its higher end is 7 m above the horizon and 2 m from the central vertical plane; its lower end is 3 m above the horizon and 5 m from the central vertical plane. Note that it does not cross either the horizon or the central vertical plane. To find the inclination of the directional diameter, it is necessary to draw a diagram of a frontal view and to extend the particular oblique line as far as the horizon. The angle, measured or calculated, is 53° (fig. 38).

Below the first diagram one draws a second, viewed from above, from which three angles are measured:

First: Angle A defines the lateral distance from the center to the intersection of the extended oblique with the horizon plane. It is equal to 36°. This angle permits us to place on the diagram's horizon line a point from which will be drawn the arc ending at the extremities of the directional diameter.

Second: Angle B, 27°, defines the lateral distance on the plane of the horizon between the line of sight and the vertical passing through the lower end of the oblique line, to the right of the line of sight.

Third: Angle C, 12°, which in the same way defines the distance from the line of sight of the vertical drawn through the upper end of the oblique line (fig. 39).

In the drawing two vertical arcs are drawn through the points corresponding to B and C. The oblique segment that we see is represented in the end by the portion of the oblique arc that is defined by the interval separating these two vertical arcs (fig. 40). For an oblique line segment with an inclination that is nearly vertical, it would be more convenient to have

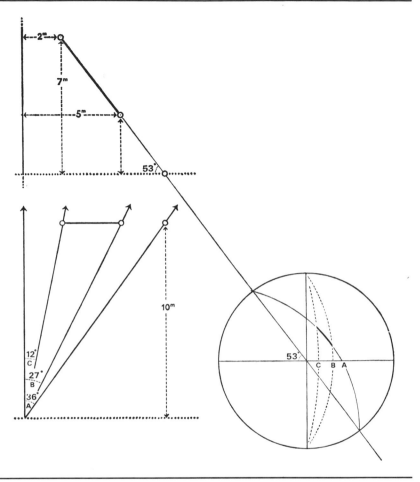

Figs. 38, 39, 40.

two horizontals define its extremities. The circular arc representing this oblique line would thus be limited by the interval between two horizontal arcs.

CENTRAL RECEDING LINES (ORTHOGONALS)

Although in curvilinear perspective all straight lines eventually recede, inasmuch as two parallel frontal lines converge

CONSTRUCTION OF STRAIGHT LINES

at two opposite vanishing points, in order to preserve the vocabulary of classical perspective we have agreed to call "receding lines" only those straight lines that are not contained in the frontal plane.

As opposed to the straight lines of the frontal plane that are perpendicular to our line of sight, the most typical receding lines are those that are parallel to it; they are consequently horizontals, the central receding lines, also known as orthogonals.

Naturally we have a particularly profound experience of the perception of these lines. The universe that we have created, the city, is essentially composed of rectangular elements, parallel and perpendicular straight lines. We travel along these elements following their direction. Along sidewalks, streets, and the facades of buildings we are channeled by the geometry of our structures. As for movement, we look ahead, parallel to the plane of obstacles the edges of which we see recede toward the precise point on the horizon to which we are going. We can, of course, cross the street diagonally, but then we disrupt the reassuring order of constructed objects. When the street turns or when we come upon a different view, we are obliged to adopt the image of a different milieu. We change our point of view and perceive a different perspective. The central receding lines are thus particularly important, whatever drawing system has been adopted. When they are represented, they indicate in what direction the observer is looking.

We have seen that on the hemisphere the central receding lines were projected as quarter-great-circles ending at the center of its surface, thus at the point of their intersection with the line of sight. In curvilinear perspective these lines are transformed into straight lines terminating at the center of the circular picture. Therefore they become radii when they are infinitely long. In observing the diagram (fig. 41), which represents a certain number of orthogonal receding lines located above and below the horizon and to the right

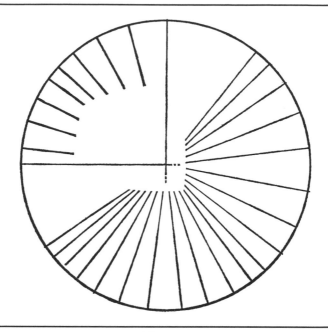

Fig. 41.

and left of the central vertical diameter, one will easily understand that the lines are characterized uniquely by the direction and amount of their inclination on the drawing. Inasmuch as they are parallel in real space to the direction of our line of sight, it may seem that their apparent obliqueness is more difficult to define than that of frontal obliques. One of the points necessary for the construction of these straight lines is already known, however: the vanishing point at the center of the diagram. In determining the other point's position, at the picture's perimeter, we will at the same time determine the angles of inclination of the drawn line. The method that permits us to define the position of this last point is particularly important, for we will see later that it also applies to the drawing of inclined or oblique receding lines, that it is the origin of the principle of the grid, and that it even makes possible the placement of frontal straight lines.

To locate the point at which a quarter-great-circle touches the edge of the hemisphere, it is necessary to imagine the hemisphere's face plane as the observer's plane. All central receding lines, if they are extended, intersect this plane. It is sufficient then to draw one line from this point of intersection to the center of the complete sphere (the observer's eye) to obtain the projection of the point on the edge of the hemisphere (fig. 42).

Now the transformation implies that the location of any point on the boundary of the hemisphere is the same on the

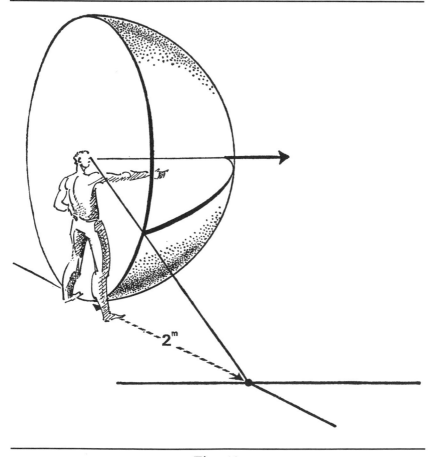

Fig. 42.

perimeter of the circle that represents this transformed hemi-sphere. The diagram used to determine the location of this point on the boundary of the hemisphere can therefore be employed directly to locate it on the picture's perimeter. Let us take a specific example: an observer whose eyes are 1.6 m above the ground. On the ground a central receding line passes 2 m to the right of the central vertical plane of sight. The radius of the circular diagram is considered equivalent to the height of the eyes of the observer. Below the circle is drawn a horizontal tangent representing the ground. At the equivalent of 2 m to the right of the vertical diameter, a point is placed that represents the receding line viewed "on end." If from this point we draw a line passing through the center of the picture, at its intersection with the perimeter we obtain the starting point for the projected central receding line. Inasmuch as this is itself a straight line terminating at the center of the diagram, the real receding line is ultimately represented by the segment of the line that we have drawn, which is bounded by the center and the perimeter of the picture. It is represented by a radius that is oriented by the characteristic point, located on the perimeter (fig. 43).

We could see that in this example the circular picture representing the total field of vision was directly integrated in the descriptive diagram that permitted us to measure the angle of inclination characterizing the central receding line that we were observing. In other words, it was not necessary either to plot or to calculate this angle. We are going to see that it is always possible in this way to construct all receding lines. In order to understand the logic of this procedure fully, it is useful to represent the circular diagram as if it were the diametric plane of a hemisphere that is perpendicular to the observer's line of sight. By means of straight lines drawn from the generating center of this hemisphere (the observer's eye) to various points in real space, those points are projected onto the surface of the hemisphere. Then the

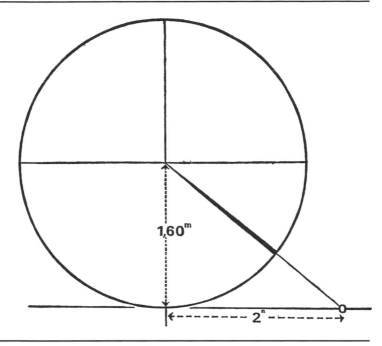

Fig. 43.

hemispheric drawing is transferred to the diametric plane, the circle of the picture (fig. 42).

EXAMPLE: The observer is looking down a street and would like to draw the edges of sidewalks and facades of buildings that border the street. Let us assume that these structures are uniform as they extend to infinity. The street is 8 m wide; the sidewalks, 2 m wide. The facades on the right are 10 m high; those on the left, 13 m high. The observer stands 4 m from the building on the left, his eyes 1.5 m above the ground.

To make the drawing it is necessary only to sketch a diagram representing in cross-section the buildings and the street, then to locate in this diagram the position of the observer's eye. This point will thus serve as the center of the picture. The diameter of the picture can be of any size, but

it would be preferable, to avoid confusion, for the lines of the diagram not to extend into the circular picture. Still, this precaution may, as in our example, involve a large diagram and a small circle; therefore it cannot always be observed. Next we will show two types of descriptive diagram: exterior and interior. In drawing lines connecting the center of the drawing to each point representing an edge seen on end, we obtain, through the intersection of these lines with the picture's perimeter, the points of departure of the lines representing each of these edges. Inasmuch as these lines end at the center of the drawing, as they are central receding lines, they are in fact identical to the connecting lines, but they are either confined within or continued into the interior of the circle. In other words, to draw the six radii representing six real edges, it was necessary only to draw line segments from six points on the diagram to the center of the circle (figs. 44 and 45).

This very simple procedure requires no calculation. One might nevertheless object that the diagram would be difficult to draw if we considered merely an ensemble of receding lines, some of them very distant laterally from the observer's eye, in relation to others. Later we will see that the grid procedure permits us to overcome this difficulty. For the moment we might have recourse to elementary trigonometry.

Suppose the facade on the right is no longer 8 m from the observer but 1,000 m from him. To draw the roof line one must know only the inclination of the line that represents it, tan $= 8.5/1000 = .0085 = 0°30'$. Thus the straight line representing this edge will form an angle of a half-degree with the horizon line. Let meticulous artists draw this angle and let purists construct that line according to classical perspective.

CONCLUSION: Central receding lines are represented by line segments ending at the center of the circular picture. They are constructed directly from the diagram that sur-

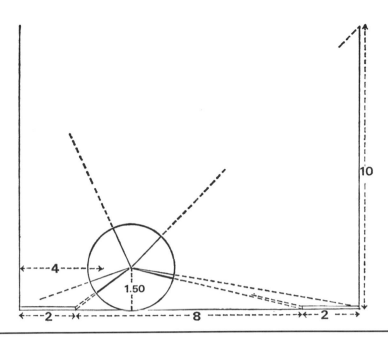

Figs. 44, 45.

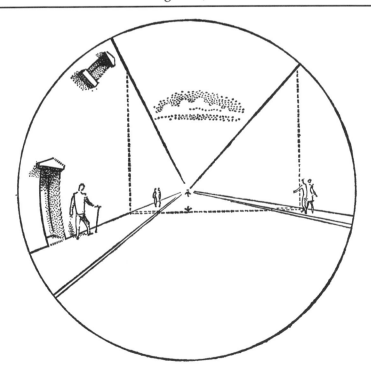

rounds this circle; they should be conceived in such a way that the real receding lines may be seen on end.

LATERAL RECEDING LINES

We have seen that the edges of facades, sidewalks, and so on situated in a straight street were perceived as central receding lines, as long as our line of sight was oriented along the street. If we pivot to put our line of sight at a certain angle on the plane of the horizon—that is, if we view the street obliquely—that implies that the imaginary hemisphere that accompanies the line of sight as it moves also pivots around a vertical axis. Thus as we have already seen, on this hemisphere the vanishing point for the edges which had been central will now slide along the equator-horizon in the direction opposite to that of our movement at an angle equivalent to the angle of our pivoting. At this moment in the drawing the central receding lines of the street become lateral receding lines and their vanishing point, while still on the horizon line, moves proportionally away from the center of the circle. At the extreme limit, when our line of sight has pivoted a quarter of a revolution, the vanishing point reaches the perimeter, while another vanishing point appears opposite the first. The receding lines of the street have then become frontal straight lines, as we now look perpendicularly at the plane of the facades.

One can conclude from these observations that the lateral receding lines have their vanishing point on the horizon at a distance from the center directly proportional to the angle formed in reality with the line of sight. In this connection there is reason to observe that because lateral receding lines have their vanishing point at some distance from the center of the circle, all (except one) of the lines that will represent them cannot intersect the center and that, consequently, they will be represented by arcs of circles. Now we know that when the arcs of the drawing are extended, they always terminate in two opposite points on the perimeter, thus always

at the ends of a diameter. Therefore to draw an infinitely long lateral receding line, it is enough to know its vanishing point and its point of departure on the perimeter; the third point necessary to the construction of the arc is always found opposite the second.

EXAMPLE: Consider a straight line on the ground forming an angle of 45° with the vertical plane of sight of the observer. Let us agree that his eyes are 1.6 m above the ground and that the line intersects the plane of the observer 4 m to his right. We will draw the circular picture with a radius that corresponds to 1.6 m. At the bottom of the circle we will draw a tangent to it perpendicular to the vertical diameter. On this ground line we will then place at the right a point situated at a distance from the vertical diameter equivalent to 4 m, taking as a basis here the length of the radius. In drawing from this point a straight line that crosses into the circle and passes through its center we obtain the starting point of the lateral receding line at the first intersection with the perimeter and at the second, the terminus of the complete circular arc that will contain the receding line. Only the vanishing point is missing. Because the straight line forms a 45° angle with the vertical plane of sight, and because it is horizontal, the vanishing point should be located on the horizon line at a distance from the center equivalent to 45°—that is, at one-quarter of a diameter to the left of center. Proceeding as indicated by the sketch in figure 46, one easily finds the radius and the center of the complete circular arc that contains the lateral receding line.

We return to the example of the street used in the preceding chapter, assuming here that the observer is always at the same spot but that this time he perceives his subject obliquely, his line of sight having pivoted 30° to the right. A view from above allows us to set up the new values for the lateral distance of the receding lines from the plane of the observer. From this sketch we can construct a diagram around the circular picture viewed frontally, which will permit us to

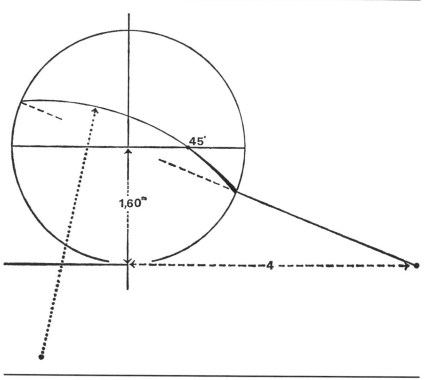

Fig. 46.

locate on the perimeter the starting points of the various receding lines and therefore the end points of the arcs. Because the observer has turned 30° to the right, the vanishing point of all of these receding lines should be found on the horizon line, at an equivalent distance to the left of center. The comparison between the two drawings representing the same street seen from different angles is particularly significant. Naturally, in the first example all of the central receding lines are represented by straight lines because they terminate at the center of the circle, whereas in the second, all (lateral) receding lines are represented by circular arcs, as they do not intersect this center (fig. 47).

CONSTRUCTION OF STRAIGHT LINES

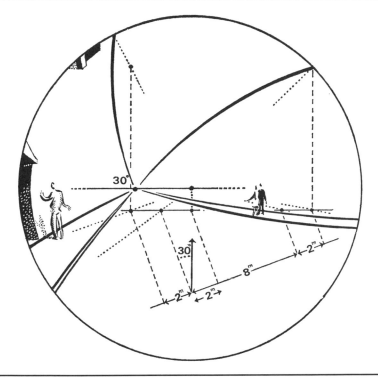

Fig. 47.

INCLINED RECEDING LINES

We call straight lines that are parallel to the vertical plane of
sight but are oblique relative to the horizon plane *inclined
receding lines.* If, in considering central receding lines, we
incline our line of sight downward, or if we raise it upward,
the vanishing point of these lines will slide along the central
meridian toward either the north or south pole of the hemi-
sphere. Raising or lowering the line of sight when looking at
horizontal lines is the same, of course, as looking at straight
lines that ascend or descend relative to a horizontal line of
sight. Therefore the vanishing point for lines oblique to the
plane of the horizon but parallel to the vertical plane of sight

is located on the vertical diameter of the circle at a distance from the center proportional to their inclination. The construction mechanism for these lines is the same as that used for lateral receding lines except for their orientation.

Let us take the example of an indefinitely high ladder, with the two parallel uprights spaced 50 cm apart. Let us assume that the observer leans the ladder against a tree. At the height of the horizon, the inclined plane of the ladder is 70 cm from his eyes, which are 1.6 m above the ground, and the upright legs rest on the intersection of the ground with the plane of the observer. A profile view permits us to note that the ladder's angle of inclination is 66° (fig. 48). At the base of the frontal sketch, which includes the circular picture, we see on the ground line two points that indicate the distance between the ladder's uprights, on each side of the vertical plumb. From these points two straight lines drawn toward the center of the picture permit us to locate the points of departure of the uprights on the perimeter and the termination of the complete arcs near the top (fig. 49).

Once the uprights of the ladder are drawn one can determine, starting from the bottom, that they diverge more and more until they reach a maximum separation a little below the horizon, at exactly 23°30', in order then to converge progressively until they meet at a vanishing point 66° above the horizon. This unusual representation of the legs of a ladder may be surprising, but in the end it demonstrates well the logic of curvilinear perspective and its capacity to explain the essential laws of form perception—that is, decreasing the given dimensions depending on their distance in whatever direction.

On the ground the ends of the ladder's legs situated 1.6 m below the observer's eyes are perceived by him at a certain angle. As he gradually looks up, the legs necessarily appear more distant from each other because the observed portion is approaching his eyes; the maximum apparent separation is

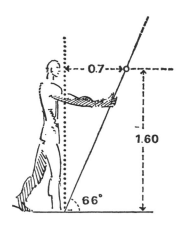

Figs. 48, 49.

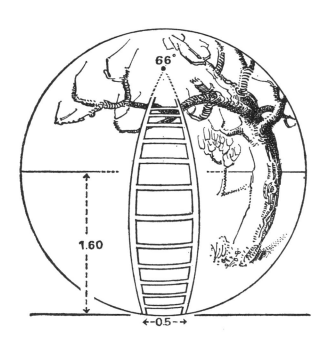

at the point closest to his eyes where one can draw a perpendicular from his eyes to the plane of the ladder.

In continuing the upward movement, the legs seem to approach each other and then to converge at infinity as the observed part recedes. If the ladder were vertical, the maximum apparent separation would occur at the height of the horizon. Note that this sketch of the ladder's legs, which takes into account rather subtle perceptual modifications, has been constructed from a very simple schematic description.

IRREGULAR RECEDING LINES

All the straight lines that we have studied until now have been parallel or perpendicular to at least one plane of the trihedral coordinate system of our customary space. Thus a single angle sufficed to define their obliqueness and consequently to locate their vanishing point. Conversely, the receding lines that we are about to study are irregular; that is, they do not fit any of the three privileged directions of Euclidean space. They are at the same time inclined and also oriented laterally. It follows that, by definition, the vanishing point of these other oblique lines will be found neither on the horizon nor on the vertical diameter nor on the perimeter of the circle. The drawing of these straight lines presents the greatest difficulties, but there would be no less difficulty if they were drawn in classical perspective. There are two methods that permit us to locate the vanishing point of these lines. The choice of one of these depends on the manner in which the coordinates of the real line are established.

Let us assume that we know the respective locations of two points on an irregular straight line. The first point will be found 2 m in front of the observer's plane, 7 m to the right of the vertical plane of sight and 1.5 m below the horizon. The second is 10 m from the observer's plane, 4 m to the right of the vertical plane of sight, and 3.5 m above the horizon. From these two well-determined points we must define the slope of the line and at the same time locate its

vanishing point. Because this type of line is both laterally oriented and inclined, its obliqueness must be expressed by two distinct angles. In fact, we can consider that the irregular line can be inscribed both within a vertical plane oriented laterally and also within an inclined plane whose intersection with the ground is frontal. The set of vanishing points of the straight lines in an irregular plane forms the plane's "vanishing line," its limit.

It is easy to see that all straight lines that are contained in the first (vertical) plane have their vanishing point on a vertical line with an angular divergence that is a function of the angle this plane makes with the vertical plane of sight. In the drawings this vertical line will be represented by an arc with its angular distance from the center of the picture at the level of the horizon equal to the angle just described.

Likewise, it is obvious that all straight lines that can be inscribed within the second (inclined) plane have their vanishing point on a horizontal line that will be represented in the drawing by a horizontal arc. Its angular distance from the picture's center along the vertical diameter will be equivalent to the angle formed between the inclined plane and the plane of the horizon.

Because the oblique line that we are studying is inscribed in both planes, its vanishing point will be located in the drawing at the intersection of the two arcs corresponding to the planes' vanishing lines. With the aid of a sketch of a view from above, one can note that the angle between the first plane and the vertical plane of sight is 21°. Then a profile sketch enables us to see that the angle between the inclined plane and the plane of the horizon is 32° (fig. 50). It is now sufficient to draw only a vertical arc and a horizontal arc on the picture using these angles. Their intersection defines the position of the vanishing point we seek. This first method for locating the vanishing point of an irregular oblique line in fact amounts to performing a double orthogonal projection of that line on a vertical plane as well as on a horizontal plane,

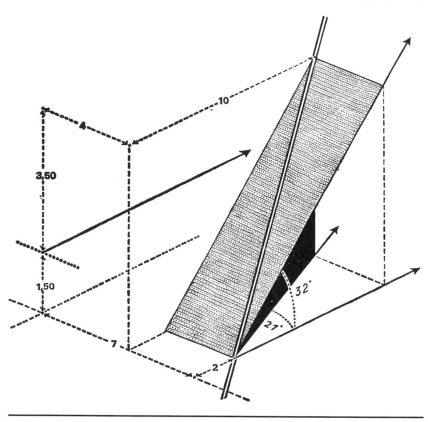

Fig. 50.

then combining the two orientations that follow from it (fig. 51).

The second method is employed when one knows the inclination of the oblique line relative to the horizon plane and its orientation relative to a reference direction—for us, the direction of the line of sight. It must be noted that the angle that the oblique line forms with the ground is different from the angle of the inclined plane that we used in the last example. These two inclinations would have been identical if this oblique line had been parallel to the vertical plane of

Fig. 51.

sight, but then it would have lost its character as an irregular oblique.

Take the example of a stairway that has an inclination of 30°, whatever its orientation. Similarly, a road can have a 15° grade, whatever its direction in other respects. Consequently the vanishing point of an irregular oblique line, when its inclination relative to the horizon plane is known, must be found on a line that represents a constant height above the horizon. On the hemisphere such a line is at a constant distance from the equator-horizon. One understands, of course, that the parallels of the terrestrial globe satisfy these conditions. Thus the vanishing point of any irregular receding line whose inclination relative to the horizon plane is known must be on the transformation of a parallel of cartography. The position of the line that represents this parallel relative to the horizon is clearly a function of the angle of inclination

of the particular oblique line. This angle corresponds to geographic latitude.

In the transformation of Postel, geographic parallels become curves that are very nearly circular arcs. As we have done for other curves representing straight lines, we will overlook the slight difference in curvature and will draw circular arcs. The parallels above the horizon are concave whereas those below the horizon are convex.[1] In the same region of the circle, their curvature is thus the inverse of that of frontal horizontals. In the particular case concerning us at the moment, it would have been more logical if the line representing a constant height above the horizon could have been represented by a straight line parallel to the horizon line. As with all transformation systems, however, the one we are using implies departures from similitude that are translated, among other phenomena, as the curvature of parallels. There are transformation systems that preserve straightness, but they have other inconveniences.

How should we draw the arc representing a constant height above the horizon—that is, a parallel? We know that along the radii of a drawn circle the dimensions are not changed. Thus one can measure proportionally along the vertical diameter the value of the angular distance between the parallel and the horizon, and thus the angular value of the inclination of the particular oblique line. We also know that the angles that subtend arcs of the perimeter, having their vertex at the picture's center, are not altered by the transformation. Consequently all it takes is to draw from each side of the vertical diameter two straight lines forming with the horizon angles equal to that which characterizes their inclination in order to obtain, at their intersection with the picture's perimeter, the position of the two other points necessary for construction of the arc.

Let us return to the irregular oblique line used in discussing

[1]See glossary.

the first method. With the help of a sketch or by calculation, we can see that its inclination relative to the horizon is [approximately] 30°. On the vertical diameter we place a point at the equivalent of 30° from the center of the picture. Then, starting at the center, we trace two straight lines forming two 30° angles with the horizon. At the intersections of these lines with the perimeter are found the terminal points of the circular arc.

When this is drawn it remains to determine the lateral position of the vanishing point, which is a function of the orientation of the real oblique line. Now this orientation has been described in discussing the first method: it corresponds to the direction of the vertical plane that contains the oblique line. We know that this direction is represented in the drawing by a vertical circular arc that is 21° from the center where it cuts the horizon line. The orientation of the oblique line thus defined, it is understood that the vanishing point is finally located at the intersection of the two arcs: the arc of constant height (the parallel) and the vertical arc (the meridian) (fig. 52).

In superimposing the two drawings obtained by these two methods, note that the position of the vanishing point is apparently the same whatever the system employed. Nevertheless a scrupulously careful observer might notice, in making the drawing under the best possible conditions, a slight difference in position between the two results. There again this discrepancy results from the fact that we are transforming into circular arcs curves that actually are not quite arcs of circles.

Fig. 52.

CONSTRUCTION OF STRAIGHT LINES

8

PLANE FIGURES
COMPOSED OF
STRAIGHT LINES

GENERAL CONSIDERATIONS

From the preceding chapters it follows that it is theoretically possible to draw all sorts of figures, even the most complex, as long as they may be broken down into rectilinear elements. If we are limited to the procedures that we have described, it is clear that the sketches and the angular measurements that they imply for each line would make this work tedious. That is why the pages that follow will be devoted to simplifying the described methods. We have already indicated certain shortcuts. We have noted, for example, that in nature very few lines appear in isolation and that in general they were defined and limited either at their extremities or by common intersections. We have also studied lines that are particularly easy to draw—receding lines—because their construction is made from descriptive sketches drawn in the margins of the picture without our having to calculate their angles. It would be convenient to apply this method to frontal straight lines. Curvilinear perspective would thus become a purely graphic system requiring only ruler and compass and demanding of the artist no more than an acquaintance with elementary geometry.

HORIZONTAL SQUARES WITH CENTRAL RECEDING LINES

The square is the simplest and most rational of all plane figures. It is composed of equal dimensions, both parallel and perpendicular. A horizontal square, with two sides parallel to the line of sight, is bounded by two central receding lines and two frontal horizontals. Thus we have studied all the lines involved in its construction.

Assuming that the observer's eyes are 1.5 m from the ground, consider a square 75 cm on each side traced on the ground with its two lateral sides parallel to the line of sight. We will assume, moreover, that the left side of the square is contained within the vertical plane of sight and that the nearest side is found directly below the observer's eyes and is thus contained within the plane of the observer. In order to construct the two lateral sides (central receding lines), it is necessary to trace a ground line tangent to the circular picture. The left side of the square is then obtained from a point at the base of the vertical diameter, and the opposite side is indicated by a point located the equivalent of 75 cm to the right of the vertical diameter (the picture's radius is 1.5 m). Last, the two central receding lines are represented by two radii that pass through the two previously cited points and through the center of the picture, the left receding line coinciding with the vertical diameter. The lateral sides of the square will be segments of these receding lines (fig. 53).

The frontal side nearest the observer, because it is located in his plane, coincides with the arc of the circumference of the picture, limited by the intersections of the central receding lines. Only the farther frontal side remains to be constructed.

If we were to limit ourselves to the methods described in the preceding chapters, we would need to make a profile sketch and to measure an angle in order to draw the horizontal arc containing this side. It is easy to avoid this complica-

Fig. 53.

tion, however, by using one of the diagonals of the square. Consider the diagonal receding from the observer toward the right. Its vanishing point is, of course, found on the horizontal diameter of the picture 45° to the right of center[1] and it will thus be represented by a circular arc. Two points necessary to its construction are still missing. The first is at the intersection of the perimeter with the left side (the corner of the square nearest the observer) and the second is diametrically opposite the first. These two points are thus at the two ends of the vertical diameter. It is clear that when the arc containing the diagonal is drawn, it cuts the right side of the square at the corner farthest from the observer. Naturally, the side remaining to be drawn should also pass through the intersection of these two lines. Because it involves a frontal horizontal, we know the other two points necessary for con-

[1]Thus halfway to the 90° perimeter.—TRANS.

structing the arc (the extremities of the horizontal diameter). Finally, with the help of a single sketch, we will have been able to draw this square without having to calculate a single angle, solely from a very simple geometric construction. It is just as easy to draw the second diagonal: simply put the vanishing point 45° to the left of the center, then project the arc that contains it from the angle formed by the right side of the square and the side closest to the observer.

This method of using a diagonal to construct a square is commonly practiced in classical perspective. On reflection one will see that this use of the diagonal in curvilinear perspective in fact does away with the need to make profile diagrams and to calculate the angles that derive from them. Their purpose was to determine the apparent size and distance of a length placed before the spectator. This same length contained in the observer's plane is put into perspective, as we have seen, by direct geometric construction. Now, in using a line oriented at 45°, we have just discovered that we can represent this same dimension oriented perpendicularly to the first, and that it then appears with the modifications of shape and position implied by its new location. Thus a point of a plane can always be put in perspective by means of an isosceles right triangle with one small side in the observer's plane and with the opposite vertex containing the perspective of the point.

HORIZONTAL, VERTICAL, OR OBLIQUE GRIDS WITH CENTRAL RECEDING LINES

The square that we have just chosen as an example was positioned with respect to the observer to permit the easiest possible construction. Before approaching less favorable examples, we will use this figure as a basic element in the construction of a grid. Why a grid? Because it is a standardized surface. If we know the size of the basic element, we will immediately know the position of any other square and of whatever it contains. As one can always subdivide a given

square into smaller squares, the estimation of detail can be very precise. For the artist such a web of lines easily becomes a very practical standardized structure for positioning various elements of his drawing.

On the ground line of the preceding example, let us carry toward the right a series of points, beginning with the first, regularly spaced the equivalent of 75 cm apart. These points represent the position in the observer's plane of the lateral sides of the squares juxtaposed in the grid. In other words, they represent a series of parallel straight lines viewed on end. From these points let us draw lines to the center of the circle. We thus obtain the perspective of the central receding lines of the grid. They intersect the extended diagonal of the first square. Through each of these intersections one can draw a frontal horizontal, an arc that ends at the two extremities of the horizontal diameter (the horizon line). One thus obtains a grid in perspective that occupies a certain portion of the lower right quarter of the picture. To continue this grid into the left portion, we can extend the line of reference points on that side in order to construct the missing receding lines; or we can draw a diagonal on the left and project the central receding lines through the intersection of this diagonal with the frontal horizontal lines.

This procedure is satisfactory when drawing a grid that does not occupy too large a part of the visual field. Proceeding in this way, however, if we wish to create a very broad scene, we may be led to extend the ground line too far in order to be able to locate a great number of reference points. To avoid too great an extension of the diagram, one can then bring the ground line closer to the center of the picture while still retaining its horizontal orientation. The spacing of the reference points will therefore be reduced proportionally to the line's reduced distance from the center. It follows that without changing the size of the diagram one can develop a much more extended grid.

One can also avoid the extension of the diagram by em-

ploying a second diagonal. Consider again the drawing of the first square divided by a diagonal receding toward the right. Beginning at the point of intersection with the perimeter of the receding line that represents the right edge, let us draw another receding line at a 45° angle which meets the first diagonal at the vanishing point. This line cuts the frontal horizontal that contains the frontal side of the square that is farther from the observer. We can draw a central receding line through this point of intersection. Thus we obtain the drawing of a second square to the right of the first. This last central receding line cuts the first diagonal at a point through which we can draw another frontal horizontal, a process that reveals two new squares behind the first two. As this last horizontal cuts the second diagonal, we can draw another central receding line, and so forth. Continuing, we can construct a grid with an unlimited surface (fig. 54).

Let us return now to the problem of the construction of an isolated square, but in a less favorable position than that in the first example. Imagine the tile floor of a kitchen on which the observer is reclining, leaning on his elbows, his chin in the palm of his hand. Before him on the right is found a tile 10 cm square. The closest side is 42 cm from the observer's plane; its left side is 15 cm to the right of the vertical plane of sight. The observer's position implies that his eyes are 50 cm above the floor. At the base of the circular picture representing the total field, we have drawn a tangent representing the floor. On this line we can place the two reference points for the receding lines that contain the lateral edges of the square. The first point should be located the equivalent of 15 cm to the right of the vertical diameter that represents the vertical plane of sight, and the second the equivalent of 25 cm to the right (the radius of the circle being 50 cm). Beginning at these reference points we draw to the center of the circle two radii that represent the perspective of the receding lines of the square. It remains now to construct the

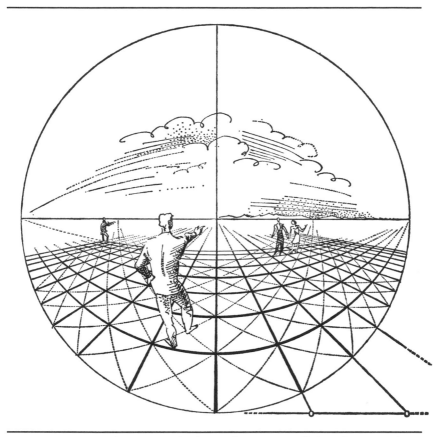

Fig. 54. *A grid composed of equidistant parallel and perpendicular straight lines intersecting at right angles. Their diagonals (in dotted line) are aligned on circular arcs receding to the first and third quarter of the horizon, which is a diameter of the 180° field.*

two horizontals that will contain the frontal edges of the square.

We know from the preceding example that when a central receding line cuts a diagonal receding line oriented at 45° and leading away from the vertical plane of the observer, we can draw through the point of intersection a frontal horizontal with its distance from the observer's plane equal to the dis-

tance from the central receding line to the vertical plane of sight. Thus on the ground line let us place a point 42 cm from the vertical diameter. From this reference point let us draw to the center of the circle a line that cuts the 45° receding line. Through the intersection of the two lines we will be able to draw a horizontal circular arc that will contain the square's frontal edge that is closest to the observer. We can place another reference point 52 cm from the vertical diameter and in the same way draw the other frontal edge of the square (fig. 55).

In order now to construct a grid around this first element, it suffices to trace one of the diagonals of the square, then to trace a network of receding lines from the reference points situated on the ground line which, by intersection with the square's diagonal, will permit us to draw the frontal horizontals.

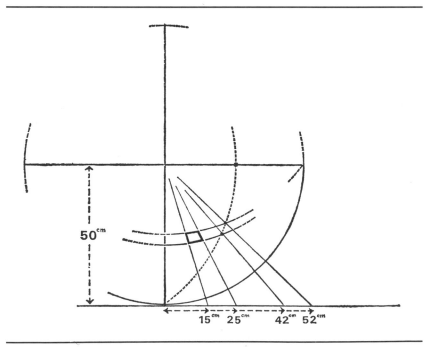

Fig. 55.

VERTICAL SQUARES AND GRIDS WITH CENTRAL RE-
CEDING LINES—It is clear that the construction of such
figures is identical, except for orientation, to those of the
preceding chapter. Instead of placing the reference points on
the ground line, these will be aligned on a vertical line. The
position of that line relative to the picture will be a function
of the distance from the real plane containing the squares to
the vertical plane of sight.

INTERSECTION OF HORIZONTAL GRIDS AND VERTICAL
GRIDS WITH CENTRAL RECEDING LINES—The reference
points of the sketch in this case are located on a ground line
and on a vertical line, with their placement and intersection
again defined by the coordinates of the system in real space.
It is even possible to use a single line of reference for several
grid planes if one utilizes the diagonals judiciously, as in the
example in figure 56, which represents four grid planes (floor,
ceiling, and walls).

OBLIQUE GRIDS WITH CENTRAL RECEDING LINES—To
make these constructions, the line of reference points should
simply be inclined at the same angle as the real plane.

HORIZONTAL SQUARES AND GRIDS WITH LATERAL RECEDING LINES

The four sides of these squares are lateral receding lines. The
example that comes immediately to mind is that of floor tiles
oriented at 45°. One can then return to the grids of the
preceding chapters and trace all the diagonals of those figures.
It is clear that the network of those diagonals forms a grid
oriented at 45° and the sides of the earlier squares become
the diagonals of the new ones. The reference points of the
ground line then no longer represent the length of the squares
but the length of their diagonals. The construction of such a
system is obviously simple enough, because a series of angles
of the grid coincides with the line of reference points.

Consider now a 40 cm square oriented on the ground at
45°, with the left corner located 2 m to the right of the vertical

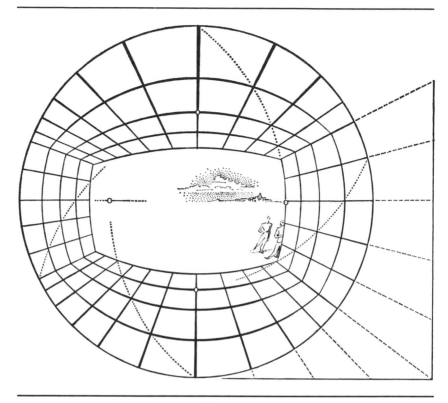

Fig. 56.

plane of sight and 1.2 m in front of the observer's plane. We will specify that the observer's eyes are 1.6 m above the floor. The problem is strictly posed, for we know the position of one corner of the square. To avoid all calculation, we can consider that the ground line represents the observer's plane and that the diagram is viewed from above. Using the 1.6 m radius as a unit, we can draw the square at its real position; the vertical diameter of the circle then represents the vertical plane of sight. If we extend the sides of the square, we determine the reference points on the ground line by their intersection with the observer's plane. From these four points, by means of four lines drawn to the center, we can locate the starting points of the four lateral receding lines on the cir-

PLANE FIGURES COMPOSED OF STRAIGHT LINES

cle's perimeter. Then, after having located the two vanishing points at 45°, we will be able to draw four arcs that will determine the shape and position of the square in perspective (fig. 57).

To develop a grid around this first element, we must only continue on the ground line an equal distribution of reference points issuing from two of the points already given which represent the spacing of the parallel lines of the grid. When the first set of parallels is drawn, one can use a second series of reference points to draw a second set perpendicular to the first, or again one can use the diagonals that will determine the points of intersection of the two sets.

It is clear that such perspective drawing is easily done freehand on tracing paper using a preestablished template of circular arcs following the procedure that we have already described. But the artist who wishes to use a compass in order to obtain greater precision will be led to calculate a great number of central points, because the grids that we are now studying are composed almost solely of circular arcs. There again, a simplified process of construction appears necessary.

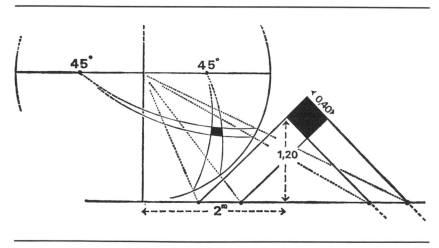

Fig. 57.

The reader may have noticed that the drawing of frontal horizontals or verticals was particularly easy, insofar as all possible central points of the circular arcs representing these lines are aligned. The centers of frontal horizontals are found on the line containing the picture's vertical diameter, and those of frontal verticals are found on the line containing the horizontal diameter. But when we make a 45° grid carefully, we will see that the same principle applies to the lateral receding lines: all centers of circular arcs that pass through the vanishing point to the left of the vertical diameter are found on a vertical line situated to the right of the vertical diameter, and all arcs that intersect the vanishing point at the right have their centers on a vertical situated to the left of the vertical diameter.

This property can be demonstrated mathematically, and this demonstration permits us to state a theorem that is extremely important in the practice of curvilinear perspective:

ALL ARCS THAT PASS THROUGH THE SAME POINT WITHIN A CIRCLE AND THAT HAVE AS A CHORD A DIAMETER OF THAT CIRCLE HAVE THEIR CENTERS ALIGNED ON A STRAIGHT LINE THAT IS PERPENDICULAR TO THE RADIUS PASSING THROUGH THAT POINT.

Note, moreover, that the centers of the arcs that represent lateral receding lines corresponding to regularly spaced straight lines are themselves regularly spaced on their alignment line.

Of course, compass drawings will be singularly simplified by using this theorem. On the one hand, when one knows the position of the vanishing point of one or more lines, it will be easy to find the centers of arcs that represent these lines because they will be aligned. On the other hand, when one wishes to draw a series of equidistant lines receding laterally, it will no longer be necessary to place a complete series of reference points on the diagram; it will be enough to situate these directly on the alignment line of the centers of arcs. Moreover it will become possible to find the center

of an arc rapidly when one knows the position of only two points, within the circular picture. This center will be at the intersection of two alignment lines relative to the two points under consideration (fig. 58).

Before using these new procedures, it is necessary to demonstrate how one can determine rapidly the position of the alignment line of the centers of all arcs passing through any one point. Take point *A* inside a circular picture (fig. 59). If

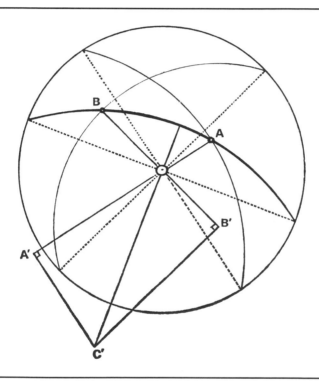

Fig. 58. *Given two points* A *and* B, *to draw an arc (chord = diameter) through these points, look for the arcs with the greatest curvature passing through* A *(center* A' *) and through* B *(center* B' *). Draw the perpendiculars to* AA' *at* A' *and to* BB' *at* B'. *Their intersection is the center of the arc we are looking for. (Because all of the arcs passing through* A *and* B *have their centers aligned on these two perpendiculars, their intersection is the center of the common arc.)*

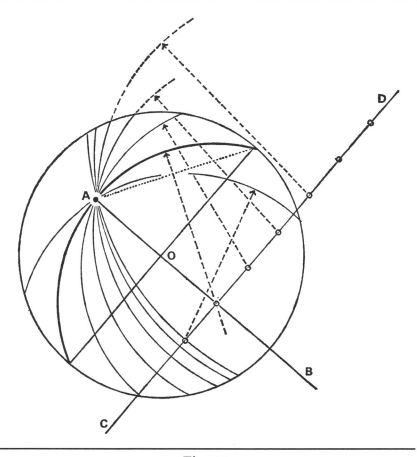

Fig. 59.

we draw through this point and through the center O a line AOB that is then cut by a diameter that is perpendicular to it, we determine the three points necessary for the construction of the circular arc of the greatest curvature containing point A (the diameter becoming the chord of this arc). The center of the arc is necessarily on the line AO. If we draw through this point a straight line CD perpendicular to AOB, we obtain the line on which are aligned the centers of all possible arcs containing A and having as a chord a diameter of the circular picture.

Take now the example of a grid oriented at 60° to the right and obviously at 30° to the left of the observer. After having placed the vanishing points on the horizontal diameter, let us trace the two alignment lines relative to these points. Now, as previously, let us draw a map of the grid together with the ground line. When we have obtained the position of the centers of only two arcs for each of the two series of receding lines, it will suffice to extend on each alignment line a sequence of equally spaced points based on the first two. All of these points will be centers of arcs representing lines of the tile floor. The radius of each arc will be equal to the distance from its center to the vanishing point (fig. 60).

VERTICAL SQUARES AND GRIDS WITH INCLINED RECEDING LINES

The four sides of these squares are inclined receding lines. The vanishing points of these figures will be located on the vertical diameter of the circle, at a distance from the center and in a direction corresponding to the real inclination of two sets of parallels. The line of reference points will then be vertical; the construction will be identical, except for orientation, to that of the figures in the preceding chapter.

SQUARES AND GRIDS ON AN INCLINED PLANE

These figures are composed of inclined receding lines and frontal horizontals. The vanishing point of the lines parallel to the vertical plane of sight will be situated on the vertical diameter, above or below the horizon line. The spacing of these lines will be determined by the reference points placed on the ground line, in the same way as in the case of central receding lines. Note that the alignment line of the centers of the arcs is parallel to the ground line and that these centers are not equidistant.

The originality of such a system resides in the placement of the vanishing point F of the diagonal that will permit us

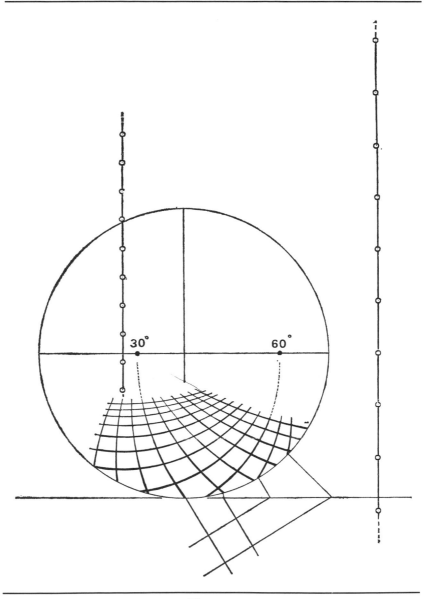

Fig. 60.

PLANE FIGURES COMPOSED OF STRAIGHT LINES

to determine the spacing of the frontal horizontals represent-
ing the lines perpendicular to the vertical plane of sight. We
must now return to the chapter devoted to putting ordinary
obliques in perspective. One will see that the vanishing point
of this diagonal is found on the frontal horizontal containing
the vanishing point of the inclined receding lines projected
to infinity on the inclined plane. The lateral position of this
point will be defined by using an arc of a curvature inverse
to that of the frontal verticals, analogous to a parallel but
oriented vertically. This arc represents the vanishing line of
planes containing all lines that recede at 45°, relative to the
vertical plane of sight (fig. 61). In the case of a grid situated
above the line of sight of the observer, the construction will
be identical, with this difference: the ground line will be re-
placed by a horizontal traced above the horizon line.

SQUARES AND GRIDS ON A LATERALLY
ORIENTED VERTICAL PLANE

The inclined receding lines of the preceding figures become
lateral receding lines, and frontal horizontals become verti-
cals. Construction differs only in general orientation, the line
containing reference points now being vertical.

OBLIQUE AND INCLINED SQUARES
AND GRIDS

The elements of these figures are determined by an irregular
oblique grid. The example that we give represents a grid
contained within a plane inclined 20° below the horizon,
where parallels are oriented 55° to the right and 35° to the
left of the vertical plane of sight. The vanishing points are
located on a frontal horizontal that represents the geometric
position of all possible vanishing points of all straight lines
that the inclined plane can contain (drawn to infinity on the
inclined plane). This line will have to cut the vertical diameter
20° below the picture's center. The exact position of the van-

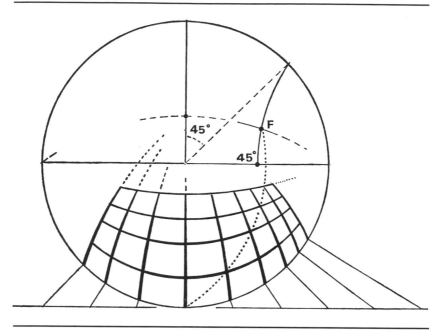

Fig. 61.

ishing points of our example is obtained by the intersection with this line at infinity on the inclined plane, of two vertical arcs of inverse curvature that represent the 55° and 35° directions (fig. 62).

SQUARES AND GRIDS ON FRONTAL AND HORIZONTAL PLANES

One can see in the following example how we can locate frontal horizontals and verticals without measuring angles, simply from a descriptive diagram identical to those used in placing receding lines (fig. 63).

On the ground line we place reference points where position and spacing correspond to the real position of the verticals of the grid, relative to the vertical plane of sight. From these points we draw the central receding lines; then, always on the ground line, we place to the right or left of the vertical

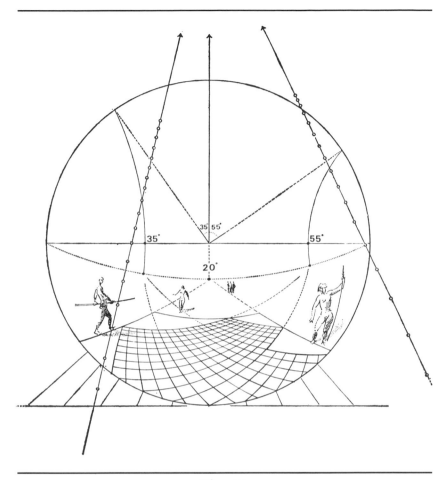

Fig. 62.

diameter a point whose distance from this diameter is equiva-
lent to the real distance from the plane of the grid to the
observer's plane. By drawing a central receding line through
this last point and using its intersection with a diagonal
ground line starting from the base of the vertical diameter,
we are able to draw a frontal horizontal that represents the
base of the grid. In cutting this line, the central receding lines
determine the spacing of the verticals of the grid. And by the
intersection of these verticals with a frontal line inclined at

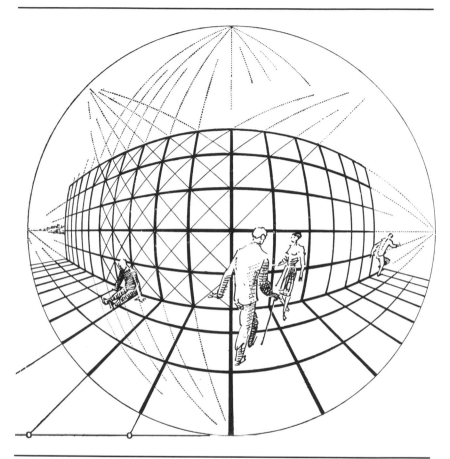

Fig. 63. *Horizontal and vertical frontal grids. The vanishing points of the straight lines contained within frontal planes (parallel to the picture plane) are on the perimeter of the image. (We synthesize here the visual impression when facing a tall building; the apertures diminishing in proportion to their distance from the observer, not their distance from the picture.)*

45° (diagonal to the grid), one determines the spacing of the figure's frontal horizontals.

HEXAGONAL NETWORKS ON VERTICAL AND HORIZONTAL PLANES

A simple equal partition of the ground line permits the construction of these networks, following the same method as in the preceding figure (fig. 63).

The vertical wall makes a 30° angle with the picture. Three vanishing points on the horizon, spaced 60° apart, indicate the directions on the horizontal plane. One of the three parallel bundles of the vertical plane recedes to 60° above the horizon, another is parallel to it, and the third recedes to 60° below (fig. 64).

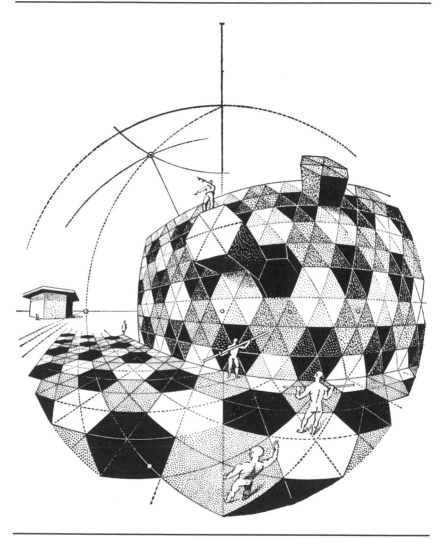

Fig. 64. *Hexagonal horizontal and vertical grids. The vertical wall makes a 30° angle with the picture. The three horizontal directions from left to right are 30°, 90°, and 30° relative to the picture plane. The three directions of the straight lines of the vertical plane are oriented parallel to the ground, at 60° above, and at 60° below it.*

9

SPACE AND VOLUME

ORTHOGONAL SOLIDS

Figures 56 and 63 show how one can proceed from flat drawings to orthogonal volumes. Applying the same procedures that we have used before, the surfaces of these volumes are determined by locating the edges. In principle only three types of vanishing points that indicate three perpendicular directions have to be located, whatever the general orientation of the construction. Nevertheless with the help of a few diagonals we will be able to develop the basic orthogonal grid to infinity within the enclosed space of the picture. Consequently the descriptive diagrams will be extremely reduced; starting with a few reference points very complex forms can be constructed.

The first example in this series (cubical landscape) is a simple assemblage of grids (fig. 65). The subjects that result (stairways, streets, etc.) are composed of rectangular elements (figs. 66, 67, 68, 69).

For the construction of a rectangle the reader is referred to figures 55 and 57, naturally giving each side its relative value.

From this point on the image will dominate the text. The figures will receive brief commentary. Progressively, visual and graphic logic should supplant theorems.

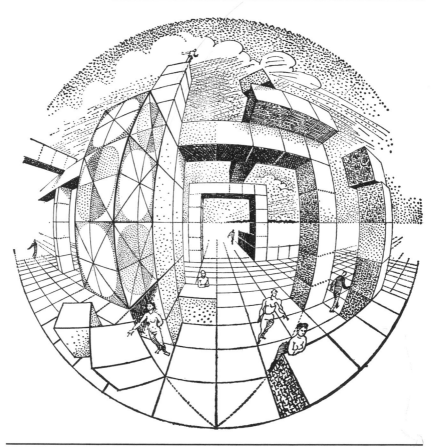

Fig. 65. *Playing with blocks. (The cubical grid is the only one that permits an equal partition of three-dimensional space.) The portico in the background indicates the limited field usually adopted in classical perspective. Note that the "cubicity" of solids is largely preserved beyond that arch.*

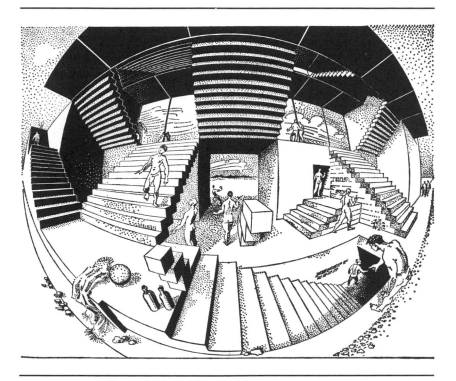

Fig. 66. *A frontal view of stairways. The edges of the steps form inclined planes that have pivoted on a frontal axis. Those in the foreground have pivoted on a vertical axis.*

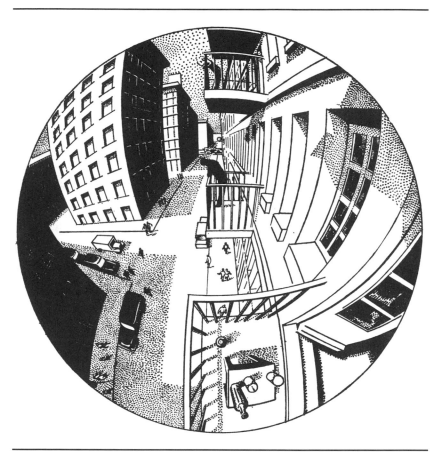

Fig. 67. *A picture when bending forward: a bird's-eye view. Frontal horizontals are preserved; the ground rises 45°; the vanishing point of verticals relative to the ground is at the lower quarter of the principal vertical. The observer perceives objects situated behind him (table, door, etc.).*

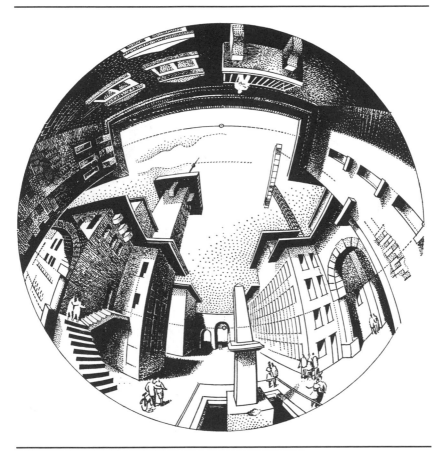

Fig. 68. *A picture when bending backward: a worm's-eye view.
Frontal horizontals are preserved. The ground slopes down at a 45°
angle; the vanishing point of the verticals is at the three-quarters
point of the principal vertical. The vanishing point of straight lines
parallel to the ground and to the main vertical plane is found at
the first quarter of the main vertical. The observer sees the building
located behind him in the upper part of the composition.*

Fig. 69. *Horizontal picture of a view from the doorsill. Verticals become central receding lines, and the horizon, coinciding with the ground, is at the perimeter of the picture.*

REGULAR POLYHEDRA

In this series of examples the perpendicularity of edges and surfaces is abandoned. The choice of subject merits some explanation. In three plates are represented the five regular polyhedra: tetrahedron, cube, octahedron, dodecahedron, icosahedron. These are the only solids that, while having their vertices equidistant on a sphere, consist of edges, regular polygons, and equal dihedral angles. Among them only cubes can fill space without interstices.

The Greeks attributed to them philosophical significance. For us their interest lies in their plastic qualities, in their geometric perfection, and in the general problems posed in putting them in perspective. This exercise is not without difficulties, but it is practiced more easily than in classical perspective, for the numerous vanishing points implied by these figures are located inside the picture. These points are determined by the planar angles of the edges and by the dihedral angles of the faces. These angles[1] are:

—for tetrahedrons:	120° and 70°30′
—for cubes:	90° and 90°
—for octahedrons:	120° and 109°30′
—for dodecahedrons:	72° and 116°30′
—for icosahedrons:	120° and 138°30′

(figs. 70, 71, 72).

[1] All angular values here are approximate, except for cubes.—TRANS.

Fig. 70. *Double tetrahedron in equilibrium. The eight vertices of this solid coincide with the vertices of a cube; its twelve (convex) edges form the diagonals of the six faces of the cube.*

Fig. 71. *Dodecahedron and perforated cube. Construction of the dodecahedron requires the preliminary descriptive construction of plan and elevation. On the ground the horizontal projection parallel to the intersecting plane of the circumscribed sphere contains the five apexes of the second level.*

Fig. 72. *Octahedron and icosahedron viewed together, balanced on one of their vertices. Construction follows the procedure for fig. 71.*

CIRCLES

The circles of figures 73 and 74 are circumscribed about octagons. The curves that represent them have been interpolated among the eight vertices of these polygons. More precise drawings might be obtained from polygons that have numerous vertices.

In curvilinear perspective real circles are transformed into curves that are not yet defined algebraically, as are the ellipses, hyperbolas, and parabolas of classical perspective. This is only apparently inconvenient. In practice the last three curves can indeed be drawn only point by point. One can therefore always trace them from the perspective of a regular polygon.

Even in the most favorable case in which the perspective of a circle is an ellipse, this does not particularly satisfy the criteria of similitude that we have defined.

The ellipse's natural symmetry, which requires that the farther half be just as large as the near half, contradicts the sense of depth that demands that the farther part appear smaller than the nearer; but the farther half does appear smaller in the curve that we obtain.

In fact, if we grant some objective value to the curvilinear perspective drawing of a polygon, all it takes to solve the problem is to remember that the circle is identical to a polygon with an infinite number of sides.

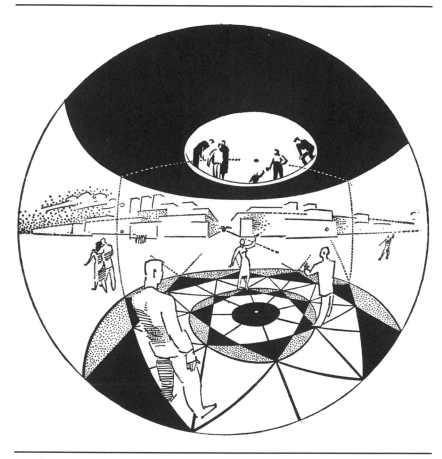

Fig. 73. *Concentric circles and inscribed octagons. The circles in the plane seen from below have the same diameter as the circles on the ground. The octagon is constructed by 45° rotation of a square.*

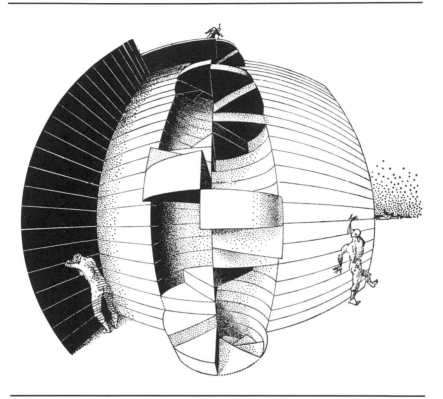

Fig. 74. *Close-up view of helical stairway. The eight upper steps are oriented parallel to the eight lower steps. Their heights are measured on the axis of rotation and are represented on the vertical plane at the left. The parallels of the frontal vertical plane are intercepted by the axis of rotation of the helix.*

TRIRECTANGULAR TRIHEDRALS

In all the illustrations that we have shown up to now, the artist has remained a slave to gravity; he has sat there, bound to the earth, whether he was perched on a balcony or lying on the ground, whether his visual vector implied a bird's-eye view or a worm's-eye view. At any rate, verticality and horizontality were present and assumed in the picture. Each image had a top and a bottom. Let us now break with these conventions; let us place ourselves under new conditions appropriate to modern men and women.

Assume that we are in a traveling vehicle. It negotiates a corner. Weight is combined with centrifugal force. Top and bottom are no longer definable following the usual order either of things or of constructions. There is only an intimate sensation, felt within his organism by each observer. In a free fall in space all sense of direction and self-orientation disappears.

Figures 76 and 77 are constructed in terms of this undefined space. They correspond to the perception that an airplane passenger or a parachutist in free-fall or a cosmonaut would have. They can be looked at from any direction. The spectator may choose any point in the image as the goal of his trajectory.

Still, the depicted subjects belong to the world of terrestrial geometry. They are articulated on three perpendicular planes; each of them is governed by a trihedral trirectangle; the three principal directions recede toward three points oriented at 90° from one another.

The construction of this type of image thus implies a preliminary placement of three vanishing points, independently of habitual notions of verticality and horizontality.

In figure 75 the vanishing point F_1 has been placed arbitrarily anywhere in the picture. The two other points F_2 and F_3 must necessarily lie on the arc ABC representing the vanishing line of the planes forming a right angle with the direction

F_1O. B should thus be placed at a distance from F_1 equivalent to 90°.

The point F_2 has been fixed arbitrarily on ABC. The arc MNP represents the vanishing line of the planes perpendicular to the direction F_2O ($F_2N = 90°$); naturally it passes though F_1. By definition, F_3 is located at the intersection of ABC and MNP. The vanishing line of planes perpendicular to the direction F_3O is the circular arc RST ($F_3S = 90°$).

The vertices of the triangle XYZ are the centers of the three arcs (drawn to infinity in the planes), and the straight lines passing through these vertices are the locations of the centers of all the arcs that pass through F_1, F_2, and F_3.

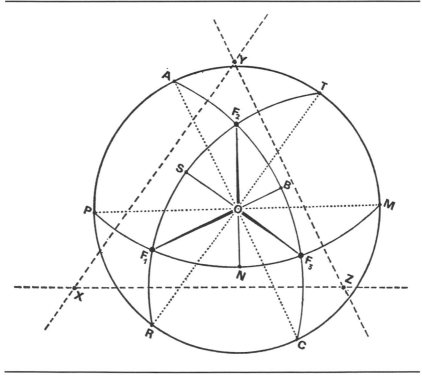

Fig. 75.

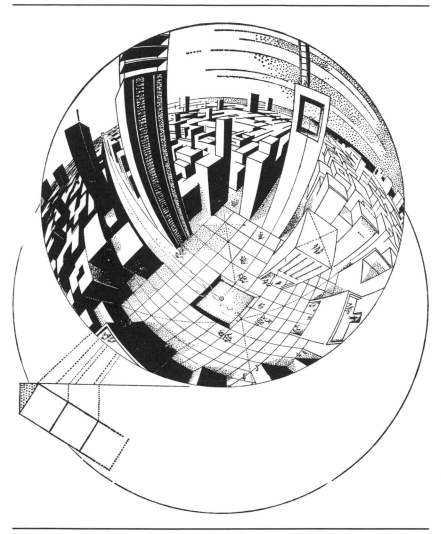

Fig. 76. *A picture when bending forward: a bird's-eye view. No plane of this trihedral trirectangle is either parallel or perpendicular to the picture plane, which makes a 53° angle with the ground. The receding directions of the bundles parallel to the ground and perpendicular to each other are calculated from the planar grid outside the composition.*

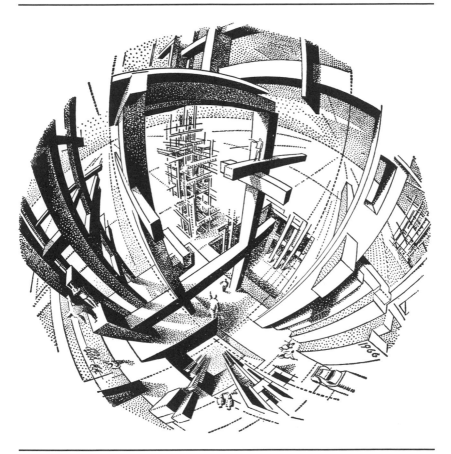

Fig. 77. *A picture when bending forward: a bird's-eye view. This construction site composed of elements intersecting at right angles is drawn freely by using the three vanishing points of the trihedral trirectangle. Half of the universe could be represented in this way.*

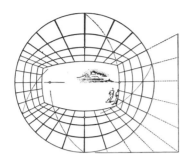

A FINAL WORD

Here it is—the end of our work. The reader with a penchant for geometry might wish to see other demonstrations and more problems to solve. Let him be reassured: putting visual space into curvilinear perspective poses a great number of geometric questions, all of them having a rational solution inasmuch as the logic of the mode of transformation, because it is essentially mathematical, cannot be faulted. For curious minds we propose, for example, the representation of total space (fig. 78).

Other readers, however, may become impatient and demand the creative liberty that we discussed earlier. They should remember that the modes of transformation of spherical perspective into plane drawing are innumerable and that there are just that many possible perspectives; but they should not forget that nothing in art (in drawing or in any other discipline) is "natural" or spontaneous. Art, by definition, implies artifice and everything made by art, by human hands. It was not by chance that Dürer gave his celebrated treatise the title *Instructions on Measurements by Ruler and Compass of Lines, Planes, and Solids.* A difficult apprenticeship in geometry, interpreted broadly, is the primordial way to approach any imagery.

It so happens, however, that we ordinarily forget the underlying construction of the image. The constructing attitude

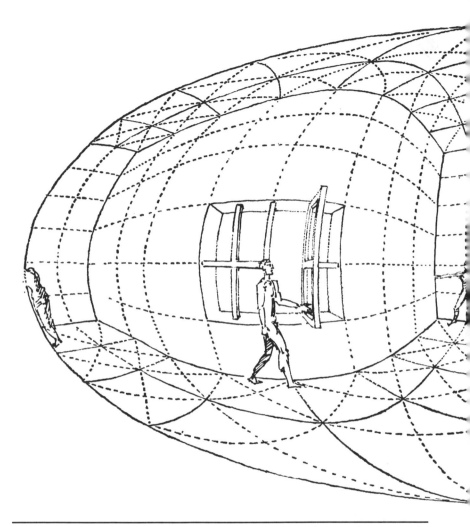

Fig. 78. *Total perspective of a parallelepiped seen from inside. The major axis of the ellipse of the total field represents a 360° horizon, therefore the entire equator of the visual sphere. Its minor axis represents the half-great-circle that passes through* P. *The el-*

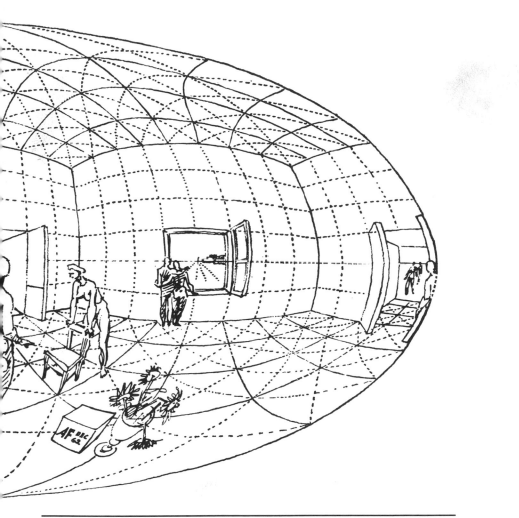

lipse itself is the transformation of the half-great-circle that passes behind the plane of the observer. It is composed of pairs of points that are symmetrical relative to the minor axis.

should even become "natural"; it will then become part of the general concern of all artists to achieve an authentic image. At first, however, it involves becoming aware of and rationalizing the fact that *all imagery* implies this rationality—that this, as we have demonstrated, leads to all sorts of possible solutions—and above all that this free choice makes us scrutinize all visual reality, be it the most familiar, as if it were new, an unknown phenomenon. We will suddenly be capable of astonishment, because relations between visible things will have lost their routine constraints, their banality.

What surprises us personally is that despite many fascinating efforts, no technician or painter or geometer up to now has ever thought of elaborating a new useful perspective. Perhaps the explanation can be found in the rigorous cloistering of intellectual disciplines but also in the interdiction cast by contemporary art on all that touches the rational possibilities of spatial representation, confused precisely by the specific case of the Albertian solution that we have so vehemently rejected.

Our surprise increases even more at the thought that the space of our own time has been so considerably transformed. We live within larger and larger spatial complexes. The modern city, where cells are now measured in hundreds of meters, implies a global vision. Our points of view are multiplied. We fly over the roads on which we formerly walked.

The menace of moving obstacles may unexpectedly loom up all around us. Simply crossing the street requires a rapid scanning, right-left, of a visual field of 180°. The cinema has become panoramic. Movie cameras, telescopes, radar, and sonar examine space in all directions.

The speed of our travel modifies our visual perceptions, obliging us to integrate a great number of sensations in a matter of seconds. We conceive space in terms of trajectory and thus in terms of curvature. Accelerations and turns create artificial gravity that undermines our routine notions of vertical and horizontal.

For the rigid Euclidian space of the Renaissance has been substituted a stretched and supple space that belongs to topology, while the imaging imagination of artists remains entangled in the rectilinear lattice of classical perspective's narrow window on the world.

Curved structures will engender architectural arrangements that will renew our understanding and our feelings. Our eyes will explore more widely, within space and within images. Infinity will be better integrated into pictorial experience. Our new grasp of the visible should transform our fear and rejection of reality into an eager desire to understand it better, to love it more. For a person who knows how to see well is one of the innumerable possible centers of the universe.

Thus the question of the representation of space has not been exhausted. Quite to the contrary, our ambition would be satisfied if we succeeded in reactivating this very old problem in inspiring and provoking new works.

Once again, curvilinear perspective is but one example, but a necessary one, because a simple critique of classical perspective was not enough to stimulate a current of research. All seekers need to be fortified in the certainty that the roads they take are not blind alleys.

Curvilinear perspective has its history, which is impossible for us to retrace within the clearly defined limits of our book; it presupposes the entire history of Albertian perspective; it embodies within it a *feeling* of space, which was often offended by attempts to teach it reason. From Fouquet to Daguerre—without forgetting Leonardo da Vinci, Dürer, the anonymous author of the Codex Huyghens, Callot, and among the moderns Delaunay, Escher, and others—many minds, interested in a rationale for their art, have confronted the impossibility of liberating their work from this obligatory way of looking at things, this compulsory rule for transferring the dilemma of space to the plane, while they were catching glimpses of other pictorial spaces.

Contemporary scholarship has also taken an interest in the question. Panofsky, in his exemplary works, proves the relativity of perspective, and after him English-speaking scholars have explored many paradoxical aspects of the perspective research of the past. In France, *Peinture et société* by Francastel (1951) describes the reinvigorated contemporary science of space. Liliane Guérry (Brion-Guérry) analyzes it in the case of Cézanne. André Chastel gives a particularly Florentine view of it. The reader who desires more information might want to consult the bibliographic references.

What prompted this work a long time ago were Albert Flocon's reflections as an artist facing nature, when he wished to represent vast visual fields. This reflection led him, by the force of circumstance, to bend the drawing of certain real straight lines and to discover the existence of the visual sphere. To arrive at the present form of curvilinear perspective, André Barre, in his turn, had to be persuaded of the importance of the question, and the artist and the technician then had to come together. (Hasn't the Greek word *techne* the same meaning as the Latin word *ars*: technique and art at the same time?) This encounter has eventually acquired its full significance: technique has to be rigorous in order to seize form in all its richness.

All the numerous problems, the true as well as the false, that arose during our search for a practical mode of construction that could be easily carried out have been resolved by almost daily comparisons of our writings and our thoughts. And finally, after living through those seven years of experiments, we believe that two ordinary heads think better than one alone.

This preliminary research ended, André Barre wrote the larger part of the text, which we then reviewed together and submitted to joint critique. Alfred Flocon drew most of the plates under the same conditions. Therefore this is our common property from the first to the last page. It is precisely

this constant discussion, and even our differences, that fill us with hope: we are both convinced that in the long run, we will convince the third and principal character in this drama— you, the reader.

BIBLIOGRAPHY

Bouasse, H. *Géographie mathématique.* Paris: Delagrave, 1919.

Chastel, Andre. *Art et humanisme à Florence au temps de Laurent le Magnifique.* Paris: Presses Universitaires de France, 1959.

Deininger, Julius. *Eine Neue Theorie der Malerischen Perspektive und deren Praktischen Resultate.* Vienna: Zentral-vereinigung Österreichischer Architekten, 1914.

de la Gournerie, Jules. *Traité de perspective lineaire.* Paris: Dalmont et Dunod, 1859.

Doesschate, Gezienus ten. *Perspective.* Nieuwkoop: B. de Graaf, 1964.

Edgerton, Samuel Y., Jr. *The Renaissance Rediscovery of Linear Perspective.* New York: Harper & Row, 1975.

Flocon, Albert. *Topo-graphies, essai sur l'espace du graveur.* Paris: Lucien Scheler, 1961.

————. "Histoire succincte de la Perspective." *Europe* (April 1963) Paris.

Flocon, Albert, and André Barre. "Une expérience objective sur l'espace plastique: 'la perspective curviligne.'" *Revue de Synthèse* (May–June 1962). Paris.

Flocon, Albert, and René Taton. *La perspective.* Paris: Presses Universitaires de France, 1963.

Francastel, Pierre. *Peinture et Societé.* Lyon: Audin, 1951.

Gregory, Robert L. *Eye and Brain.* New York: McGraw-Hill, 1972.

Guerry (Brion-Guerry), Liliane. *Cézanne et l'expression de l'espace*. Paris: Flammarion, 1950.

Hansen, Robert. "This Curving World: Hyperbolic Linear Perspective." *Journal of Aesthetics & Art Criticism* (winter 1973).

Hauck, Guido. *Die subjektive Perspektive*. Stuttgart: Wittwer, 1875.

Hegenwald, Horst. *Das Problem der Netzhautbildperspektive*. Braunschweig: Polytechnische Braunschweig, 1932.

Helmholtz, Hermann von. *Treatise on Physiological Optics*, III:178–185. New York: Dover, 1962.

Herdman, William Gawin. *A Treatise on the Curvilinear Perspective of Nature and its Applicability to Art*. London: John Weale & Co., 1853.

Ivins, William M., Jr. *Art and Geometry*. Cambridge: Harvard University Press, 1946.

Malton, Thomas. *A Compleat Treatise on Perspective*. London, 1776.

Nicod, Jean. *La geométrie dans le monde sensible*. Paris: Presses Universitaires de France, 1962.

Panofsky, Erwin. "Die Perspektive als 'symbolische Form.'" *Vortrage der Bibliothek Warburg* (1924–25); 258–330. Leipzig, Berlin: 1927.

———. *The Codex Huygens and Leonardo da Vinci's Art Theory*. London: The Warburg Institute, 1940.

Poudra, Noel-Germinal. *Histoire de la perspective ancienne et moderne*. Paris, 1864.

Prat, R. *L'Optique*. Paris: Editions du Seuil, 1962.

Ronchi, Vasco. *The Nature of Light: An Historical Survey*. Cambridge: Harvard University Press, 1970.

———. "Optique classique et Optique énergétique." *E.R.G. et champ visuel* (November 1962), Marseille.

Rossier, P. *La Perspective*. Paris: Dunod, 1960.

Stark, Fritz. *Das Netzhautbild*. Neuss: (self-published), 1928.

Vagnetti, Luigi. *De naturali et artificiali Perspectiva*. Florence: Libreria editrice fiorentina, 1979.

Veltman, Kim. "Literature on Perspective (1971–1984)." *Marburger Jahrbuch für Kunstwissenschaft* (1986), Marburg.

————. *Linear Perspective and the Visual Dimensions of Science and Art*. Munich: Deutscher Kunstverlag, 1986.

White, John. *The Birth and Rebirth of Pictorial Space*. New York: Harper & Row, 1972.

IN LITERATURE, CURVILINEAR PERSPECTIVE IS SUGGESTED IN:

Etiemble. *Peaux de couleuvre*. Vol. III. Paris: Nouvelle Revue Francaise, 1948.

Schmid, Arno. *Nobodaddy's Kinder*. Hamburg: Rowohlt, 1954.

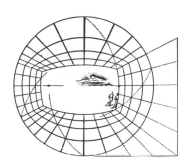

TRANSLATOR'S
AFTERWORD

While Flocon was presenting his ideas to Barre, and well before the appearance of their book in Paris in 1968, I had independently become aware of my own curvilinear view of the world and had presented it to my drawing students, first at the University of Hawaii in 1955 and since 1957 at Occidental College. By 1968, after I had despaired of finding a curvilinear system in the literature of scholarship, let alone in how-to-draw perspective books, I had begun to write the article, "This Curving World: Hyperbolic Linear Perspective," which eventually appeared in the 1973 winter issue of the *Journal of Aesthetics and Art Criticism.*

I discovered the title, *La Perspective Curviligne,* in a bibliography in the mid-seventies, ordered the book from the Paris publisher, and gradually over several years determined to translate it, with the gracious authorization of Professor Flocon (André Barre died in 1972) and with help from professors Moschovakis, Grayson, and Hart. In addition to teaching courses in drawing and painting, I am a professional painter and have exhibited widely in California and occasionally in New York. My lacquer-on-board paintings, rather abstract images suggesting the human figure, lack even the slightest hint of foreshortening, whether curvilinear or rectilinear.

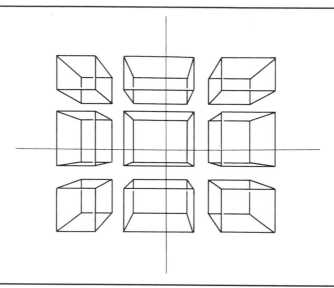

Fig. A. *15th Century 1-point space. Albertian "artificial" perspective*

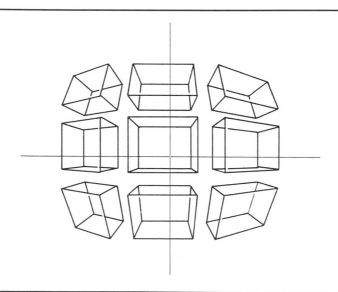

Fig. B. *19th Century 1-point, 2-point, and 3-point space. Whenever three planes of an opaque cube are visible, three points are operative; two planes, two points; one plane, one point.*

TRANSLATOR'S AFTERWORD

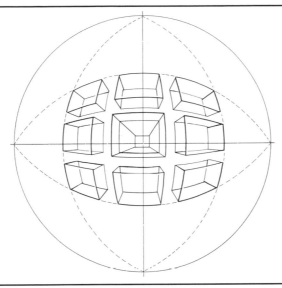

Fig. C. *Spherical 5-point space, as in Flocon-Barre. All lines are simple arcs except the orthogonals which are straight.*

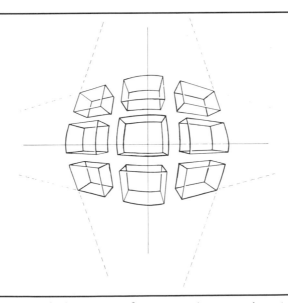

Fig. D. *Hyperbolic "natural" perspective: 3-point, 4-point, and 5-point space. When three planes of a cube are visible, three points are operative; two planes, four points; one plane, five points.*

In point of fact modern central perspective is a mathematically exact abstraction substituted for a physiological image which is wholly deceptive. We see not with one fixed eye, but with two constantly moving eyes; the image which we receive on the retina is a spheroid world projected on a concave plane. Thus, in a perspective drawing, straight lines are presented as straight, but in our visual image they are actually curved. Through the use of the printed page and mathematical perspective we are now accustomed to discount mentally this image; but for the ancients this curving world was an accepted phenomenon.

> —A. G. M. Little,
> "Perspective and Scene Painting,"
> *Art Bulletin,* XIX (1936):492.

The "ancients," artists before Alberti, seldom used curves to depict rectangular objects, but their approximations of foreshortening, unlike the rigidly regimented realism since the fifteenth century, permitted a flexible space and a variety of non-Euclidean shapes and measurements. As Flocon and Barre make clear, their new system is offered not in order to replace Renaissance perspective as the only "true" manner of representing the three-dimensional world on a two-dimensional surface but rather as another, and in some sense better, means of seeing and describing our visual environment. They welcome still other alternative visions. In this light, consider now a hyperbolic version of the spherical imagery presented in this book.

HYPERBOLIC PERSPECTIVE [1]

Note that an arc-based system, while providing an efficient method of reproducing the curving appearance of our world

[1] For a more complete introduction to hyperbolic perspective, see Robert Hansen, "This Curving World: Hyperbolic Linear Perspective," *Journal of Aesthetics and Art Criticism,* winter 1973, pp. 147–161.

on a flat surface, retains one of the anomalies of traditional perspective: the absolute difference in kind between the rectangular frontal grid represented here as arcs and the straight diagonal "orthogonals" that radiate from the central vanishing point in both systems. At the same time, arcs seem to exaggerate the appearance of curvature near the extremities of receding lines (*fuyantes*) as they approach a vanishing point. In our experience, as we carefully attend to appearances these parallel lines appear to curve nearest our eye on the frontal plane but remain straight in oblique planes where they converge at a vanishing point. How can these experienced straight orthogonals be reconciled with the demonstrable curves of the frontal grid?

A preliminary question may be useful. Even after we agree that straight lines of the frontal plane usually appear as curves, a question remains: Are these curves really arcs of circles?

In one fundamental sense, I believe that they *probably* are circular curves. Without moving the head, we of course cannot see accurately the entire area between diametrically opposite vanishing points. But my guess, based on the curves that I can see clearly in front of me, is that these curves do continue as arcs, and that convex mirrors and wide-angle lenses give us a fair picture of the circular nature of all straight lines as they would exist if we could see the entire 180-degree field.

However, do we *see* arcs? If in fact we must turn our head in order to see the extremities of each line, and if as the head turns the curving line gradually straightens, *is it not this graduation from curve to straight line that characterizes our experience*? I am not prepared to prove that we see mathematically defined hyperbolas, but I am convinced that every straight line appears to us *like* a hyperbola, a curving ligament connecting two almost straight orthogonal asymptotes. Only the hyperbola possesses both the virtually straight extremities and also the bent central region that we acknowledge in wide-angle viewing of straight edges outside our foveal vision.

Note that Helmholtz reported that his own experiments produced hyperbolic transformations of straight lines at the periphery of the visual field.[2] Note also Flocon and Barre's figures 6, 7, and 78.

Now the Flocon-Barre methods of applying the geometry of arcs to our task of representation is admirably rational, and they have made it possible for any artist or student to create images quickly and consistently, especially if arc-based grids (*reseaux*) are utilized. Comparable hyperbolic grids are conceivable (see figure 78), but because they must respond to several variables they would require and be subject to considerably more individual choice than would be necessary or possible with the more easily standardized arc system.

One result of choosing hyperbolic rather than circular convergence is the relative broadening of the representation of the 180-degree field of vision, and along with it the severe reduction in scale of the focal (foveal) subject matter, and less restriction of areas in the corners of the rectangular picture where plane distortion of the hemisphere is so severe in circular projection. Thus in considering frontal plane subjects, it is almost required that all four outer vanishing points be placed far outside the frame of the picture. Of course, limiting our focus to the central areas of the Flocon-Barre pictures may also permit us to reduce radical distortion and to rescue a degree of rational similitude from the influence of the more irrational periphery.

In one sense the hyperbolic system seems to be more fundamentally true to experience than a circular system. Moreover hyperbolas offer a compromise that maintains curves and virtually straight lines within the same system. It also provides flexibility for subjects in motion and for moving observers. A rotating box will alternately present frontal and oblique faces, each face seen frontally only for a moment—and therefore alternate straight and curving appearances of

[2] Hermann von Helmholtz, *Treatise on Physiological Optics* III: 390.

the same straight edge. A rotating observer—an artist—will likewise change an oblique plane of a box or a room to a frontal plane simply by looking to right or left. In a spherical system of arcs, however, the same motion will require the erstwhile straight orthogonals to collide with the curving frontal edges and the initial arc of the frontal plane to become at some point a straight orthogonal. We are becoming accustomed to such a transformation in wide-angle cinema and television, in which the transition from straight line to curve and back again appears natural and may lead us to acknowledge the same change in our everyday observations of ordinary movement, as well as in the images we see even as we ourselves move. Only a hyperbolic system expresses this transition from curve to straight line.

Such a hyperbolic system, however, does not lend itself easily to precise measurement. This practical advantage of regular arcs in the geometric construction of a static view may make the system presented in this book preferable on most occasions to the less reliable freehand approximation of hyperbolas, with their constant graduation between curve and straight line.

The Flocon-Barre construction methods, admirably precise, described here with economy and wit after an incisive analysis of traditional linear perspective, for the first time offer artists a practical reconciliation of experience and expression. Three-dimensional vision—wide-angle vision projected onto a spherical retina—has for the first time been given a systematic two-dimensional analogue. A picture can now depict consistently the visually diminished size of all receding planes. It remains to be seen how soon artists, architects, and schools of visual art may recognize the validity of this alternative to the old "laws" of perspective.

Occidental College Robert Hansen
Los Angeles

Académie royale de Belgique Koninklijke Academie van België

BULLETIN

DE LA

CLASSE

DES SCIENCES

5ᵉ Série. — Tome L

MEDEDELINGEN

VAN DE

KLASSE DER

WETENSCHAPPEN

5ᵈᵉ Reeks. — Boek L

1964 — 3

EXTRAIT — UITTREKSEL

Étude comparée de différentes méthodes de
perspective, une perspective curviligne,

Note de

MM. Georges BOULIGAND, Albert FLOCON, André BARRE.

BRUXELLES BRUSSEL
PALAIS DES ACADÉMIES PALEIS DER ACADEMIËN
RUE DUCALE, I HERTOGSSTRAAT, I

—

1964

APPENDIX

*ABSTRACT, EXCERPTS, AND
SUMMARY DIAGRAMS OF THE PAPER
PRESENTED AT THE SCIENCE SESSION
OF THE ROYAL ACADEMY OF
BELGIUM IN 1964*

A COMPARATIVE STUDY OF VARIOUS METHODS OF PERSPECTIVE: A CURVILINEAR PERSPECTIVE

by Georges Bouligand, Albert Flocon, and
André Barre

ABSTRACT: Classical linear perspective is contrasted to the curvilinear perspective proposed by Flocon and Barre. Three methods of transforming a sphere on a plane are then compared: (1) the gnomonic projection, which is neither conformal (angle-preserving) nor equidistant (distance-preserving); (2) stereographic projection, conformal but not equidistant; and (3) the analytic transformation of the sphere by the method of Guillaume Postel (1510–1581), which he introduced to the science of cartography. Although Postel's projection is not conformal, angular alterations of the sphere are slight; and it is preferred in Flocon/Barre's curvilinear perspective because it preserves distances along one axis while altering distances the least along the perpendicular axis in wide-angle views, especially in views wider than 30 degrees.

EXCERPTS FROM THE PAPER

The question Δ: how to arrange visual elements on a flat surface in order to form an image that stimulates in the viewer the sensations of three-dimensional volume and space.

The fundamental axiom (Axiom A): a measurement of equal size in the real world appears smaller the farther it is from the observer.

Is it preferable to conserve angles? Should one seek the least general alteration of lengths or should one retain certain equidistant relationships?

Must the geometric aspect or the simplicity of the system prevail?

Classical perspective, rejected because it cannot entirely satisfy axiom A, might be identified with a process utilized in cartography: *gnomonic projection*. The modes of transformation that might be chosen for the new perspective necessarily ought to have a less serious defect than that of gnomonic projection.

As examples, the authors describe here the three modes that remain in the running after eliminating other options: gnomonic projection (kept by way of reference), stereographic projection, and the transformation of Guillaume Postel.

The tables below show the variations in change of length and angle in the immediate vicinity of points *M*, situated at intervals of 15° at angular distances *S* from the center *C*.

The alterations of length are defined by two relations that express the dilatations of the large axis and small axis of the elliptical image of the circle of radius λ.

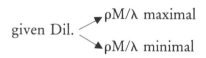

given Dil.
- ρM/λ maximal
- ρM/λ minimal

The angular alteration is given in its maximal value.

The *gnomonic projection* is a central projection of the sphere on a plane *P* tangent to it: the view point *O* being situated at the center of the sphere. To any point *M* on the spherical surface corresponds point *m*, which is the intersection of the straight line *OM* with plane *P*.

S	0°	15°	30°	45°	60°	75°	90°
Dil. ρM/λ	1	1.07	1.33	2	4	15	∞
ρm/λ	1	1.03	1.15	1.4	2	3.8	∞
ω	0	1°59'	8°14'	19°46'	38°57'	72°09'	180°

. . . The *stereographic projection* is defined geometrically as the projection of the sphere on a plane *P* tangent to it, the point of view *O* being situated at the antipode of the point of tangence.

S	0°	15°	30°	45°	60°	75°	90°
Dil. ρM/λ	1	1.017	1.07	1.17	1.33	1.6	2
ρm/λ	1	1.017	1.07	1.17	1.33	1.6	2
ω	0°	0°	0°	0°	0°	0°	0°

. . . The *method of Guillaume Postel* introduces an analytic transformation that can be defined simply. Geodesic polar coordinates are adopted as plane polar coordinates.

S	0°	15°	30°	45°	60°	75°	90°
Dil. ρM/λ	1	1.01	1.04	1.11	1.2	1.35	1.57
ρm/λ	1	1	1	1	1	1	1
ω	0°	0°39'	2°39'	6°01'	10°52'	17°21'	25°39'

. . . Of all possible modes, the transformation of Guillaume Postel is the one that alters length the least.

. . . In practice, the alteration is usually not distinguishable from the physical imprecision involved in *all* drawing. The solution except for ε thus permits us to consider these curves as circular arcs.

Over and above the practical advantage, the artist can mentally arrange the finite elements. He can establish a logical correlation

between the rational elements of reality (*LS*) and the rational elements of the drawing that have this in common: a constant curvature. To summarize, the characteristics of curvilinear perspective are the following:

—The total visual field of 180° is contained in a circle.
—The horizon is represented by the horizontal diameter.
—The real straight lines (*LS*) become circular arcs or portions of circular arcs a chord of which is always the diameter of the picture, except where the two are identical.
—Every frontal straight line has two diametrically opposite vanishing points on the perimeter (example E presents the appearance of a spindle).
—Straight lines perpendicular to the picture plane are represented by straight lines that converge at the picture's center (vanishing point).
—All other straight lines (circular arcs) have a single vanishing point inside the picture that corresponds to their direction.

FORMULA FOR CONSTRUCTING A POSTEL'S ARC $\overline{\Delta}$

(CALCULATED BY JACQUES HARMEY)

M* indicates location on the sphere

M indicates location on the plane of the drawing

POLAR COORDINATE EQUATION.

Figure 1 (the visual hemisphere) shows that:

$$\cos \alpha = \frac{P^* \, M_o'}{P^* \, M'}$$

$$\tan \beta = \frac{P^* \, M'}{R} \quad (R = \text{radius of hemisphere})$$

$$\tan \gamma = \frac{P^* \, M_o'}{R}$$

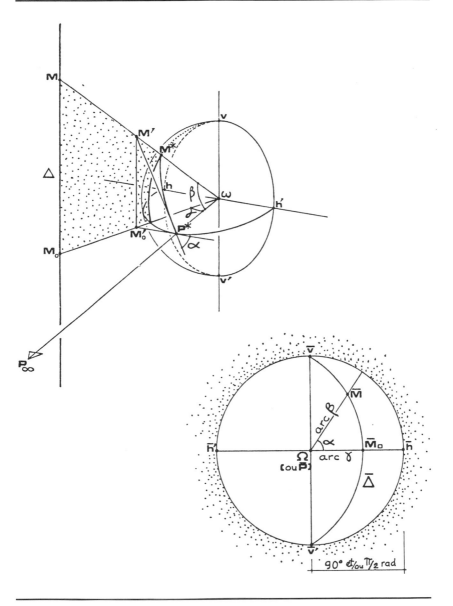

The circular picture, analytically transformed from the equivalent visual hemisphere, contains the curvilinear image of half the universe.

therefore

$$\cos \alpha = \frac{\tan \gamma}{\tan \beta}$$

then

$$\cos \alpha = \frac{K}{\tan \beta}$$

($\tan \gamma$ is a constant for a given vertical Δ)

again where

$$\tan \beta = \frac{K}{\cos \alpha}$$

the equation for the curvilinear perspective of Δ in polar coordinates is therefore written:

$$\beta = \text{arc tan} \left(\frac{K}{\cos \alpha} \right)$$

on the circular diagram, α is the polar angle and β is the polar radius expressed in radians, the value of the diagram's radius being $\pi/2$.

GLOSSARY

Alignment line. A straight line joining centers of arcs.

Azimuth. The polar angle; the angle of separation from the horizontal.

Concave. Curved away from, hollow; in mathematical parlance, an arc segment is concave when it lies *below* a chord that cuts it off.

Conformal. As applied here, angle-preserving.

Convex. Curved toward, bulging; in mathematical parlance, an arc segment is convex when it lies *above* a chord that cuts it off.

Develop. To roll out a three-dimensional surface on a plane without stretching or shrinking.

Dilatation. A kind of transformation (q.v.) that expands or contracts all elements of a form similarly.

Directrix. As applied in chapter 5, the circular boundary of the hemisphere; the equator.

Equidistant. As applied here, distance-preserving.

Generator. As applied in chapter 5, a quarter-great circle anchored at a pole (like a meridian on a globe).

Gnomonic projection. Refer to text in chapter 5.

Grid. A network [*reseau*] of perpendicular lines.

Groundline. A horizontal line drawn tangent to the circular periphery of a picture at its base.

Homothetic dilatation.	A spreading out of a three-dimensional form in which each element is mapped into a positive constant multiple of itself.
Line of sight.	An imaginary line projected straight forward from the eye.
Non-Euclidean geometry.	Any geometry that rejects Euclid's parallel postulate: through a point not on a line there is exactly one line parallel to the given line.
Observer's plane.	The plane of the eye perpendicular to the line of sight.
Orthogonal line.	A line depicting an edge parallel to the line of sight that converges with other orthogonals at the central vanishing point.
Picture plane.	The plane of the picture's surface.
Plane of sight.	Any plane containing the line of sight.
Receding line.	Any line depicting a straight edge that is not parallel to the picture plane.
Receding plane.	Any plane that is not parallel to the picture plane.
Tangent of an angle (abbreviation: tan).	In trigonometry: the ratio of the side opposite the given acute angle in a right angle triangle to the side opposite the other acute angle.
Template.	A diagrammatic pattern serving as a guide in construction.
Transcendental curve.	A curve that cannot be defined algebraically.
Transformation.	In perspective, a two-dimensional mapping of a surface that is in three-dimensional space.
Vanishing line.	A line containing a number of vanishing points for various lines that depict parallel receding edges.
Vanishing point.	A point (at infinity) toward which parallel edges (receding lines) appear to converge.

View point. The location of the observer's eye, also known as observer's point, eye point, station point [*point de vue*].

Visual axis. The line of sight, projected straight forward from the eye.

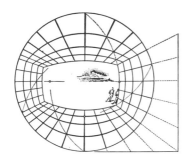

AUTHOR BIOGRAPHIES

Albert Flocon is widely respected in Europe both as an artist and as a writer on art history and theory. Born Albert Mentzel on 24 May 1909 in Kopenick, Germany, his studies at the Bauhaus included theater projects under Schlemmer as well as classes with Klee, Kandinsky, and Albers. Escaping Hitler's Germany, he moved to Paris in 1933, working in a graphics atelier there with Vasarely. After a voluntary hitch in the foreign legion, he sought refuge in southern France in 1941 but was arrested by the Gestapo in 1944 in Toulouse, along with his wife and daughter, both of whom later died at Auschwitz. Becoming a French citizen as Albert Flocon in 1947, he was introduced to burin engraving by Albert Yersin and in 1948 illustrated his first book, a volume of poems by Paul Eluard called *Perspectives,* with twelve engravings. He was a founder, with Yersin, Fautrier, Villon, and others, of the artists' group Graphies in 1949. Between 1954 and 1964 he was professor of printmaking and history of the book at the École Estienne, where he developed his principles of curvilinear perspective in collaboration with his colleague André Barre, and where he began a correspondence with Escher. He held the chair of perspective at the École des Beaux Arts from 1964 to 1979.

His publications include children's books by Albert Mentzel (three volumes, Flammarion, Paris, 1937, 1938).

Beginning in 1948 drawings, engravings, and lithographs of Albert Flocon have appeared as illustrations in twelve separate volumes, including his own texts as well as the writings of Paul Eluard, Gaston Bachelard, Jean Rostand, Louis de Broglie, and Victor Hugo. Among his most important works is his book, *Entrelacs* (Paris, 1975), featuring thirty engravings of images of knots, chains, and other interlaces. His work has been shown in numerous exhibitions in galleries in Paris, Lausanne, Geneva, Frankfurt, and most recently in the Museum of the Bauhaus in Berlin. Suites of his engravings are in the collections of the New York Public Library and in Philadelphia's Lessing Rosenwald Collection, as well as in many collections in France, Great Britain, and Germany. In addition to *La Perspective curviligne*, Albert Flocon has published widely on historical and theoretical topics: a book, *La Perspective*, with the mathematician René Taton in 1962 and numerous articles on perspective, on the sixteenth-century perspectivist engraver Wenzel Jamnitzer, on the work of Yersin, Escher, Meryon, and Villon, and on print history and techniques. He has just completed a history of the Little Theater of the Bauhaus from 1927 to 1930. Flocon lives in Paris, where he is a consultant to the new Musée des Sciences et Techniques.

André Barre, born in 1918, was the director of intaglio printmaking at the École Estienne, becoming its director in 1968, four years before his death in 1972. An expert technician, he took an immediate interest in curvilinear perspective when Flocon arrived at the school and showed him his first essays on the subject in 1956. Barre collaborated with Flocon in a book, *L'Image en question* (Estienne, Paris, 1968), and in an article, "Une expérience objective sur l'espace plastique: la perspective curviligne" (*Revue de synthèse*, May–June 1962), essentially a critique of Renaissance perspective and their first publication declaring the primacy of curvilinear perspective in visual experience. About 1965, when the au-

thors became discouraged by the extreme delay in preparing this book for the press and Flocon was about to abandon the project, it was Barre's "friendly insistence," according to Flocon, that kept them going until *La Perspective curviligne* was published. The present book is the result of seven years of almost daily confrontation by artist and technician together of every aspect of theory and construction methods.

Designer: Kitty Maryatt and Robert Hansen
Compositor: Prestige Typography
Text: 12/14 Stempel Garamond
Display: Helvetica
Printer: Braun-Brumfield
Binder: Braun-Brumfield

ART CENTER COLLEGE OF DESIGN LIBRARY
1700 LIDA STREET
PASADENA, CALIFORNIA 91103

3-21-89 3850 ht 38148